THE ART AND MAKING OF
THE FLASH™

ABBIE BERNSTEIN

FOREWORD BY
GREG BERLANTI

CONTENTS

FOREWORD BY
GREG BERLANTI

I f Barry Allen were a real person he would no doubt start this by saying "thank you." Thank you for caring enough about *The Flash* that you purchased this awesome book. Or maybe you haven't bought it, maybe you're just flipping through it in a bookstore. Thanks for that too.

In one way that's how *The Flash* TV show was born, somebody flipping through something they should have paid to read. You see, television shows are born many times over (more on that in a second) and one of the ways *The Flash* was born was at a comic stand in the back of a flea market in the mid-1980s in Port Chester, New York. I would save up for comics all week and the cantankerous owner, provided I didn't talk to him, would allow me to read whatever comics I couldn't afford. That's when I first fell in love with the Silver Age Flash, Barry Allen, the fastest man alive.

I remember reading "Crisis on Infinite Earths" like it was yesterday, standing amongst the comic racks, breathlessly flipping pages as the Flash raced to save the day (Fathwoom!), and in so doing, gave his life for his fellow Super Heroes and the world. Barry wasn't the strongest Super Hero or the oldest or the wisest but he had the greatest heart and believed that it was his job to do what he could do, even if it meant he would make the ultimate sacrifice. I was gut wrenched by his loss and it was in that moment that I realized how much his character and the world of comic books really meant to me. You can only imagine how rewarding it has been to play a role in bringing that character to life on screen.

It was also incredibly fitting then that one of my partners in creating that show turned out to be Geoff Johns who, amongst his many notable achievements, was bringing Barry Allen back to life in the comics in his run "Rebirth." But Geoff isn't just the smartest guy about comics you'll ever meet, his real talent is simply with storytelling and his ability to share his love for what makes a character great. Our other incredibly talented co-creator and fellow writer was Andrew Kreisberg. Andrew is one of those guys who is so good at writing and story and comedy and drama and action that you would hate him more if he weren't also so kind.

The three of us huddled together for weeks and hatched a story that would at the very least entertain and excite us, fans of the comic, which then in turn would hopefully entertain and excite others too. And that is the next time *The Flash* TV show was born. As I mentioned earlier, TV shows are born several times over and in several different ways. All of these births have to go just right for a show to work.

You can't just work hard AND get lucky at writing and then screw up the casting or directing

Greg Berlanti is the co-creator/executive producer on four CW series all set in the DC Comics-verse: *Arrow*, its spinoff *The Flash*, *Legends of Tomorrow* (a spinoff of both of the other two) and *Supergirl*.

or producing stage of the pilot; you have to work hard AND get lucky at EVERY stage. And since you can't control the luck portion of the process you'd best work with people who are smart and share your work ethic. That brings me appropriately to Peter Roth and Mark Pedowitz. Respectively they're the Presidents of Warner Bros. Television and the CW Network, but what's more important is that they're fans of great television and true supporters of people who work to make it. They were the first two people to encourage and entrust us to bring *The Flash* to life.

Before we even finished a script we somehow convinced famed TV pilot whisperer David Nutter to direct *The Flash*. David had directed the *Arrow* pilot flawlessly (that show was also a blessed experience, the parent of this show, and one of the first in a new era of comic book TV shows) and there really wasn't anyone else that could have pulled this pilot off so thank god he said yes. The next time *The Flash* pilot was born was in David's head. David found the crew to execute an incredibly cinematic version of our TV show because no one bothered to tell David or his crew that we weren't making a movie. Amongst those folks (and there are really too many to mention all of them) was cinematographer Glen Winter, who was and still is a first-class director in his own right; production designer Tyler Harron, who pours his genius and love of *The Flash* comic into the show every week; stunt coordinator JJ Makaro, who always figures out a way to make our fights look like they were shot for ten times the budget. And costume designer Colleen Atwood (multiple Oscar® winner) who designed a modern streamlined suit for the Flash that made us all feel like we were watching the comic book come to life.

The next time *The Flash* was born was in casting. Our casting director, David Rapaport, brought Grant Gustin in first for the role of Barry Allen. This was not an accident. How do I know this? David had also brought in Stephen Amell first for *Arrow* and Melissa Benoist in first for *Supergirl*. See what I mean? Not an accident. We saw a thousand actors after Grant and we couldn't get Grant out of our heads or our hearts. Because when Grant acts, you smile. He wasn't quite the age we thought we had wanted and he didn't have Barry's traditional blond locks but he to us was the living embodiment of "the heart and soul" of the Flash. When Peter Roth first saw Grant's read he didn't even let me finish playing the audition before he screamed, "That's Barry Allen! That's our Flash!" The network agreed wholeheartedly as they did with the rest of the cast (in fact, it was one of the easier casting processes I've ever had for a show).

Jesse L. Martin sat down with Andrew and me in a tea shop in Manhattan and had all the warmth and goodness that he brings to Joe West. We weren't even done with the script before we were rewriting it with Jesse in mind. I'd worked with Tom Cavanagh twice before, and twice before his brilliance had made roles even more complex than I imagined and then somehow he went and outdid himself with Dr. Wells. It doesn't take an actual genius to play one but Danielle Panabaker who read for Caitlin Snow is an actual one (she graduated college at like nineteen or something insane). That's why she exudes such intelligence in the role. As for the kindness – that's also because she's one of the nicest people you'll ever meet. Carlos Valdes came in for Cisco Ramon not ever having acted on screen before. He was starring in a Broadway show and Peter Roth had him sing from *Jersey Boys* in the audition room. He dazzled us with his acting and his voice and snagged the role in the room. Carlos's first actual screen time was then on an episode of *Arrow* right before we started shooting *The Flash* pilot and if there's a better definition of "natural" I'd like to know what it is. John Wesley Shipp and I had worked on *Dawson's Creek* together many years before. Geoff and Andrew and myself had loved him as the Flash on CBS in the nineties and couldn't imagine making this rendition without him. We are grateful every day for him saying yes. Iris West was the most challenging to cast and perhaps that's just because we were waiting for Candice Patton to walk in the room. Once she brought her presence and her strength we all finally realized why Barry had loved her all his life and the cast finally felt complete for the first time.

After the pilot was shot and edited (by another talented soul, Paul Karasick) it was born at least three or four more times. First when composer Blake Neely scored it and gave the show its sweeping, classic and timeless musical voice. I've worked with Blake almost my entire career and I've never ceased to be in awe of his abilities. It was born one last time visually when VFX supervisor Armen Kevorkian personally decided it was time for feature-style visual effects to make their way onto the small screen. *The Flash* was also born when many gifted folks at Warner Bros. and the CW worked tirelessly to introduce this show to the world. And finally, it was born with you, the fans of the show. We know you have as much affection for the show as all of us who make it. How could you not? There will never be another comic-book character who exudes more of the heart and hopefulness we look for in our heroes than Barry Allen's Flash. If Barry Allen were a real person he would end all of this by saying "thank you" one last time before winking and racing off to save the world. So let's end with that. Thank you. Wink. Fathwoom!

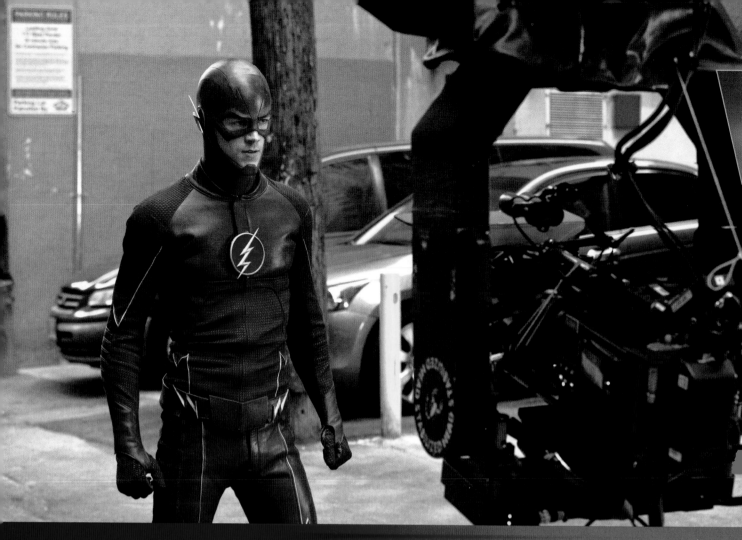

MAKING THE FLASH

The CW television series *The Flash* debuted on October 7, 2014. Its hero, police forensic analyst Barry Allen, played by Grant Gustin, had previously been introduced on the December 4, 2013 episode of *Arrow*. Both series are based on DC Comics, with the Flash first appearing in 1940, and Green Arrow in 1941.

The current *Flash* series was developed by executive producer Greg Berlanti and Andrew Kreisberg, and DC Entertainment chief creative officer Geoff Johns.

Out of so many DC characters, how did the Flash get his own show? Johns explains, "There are a ton of characters out there, but there are those few that get a foothold and survive, generation after generation, like the Flash, or Green Arrow. We look at the characters that we all love and their mythology. Then we match that up with the best creators, and work with the studio. It's a very organic process."

By the time *The Flash* was developed, Johns continues, "There was more of an appetite for a straight-on Super Hero show. *Arrow* was the first [in the] new wave of Super Hero shows, but it was a much darker, more grounded approach. When we decided to do *The Flash* and Greg Berlanti, Andrew Kreisberg [both of whom also developed and executive-produce *Arrow* with Johns and Marc Guggenheim] and I first

Above: Grant Gustin hard at work as the Flash, filming on location in Vancouver, B.C.

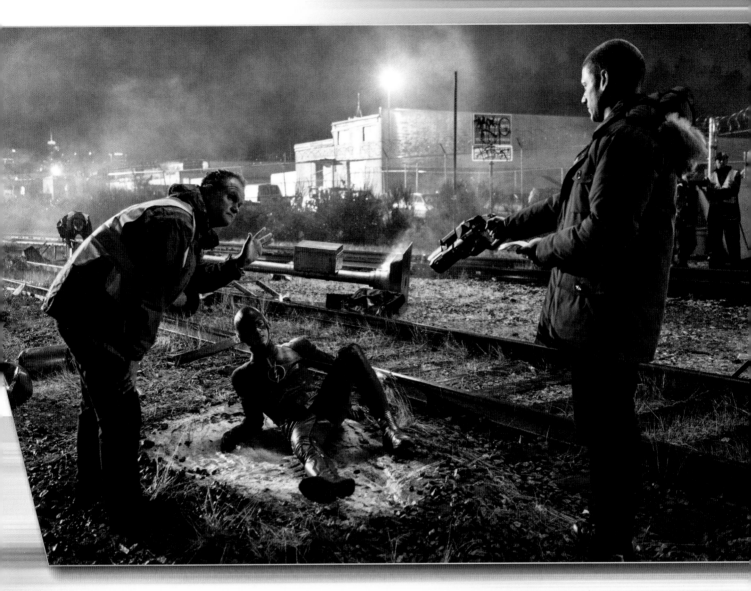

talked about it, I think I said, 'It will be the most quintessentially DC Comics Super Hero show on television.'"

Berlanti is a lifelong Flash fan. "I loved *The Flash* comic as a kid, I loved the character of Barry Allen. I always liked the fact that he was, in a way, the heart of a lot of the Justice League." Kreisberg expresses similar sentiments. "I grew up with these guys. From a very young age, I was deep into DC. The Flash was always the fun one."

Did Berlanti, Kreisberg and DC start with *Arrow* because the mythology was less superpower-heavy and therefore perhaps easier to produce? "When we started," Berlanti says, "*Arrow* was really the one that was on my mind, because it seemed like the most applicable character to do a TV show about. It had crime storylines, it had the narrative on the island. Those things were really exciting. But we had to figure out, 'How do we make a Super Hero show every week?' And then, figuring that out, we thought, 'Okay, maybe now we can actually add a lot of visual effects and powers to it.' And that was in part how *The Flash* was born."

Kreisberg remembers during *Arrow*'s first year, "Greg said, 'Next season, we should bring Barry Allen on for a couple of episodes, and have him get struck by lightning, and then spin him off into his own pilot.' That's pretty much exactly what we did. The only big change that came was, as we sat down to write the pilot episode, we realized we had to make it as if people

Above: Gustin as the Flash on the ground, and Wentworth Miller as Captain Cold, receiving direction from Glen Winter on train tracks before a take in the Season 1 episode "Going Rogue".

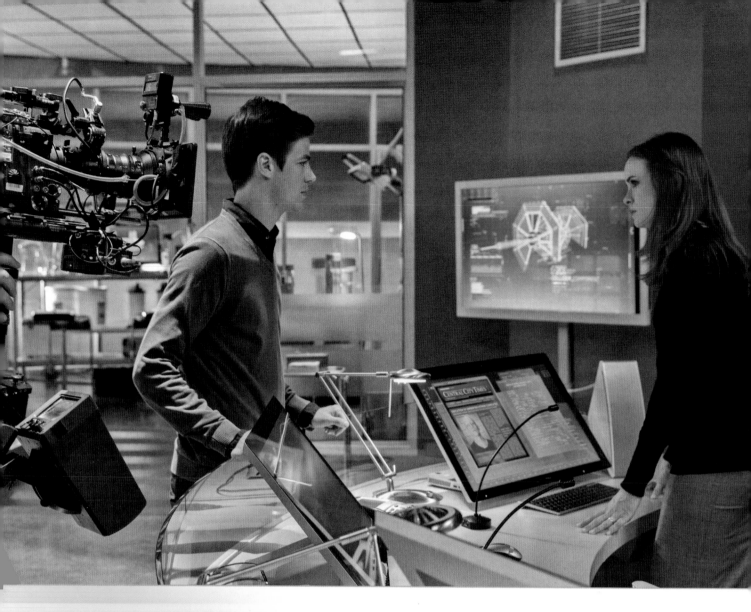

hadn't seen the Flash episodes of *Arrow* so they could really just enjoy it on its own terms."

Berlanti relates, "We didn't know, at the time that we were trying to do it, if we could do it, to be honest. We didn't know if we could pull off those kinds of effects every week."

Kreisberg credits *The Flash*'s visual effects with making the show possible. "We have Encore Hollywood doing our VFX and our genius VFX producer Armen Kevorkian, and they proved to us during the pilot that every week we could keep up this level of spectacle."

It was also important to make *The Flash* stand apart from *Arrow*. Kreisberg adds. "How are you not making two of the same hour of television every week? We were very conscious that we didn't want to just do *Arrow 2*. *The Flash* has a different tone, it's got a different central character, it's got a different cast. Obviously, there are some similarities between the two, (but) family stories tend to work better on *The Flash*, especially the father-son (dynamic). Barry has his own father (Henry), played by John Wesley Shipp, and his adoptive father Joe, played by Jesse L. Martin, and in some ways, (Harry, played by) Tom Cavanagh is like a third father to him. We were heavily influenced by the movie *Searching for Bobby Fischer*, which also featured a young protagonist with (both a real and a mentor figure) father, each one representing mind, body, and soul. Another early touchstone is *The Right Stuff* – young scientists trying to figure out the un-figure-out-able, and challenge each other. Barry in some ways is like a test pilot, but he himself is the jet."

Above: Grant Gustin as Barry Allen, and Danielle Panabaker as Caitlin Snow filming on the S.T.A.R. Labs set – note the active computer screens.

Berlanti explains that he and Kreisberg are not only executive producers but also showrunners on *The Flash*. "We've now got two other gentlemen we run the show with, brothers Todd and Aaron Helbing. I guess I'm the final say in a lot of things, but we meet at the very beginning of a story to talk about what an episode should entail, and then we meet when the outline is broken, and then when the script is written, and then when the cut comes in.

"We talk at the beginning of the year about the moments we'd like to see, things we'd like to do. We talk a lot about themes, about the emotional arc, as though each of the characters were real, breathing human beings. And then as we watch the dailies [footage shot each day], and we watch the actors, we get so inspired by the work that can push us in different directions."

Johns feels, "The Flash is my favorite Super Hero. The best Super Heroes are metaphors for things that we all go through. In the TV show, it's about lifting up that anchor of the past, things that might prevent us from moving forward and embracing life. It's [about] finding joy, and trying to keep putting one foot in front of the other."

Actor Grant Gustin, who plays the Flash/Barry Allen, credits the creative team with making the performers feel comfortable in their roles, and with the happy environment on set. "Our writers and producers put a lot of trust in the cast to take care of our characters and make sure that they are true to what they should be. We all have a lot of fun making *The Flash* and I think our chemistry is genuine, so a lot of unexpected fun things can happen in a scene in the moment."

In terms of Team Flash, Johns says, "Obviously, some of the characters were straight out of the comics. In the first draft of the pilot, it was Wells, Cisco, Caitlin, and Hartley Rathaway [aka the Pied Piper]. Then it felt like we didn't have enough space to service the characters, so we thought we'd just save [Hartley for later]."

The Flash is made at Vancouver Film Studios, where *Arrow* also shoots. Stunt coordinator JJ Makaro says, "This is one of Vancouver's main film studios, it's very centrally located and it's very close to everything that we need it to be around."

Asked to describe the overall aesthetic of *The Flash*, Berlanti says, "Bright, warm, sleek, and highly caffeinated, like a character and like all the people that write the show." He acknowledges with a laugh that Jitters Coffee Shop is an in-joke comment on this.

Kreisberg elaborates, "*The Flash* has a depth and a richness, especially in the Cortex, where we like a lot of long-lens work. We love the camera to always be moving, always be feeling fluid and dynamic."

Production designer Tyler Harron says, "With *The Flash*, a philosophy of design that I've

Above: *The Flash* producer/director Glen Winter on set, showing support for Team Flash with his personal wardrobe choices!

taken is that everything is new-meets-old. Central City is moving at such a pace that they don't have time to build something new – they take something old and then modernize it, as if our sets are built into 1941 buildings, but a layer of modern adaptation/renovation has taken place over time."

Costume designer Kate Main says she's particularly careful with designing for characters that originated in the comics. "People have conceived what the character looks like, so the huge challenge is being able to touch on what our story requires and what people might expect. There are a lot of imaginations to accommodate, if that makes sense."

Maya Mani, the costume designer on *Arrow*, is responsible for creating many of the Super Hero costumes across the CW's DC Universe, including in *The Flash*. She reveals, "Whenever somebody puts on a Super Hero suit, there's that moment where they look in the mirror and they say, 'Holy smokes, I'm a Super Hero.' Even if they don't utter those words, you can see it across their eyes. And you always have to give them a moment just to digest that."

Stunt coordinator JJ Makaro says, "*The Flash* is one of those dream jobs where every episode you have a new character with a new superpower that you've never thought about before, and now you have to plan a different way of doing something. Most shows, you have the mechanical effects guys and the stunt guys, and they work out everything that they need to do between them, but here, we have such a strong element of computer graphics and digital effects that it's actually a three-ring circus. The very first day of having the script, the pack of us sit down and go through all of the action and discuss who's best to take the lead, how much is going to be CG, how much is going to be practical, how much is going to be mechanical effects, and then we start figuring out how to communicate amongst the three of us to make sure that we're getting the best product. Safety is always paramount."

Senior VFX supervisor Kevorkian explains that sometimes shots of Central City that appear to be live action are digital. "One thing that I really pushed for when we were going to do the pilot," Kevorkian says, "is to build a digital city, so we could start working on shots without plates. That way, I could have camera moves that would [otherwise] be pretty much near impossible on a TV production schedule."

Gustin notes, "There was definitely a learning curve when it came to working with all the CGI and special effects elements on the show. Early on, I was still just getting used to being

Below and opposite: Character height charts created by costume designer Kate Main, featuring King Shark, Grodd, Barry Allen/the Flash, Hunter Zolomon/ Zoom, Jay Garrick, Earth 2 Caitlin Snow/Killer Frost, Earth 2 Cisco Ramon/Reverb, John Diggle/Spartan, Nyssa al- Ghul, Mari McCabe/Vixen, Thea Queen/Speedy, Oliver Queen/Green Arrow, Laurel Lance/Black Canary, Tatsu Yamashiro/ Katana, John Constantine, Ray Palmer/the Atom, Rip Hunter, Jefferson "Jax" Jackson/Firestorm, Dr. Martin Stein/Firestorm, Leonard Snart/Captain Cold, Mick Rory/Heat Wave, Sara Lance/ White Canary, Hath-Set/ Vandal Savage, Kendra Saunders/Hawkgirl, Carter Hall/Hawkman.

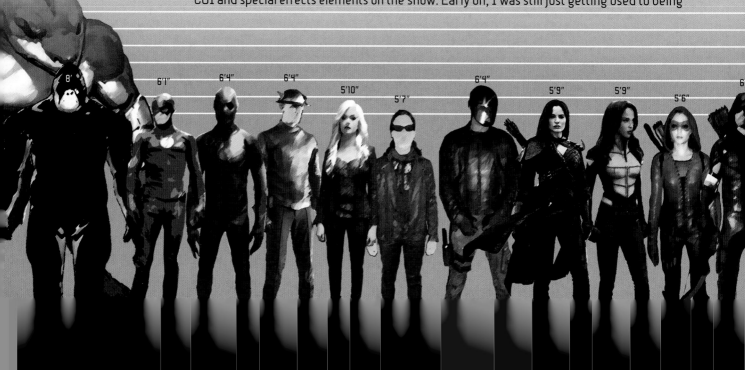

on a set every day and being Number One on the call sheet. There was no way I could have a serious handle on anything that was going on with the effects on the show. Now, I pride myself on how well I understand a lot of the 'Flash tricks' we do on the show. I like to help come up with easier ways and cooler ways of doing things. I trust our stunt department, and effects department, with my life and this show's life. They are some of the hardest-working people in the business and they are the ones that make it feel like it's a comic book jumping onto a screen."

Asked for favorite aspects of working on *The Flash*, hair designer Sarah Koppes says, "When I get to overcome a challenge, and I'm super-happy when the fans are enjoying the way everybody looks, and notice the little different things that we throw in."

Makeup designer Tina Teoli relates, "I'm honored and privileged to work on this show. They allow me a fair amount of creative freedom, which is not easy to find on any show, and the fans love every creative aspect of it. It's nice to work on a show where what you do actually does matter."

Kevorkian gives kudos to his VFX unit, including producer Carrie Stula, post-production producer Geoff Garrett, and visual effects coordinator Greg Pierce. "We have a great team of really dedicated, talented artists that enjoy coming to work every day, working on something that most of them grew up with."

Berlanti describes *The Flash* as, "A labor of love, and if so many people that worked on it weren't fans of *The Flash*, I'm not sure it would have been as good as it is. At every phase, whether it was a single person working on the set, or an artist, or a writer, or a visual effects designer, you could see everyone putting in that extra effort, because they love this character so much."

Johns points out, "The Flash has always been at the forefront of every big change in the DC Universe in publishing. Thanks to all the wonderful people working on the show, it's been able to become the most true-to-comic-book show that we've ever seen on television."

Kreisberg reveals, "We always say that every episode of *The Flash* has heart, humor, and spectacle, and you can't have too much of one and not enough of another. How much these characters care about each other, how quickly they bonded as sort of a found family, I think is the paradigm of the show's success."

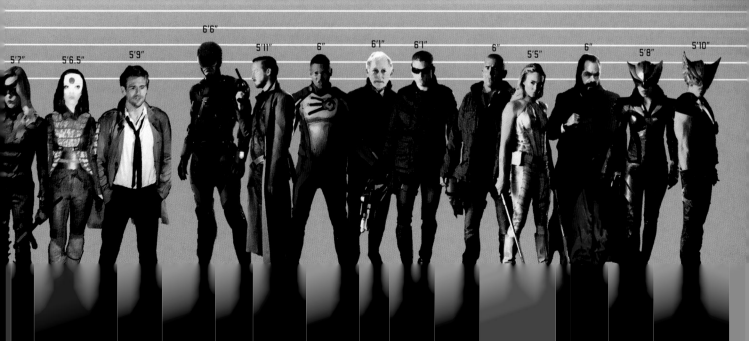

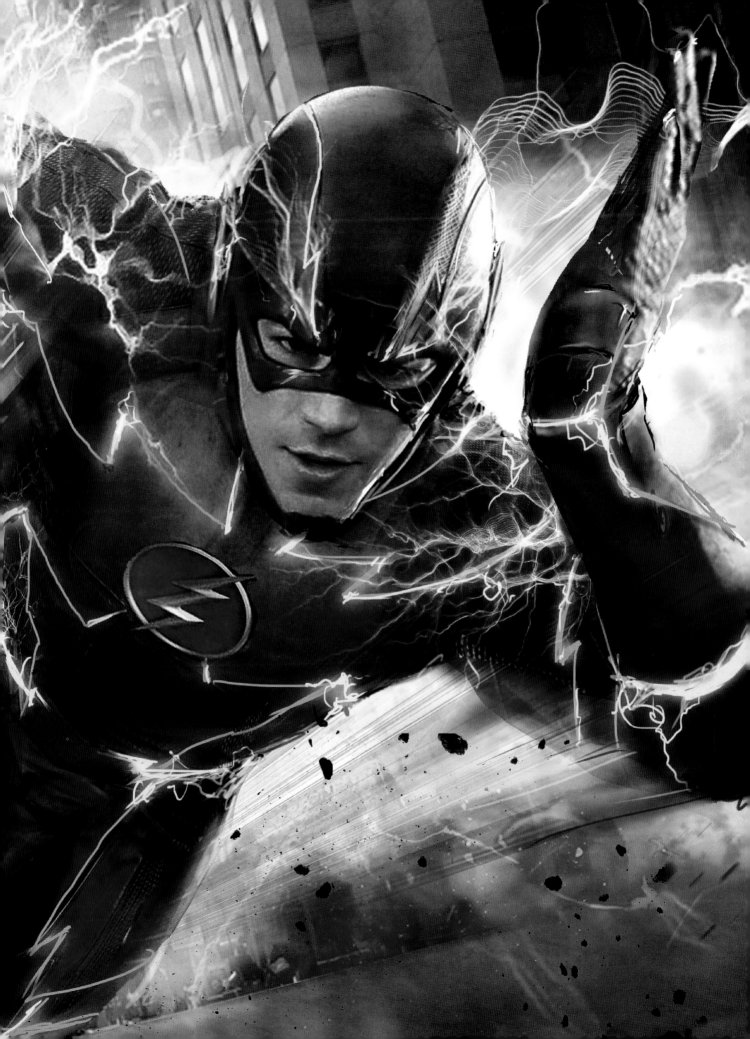

THE FLASH
BARRY ALLEN

GRANT GUSTIN

Above and right: Grant Gustin as the Flash and as Barry Allen; the logo on the Flash's chest is the first season gold on red (the second season is gold on white).

Tyler Harron explains that: "Colleen Atwood, who designed the costume for the initial pilot, had taken the synthetic materials, the pieces that would be deemed as cloth, and actually had little lightning bolts printed onto them with rubber."

With three different Flashes in the DC Universe, including Jay Garrick and Wally West, how was it decided to make Barry Allen the central character in the series?

Geoff Johns points out, "We do incorporate Jay and Wally, but Barry Allen was the first Flash that kicked off the Silver Age (of Comics), and his story, working in forensic science, his mother being killed, his father going to prison for it, him getting hit by lightning, were all iconic things. We always wanted to use Jay Garrick. When Jay Garrick was going to appear to be the villain, the first conversation was, 'Of course, Jay Garrick cannot be a villain.' And we always had plans for Wally, but Wally's story really came after Barry's, once he picked up the mantle and became a protégé of Barry, and so it was just organic and why we chose Barry."

"It was always Barry to me," says Greg Berlanti. "The Silver Age Flash was the central Flash that people knew and grew up with. And it's not uncommon in the books to have a family of Flashes. You have issues where you've got Wally and Barry and Jay, especially when they're all bouncing around through the Speed Force and through time. That is something that we hope to do as time goes on with the show, where you really feel a presence from each of those characters. But Barry was always our notion for the heart and center."

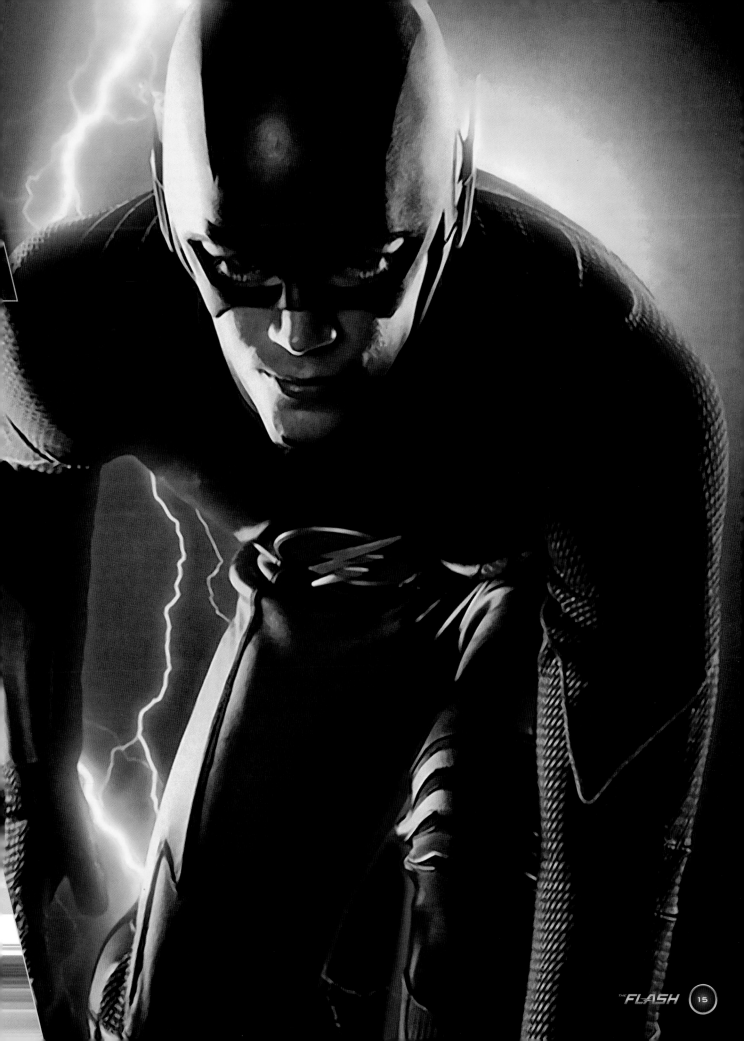

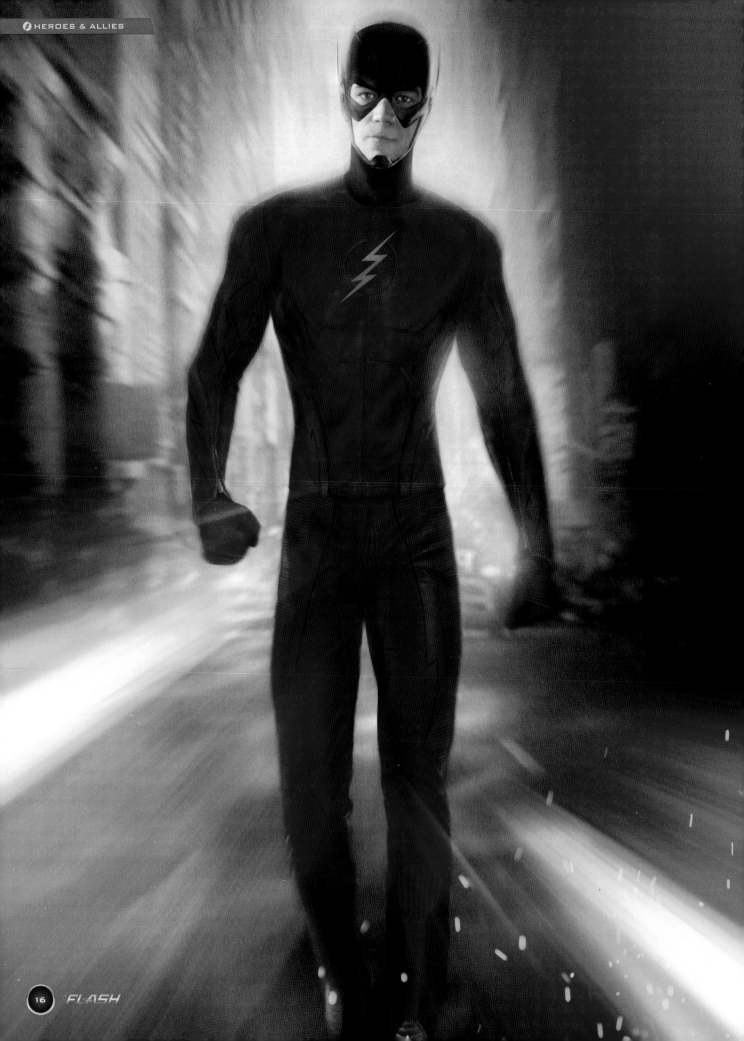

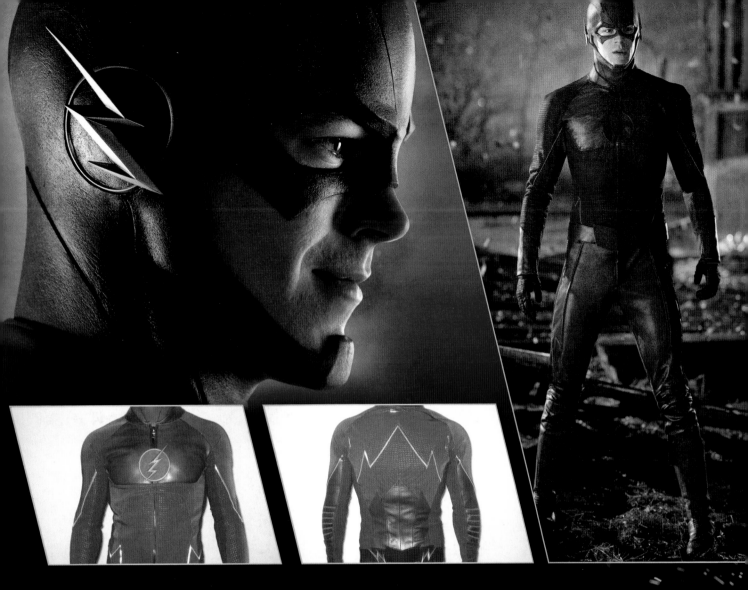

Andrew Kreisberg agrees, "We always knew it was going to be Barry – he's the person who everybody associates with the Flash. So it was important to us to go with that version. Although, that being said, we did modify the character slightly. He still has Barry Allen's wit and humor from the comic books, but we made him a little bit younger, and a little bit more wide-eyed, and probably a little bit more soulful than he'd been in the comic books, to give him a starker contrast to the Oliver Queen that we'd created, who was more prototypically stoic and square-jawed as a hero."

Kreisberg cites Barry as one of his favorite characters to write. "Sometimes on shows, the supporting characters can overwhelm the leads. That is certainly not the case on this, so writing Barry, a character who's far smarter than I am, far more noble, is always exciting."

Actor Grant Gustin says, "When I auditioned for Barry, I knew the comic book basics. I knew that he was an original member of the Justice League. I knew that he had faced Superman in races in the past and it was always debated who was faster. I knew how he got his powers and what his suit looked like."

What Gustin didn't know at first about Barry, he continues, was the core of the character. "While our version of Barry can be incredibly stubborn, I also think of him as a very selfless person. Barry is a hero who doesn't want to leave anyone behind and he makes his best efforts to save every possible life he can. I am still learning things about Barry and about myself through playing him."

Clockwise from left: Costume concept image; a close-up of the Flash in his cowl; the Flash minus his chest emblem; back of the Flash suit; front of the Season 1 Flash suit.

Gustin was the first actor the producers saw for the role of Barry Allen/the Flash. He was found, Kreisberg says, "through David Rapaport and Lyndsey Baldasare, our amazing casting directors. I've told the story before, but it's true – Stephen Amell was the very first person who read for Oliver, and Grant Gustin was the very first person who read for Barry. David had a great instinct for who these characters were on the page, and he wanted us to see who he thought should be playing these characters. Everybody else was playing catch-up, and nobody caught up to him [Gustin], thus proving he is the Flash."

Johns concurs. "I think Grant Gustin playing Barry Allen is the key to the show's success. He's a very joyful character, even though [he has] a dark past."

Stunt coordinator JJ Makaro praises Gustin's fitness. "Grant's in incredibly great shape, with his dance background and discipline. His regular workout routine is very solid. He's got a lean build, and it works perfectly for this particular character, who's supposed to be so fast."

Gustin isn't called upon to do the bulk of the running, Makaro adds. "[The stunt department] supplies people stopping and starting. Most of the running stuff is the really good, really strong visual effects department."

"We scanned Grant early in the process," says senior VFX supervisor Armen Kevorkian, "and we used the method that they use in features, with the higher-res scans, so you get better data, you can build a better digital double. When Barry runs out of a room, it's Grant; he does the take-off, and then we tie in with our digital double of him. When he comes in, our digital double lands and becomes Grant."

Flash costume designer Kate Main explains that Colleen Atwood designed the first version of the Flash suit. "The suit is ever-changing as our story grows. I think the most important part about Colleen's original design is that she worked with Grant's body, his dancer's physique and his own strengths."

Below: Concept art of the Flash at a crash site.

Opposite left: The Flash in a suit broken down and painted by the wardrobe department to make it look burned.

Opposite right: The Flash with his Season 2 chest emblem.

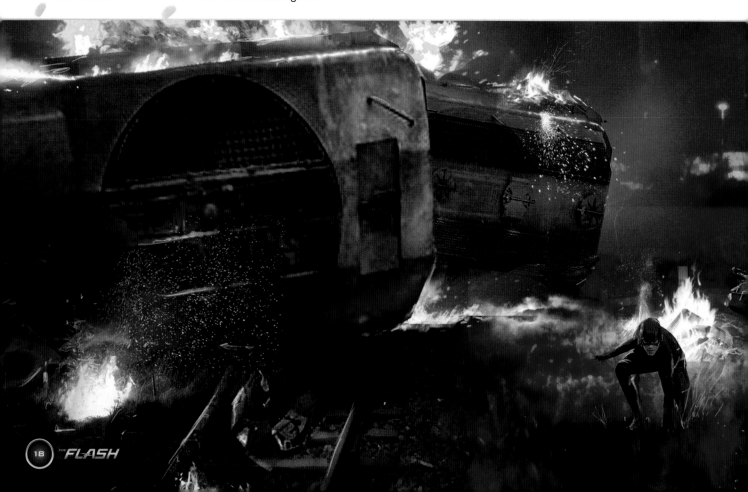

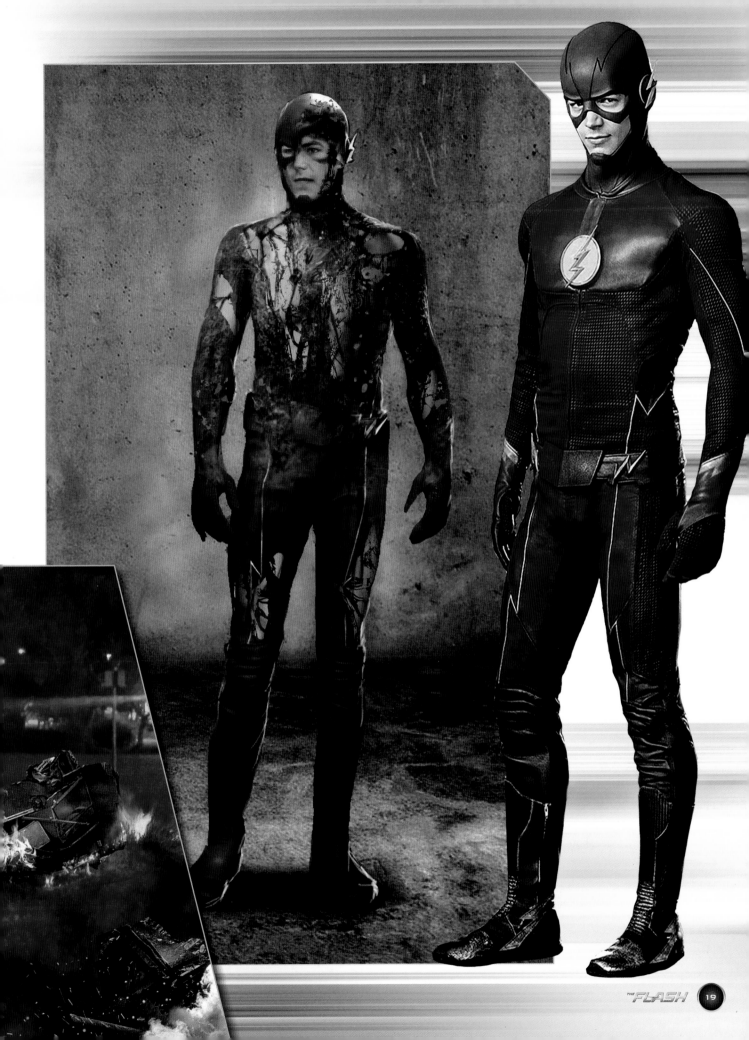

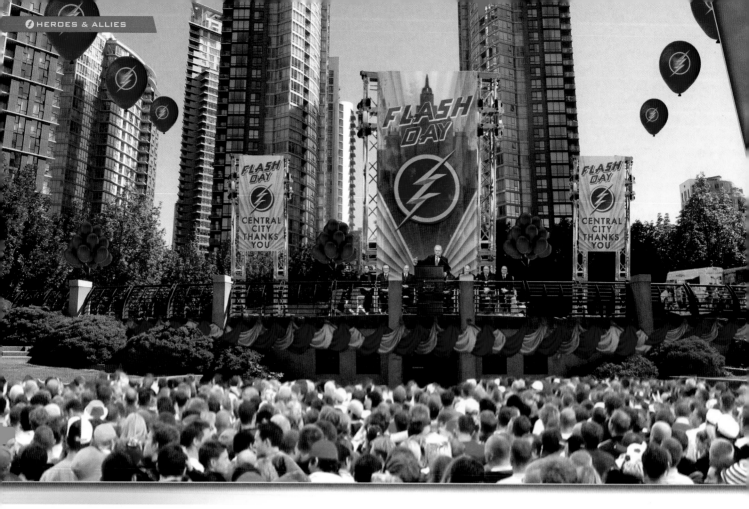

Barry's Flash costume goes through a progression, explains production designer Tyler Harron. "In the pilot, Barry is given a prototype fireman's suit, in which the elements of the actual Flash costume can be seen. They integrate some technology into the Flash symbol, which was just to give him his stamp of who he is and the mantle he was taking on."

The costume is constructed from a variety of materials. "The cowl," Harron relates "is a latex rubber mask, with an internal liner of elastic material, and then the rest of the bodysuit is a mix between synthetic leathers, leathers, and synthetic fabrics. Some are coming out of the sports clothing world, just to get the stretch and versatility, and some are built to be a little more durable, like the leathers that give a sheen and a body to the whole suit."

The cowl is the province of the makeup department. Makeup designer Tina Teoli relates, "The Flash is all about his cowl, so it's all about improving the cowl, making it more comfortable, and easier to maintain. The cowl is sealed, but it's also very sensitive. Some normal [makeup] products will break down the latex. You have to be very aware of what you're using around the cowl."

Gustin observes, "Working in the suit and the cowl was an evolving process over the course of Season 1. We still find small, new ways of making it easier, but for the first nine episodes of the series, I was glued into that cowl, sometimes for ten, twelve hours at a time on set. But by Episode 10 of Season 1, we had come up with a much easier and more practical way of getting me in and out of the cowl and that changed my life! Seriously. I love being in the suit now. If a set-up is going to take more than ten, fifteen minutes, we can slip the cowl right off and I can chill like a normal person."

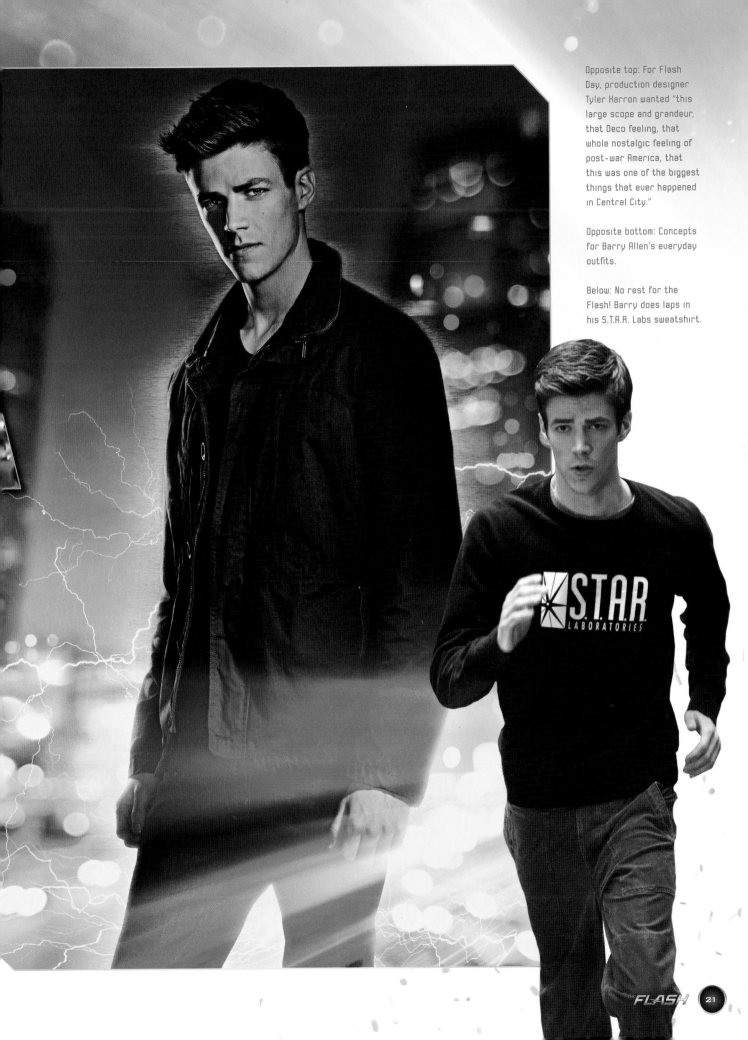

Opposite top: For Flash Day, production designer Tyler Harron wanted "this large scope and grandeur, that Deco feeling, that whole nostalgic feeling of post-war America, that this was one of the biggest things that ever happened in Central City."

Opposite bottom: Concepts for Barry Allen's everyday outfits.

Below: No rest for the Flash! Barry does laps in his S.T.A.R. Labs sweatshirt.

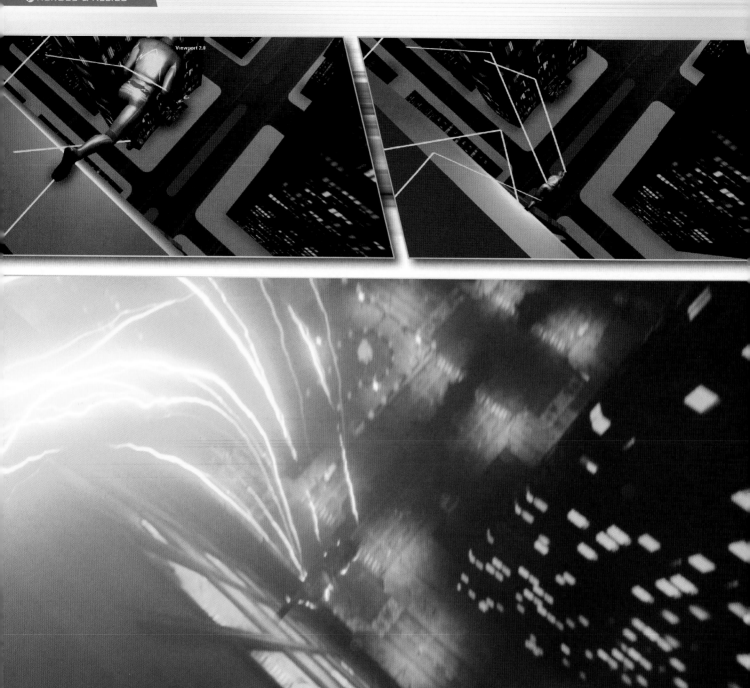

As to its effect on him, Gustin relates, "The suit definitely brings (out) the outgoing side of me. Having my very own super suit was always a dream of mine as a kid, so it may be the most surreal part of the entire experience. I'm glad we made it comfy as well."

Maya Mani, who designs Super Hero costumes for *The Flash*, *Arrow* and *Legends of Tomorrow*, says that she made some alterations to Atwood's original design. "We did his muscle suit and tightened it up, changed out some of the material. There are different grades of leather. There was piping in there that I removed and we went with a sharper line, and also just made it a little snugger. (The trousers are) made of leather, and Euro Jersey, and a printed fabric called Goma. Wherever you see Goma, you'll see lightning bolts. They're on the upper body and the lower body."

Harron observes that the suit is fairly faithful to the comics, "while being modernized. I

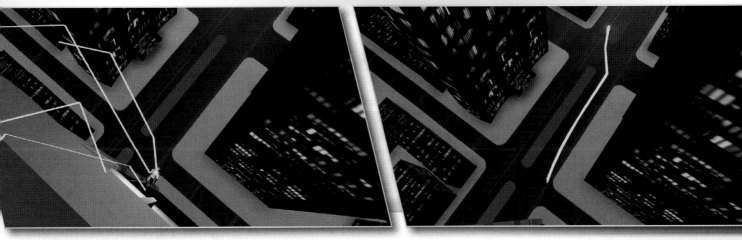

think the only thing that has really been slightly played with is that we've taken a tone that is a more dark and muted burgundy, as opposed to vibrant red."

For Super Hero boots, Mani says, "We use a running shoe sole. Because [the actors are] on their feet all day, we want to make sure that they have good traction, that they're not going to split, that they are comfortable, and that they can do their action in them."

Gustin concludes, "I think the most challenging part of the role is also the most fun part of the role, and that's how emotionally deep of a character Barry is. Barry's origin story, which was spawned by the brilliant Geoff Johns, is beautiful and heartbreaking. It has made exploring Barry terrifyingly fun and challenging. I've gotten to go through every possible emotion as Barry, it feels like, in just the first two seasons. I'm an incredibly lucky actor to get to play a character like this week in, week out, on a TV show."

Above: VFX renditions of the Flash running through the Central City street grid, from preliminary animatics to the 3D-animated final product.

TEAM FLASH

CISCO RAMON

CARLOS VALDES

Geoff Johns says the character of Cisco Ramon entered the planning of *The Flash* "pretty early on. In the comics, Cisco is Vibe. At the time, Andrew Kreisberg and I were writing the comic book, and we really liked the idea of a Hispanic Super Hero, we liked Vibe, and we thought we could make him the excitable fanboy in the group."

Kreisberg relates that Cisco is one of his favorite characters to write. "Cisco in a way represents us, the audience, and us, the writers, who grew up watching movies and TV shows, and reading comic books, and playing video games. Cisco comments on what's happening the same way we would, so I think that's why he proved to be such a popular character, because he's speaking for the twelve-, fourteen-, sixteen-year-olds who are enjoying the show."

Carlos Valdes, who plays Cisco, agrees. "I imagine he came up in school feeling ostracized and bullied, so (he didn't feel) like he could fully be himself. But Barry, and being on a hero's team, has allowed him to understand that he is a hero. That heroism he was exposed to, and the fiction that he's read, he is a part of that now. That changes him forever, and I think that is possible with anyone watching this show."

A crucial scene for Valdes was Wells/Thawne killing Cisco in the alternate timeline. "Tom (Cavanagh) and I tried to access the honesty and the trauma of that, (which) gave our show a color it needed and became definitive for the style that we're going for." Also, "The moment where Wells tells (Cisco) that he has a destiny, that was huge (and) led to the team depending on Cisco to stop Zoom, but Cisco feels an attraction to his powers that he fears might lead him to a sinister side."

CAITLIN SNOW

DANIELLE PANABAKER

Andrew Kreisberg points out that one of Barry's staunchest allies, S.T.A.R. Labs scientist Caitlin Snow, is a DC Comics' character who was not originally associated with the Flash. Caitlin is of great help to others in an emergency, but she's far less adept at healing her own grief when she loses a loved one. We know that Caitlin comes from money and had a strained relationship with her mother.

Given that Caitlin Snow becomes Killer Frost – although on *The Flash*, so far, Frost is only her Earth 2 doppelganger – Kreisberg says that at first, "I think we conceived Caitlin as being slightly more of a blonde ice queen." He notes that he and Greg Berlanti had worked with Danielle Panabaker before. "We just love her so much, we modified the character to Danielle, rather than finding the perfect person to play our original iteration of Caitlin. So we went through a little bit of an overhaul. Not too much, but we knew she could be so amazing as this generous, kind person."

Co-producer Carl Ogawa says of Panabaker, "She really brings that character to life. She brings a lot of herself to it. She's a very sharp, witty person."

Regarding Caitlin's place in Team Flash, Ogawa notes, "Where Cisco is your fanboy, Caitlin is the grounded person of the group that everybody looks to. She's very much the healer of the group. She's the grounded mother, the healing doctor. She embodies all of those elements. She innately nurtures the other characters, she really cares for them, empathizes with them, so those moments where you see this sort of coldness (prefiguring Killer Frost) in Season 2, it's a very different piece of her character."

HARRY WELLS

TOM CAVANAGH

Greg Berlanti and Andrew Kreisberg had worked with Tom Cavanagh prior to *The Flash*. Berlanti says, "When you [as a producer] want to try things, you go to some of the people you've worked with before. We just kept bringing up ideas to Tom. At the beginning [Cavanagh joined the cast as] a quasi-favor to us, but he enjoyed it so much he stayed."

Eobard Thawne masquerading as Harrison Wells perished, but there was no way *The Flash* was getting rid of Cavanagh. Kreisberg relates, "I don't think we necessarily knew early on what we were going to do, but when we hit upon the idea of doing Earth 2, we quickly came up with the idea [of] Harrison Wells from Earth 2, and that's how Tom would continue on in the show."

Co-producer Carl Ogawa observes that Harry Wells is "a very complicated character. He's a father first so, ultimately, he's doing whatever he has to do to protect his child. But he creates an alliance with this new group which becomes his extended family."

When Harry first comes to our world, which he perceives as the second Earth, he doesn't trust Team Flash at all. Ogawa notes, "He doesn't look at them as allies. He's [on our Earth] to save his daughter, but he develops this bond, this kinship, with this group, and he becomes a fatherly figure, and he does want to protect them like his own children as well."

Costume designer Kate Main, who notes Cavanagh is "one of my favorite people in the world," says, "The best direction that Tom gave me is, 'Harry doesn't want to be [on Earth 1]. He came here on a mission, he hasn't hung his hat anywhere.' So he's in fight or flight mode, he's always in a good boot."

JOE WEST

JESSE L. MARTIN

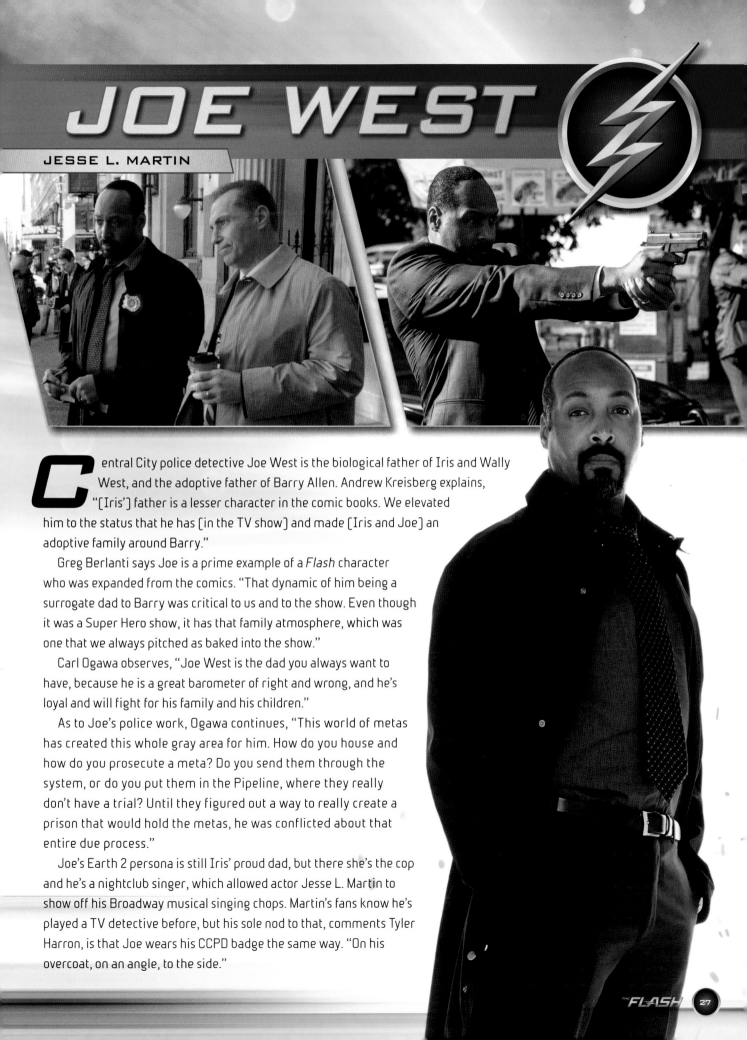

Central City police detective Joe West is the biological father of Iris and Wally West, and the adoptive father of Barry Allen. Andrew Kreisberg explains, "[Iris'] father is a lesser character in the comic books. We elevated him to the status that he has [in the TV show] and made [Iris and Joe] an adoptive family around Barry."

Greg Berlanti says Joe is a prime example of a *Flash* character who was expanded from the comics. "That dynamic of him being a surrogate dad to Barry was critical to us and to the show. Even though it was a Super Hero show, it has that family atmosphere, which was one that we always pitched as baked into the show."

Carl Ogawa observes, "Joe West is the dad you always want to have, because he is a great barometer of right and wrong, and he's loyal and will fight for his family and his children."

As to Joe's police work, Ogawa continues, "This world of metas has created this whole gray area for him. How do you house and how do you prosecute a meta? Do you send them through the system, or do you put them in the Pipeline, where they really don't have a trial? Until they figured out a way to really create a prison that would hold the metas, he was conflicted about that entire due process."

Joe's Earth 2 persona is still Iris' proud dad, but there she's the cop and he's a nightclub singer, which allowed actor Jesse L. Martin to show off his Broadway musical singing chops. Martin's fans know he's played a TV detective before, but his sole nod to that, comments Tyler Harron, is that Joe wears his CCPD badge the same way. "On his overcoat, on an angle, to the side."

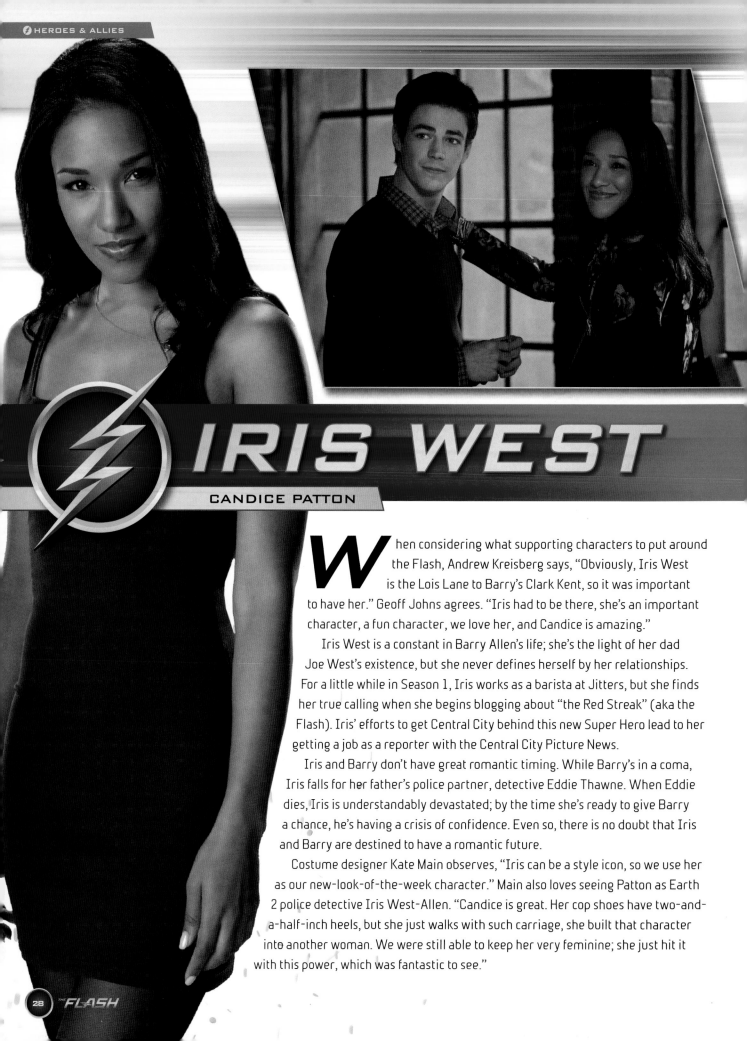

IRIS WEST

CANDICE PATTON

When considering what supporting characters to put around the Flash, Andrew Kreisberg says, "Obviously, Iris West is the Lois Lane to Barry's Clark Kent, so it was important to have her." Geoff Johns agrees. "Iris had to be there, she's an important character, a fun character, we love her, and Candice is amazing."

Iris West is a constant in Barry Allen's life; she's the light of her dad Joe West's existence, but she never defines herself by her relationships. For a little while in Season 1, Iris works as a barista at Jitters, but she finds her true calling when she begins blogging about "the Red Streak" (aka the Flash). Iris' efforts to get Central City behind this new Super Hero lead to her getting a job as a reporter with the Central City Picture News.

Iris and Barry don't have great romantic timing. While Barry's in a coma, Iris falls for her father's police partner, detective Eddie Thawne. When Eddie dies, Iris is understandably devastated; by the time she's ready to give Barry a chance, he's having a crisis of confidence. Even so, there is no doubt that Iris and Barry are destined to have a romantic future.

Costume designer Kate Main observes, "Iris can be a style icon, so we use her as our new-look-of-the-week character." Main also loves seeing Patton as Earth 2 police detective Iris West-Allen. "Candice is great. Her cop shoes have two-and-a-half-inch heels, but she just walks with such carriage, she built that character into another woman. We were still able to keep her very feminine; she just hit it with this power, which was fantastic to see."

EDDIE THAWNE

RICK COSNETT

Eddie Thawne, Joe West's partner for most of *The Flash*'s first season, falls in love with Iris West and becomes her fiancé, much to Barry's dismay. However, when Eobard Thawne – in the body of Dr. Harrison Wells – threatens to kill everyone Eddie loves, Eddie kills himself to erase his murderous descendant from the timeline.

Co-producer Carl Ogawa observes, "Eddie was designed in Season 1 to be just a really solid, stand-up love interest for Iris, [and] a little bit of a foil to Barry." It was Barry, Ogawa observes, who was the loser in their love triangle throughout the first season of the show. "For somebody as fast as he is, Barry is always just too late in some areas of his life, that being one of them. When Eddie sacrifices himself, we see how deeply in love he really was with Iris, and what he would do to save her, and to save his friends. It really showed how much he loved her."

While the two detectives are partners, it takes Joe a long while to warm up to the idea of Eddie dating Iris. "Joe wasn't thrilled about Iris dating a cop," Ogawa acknowledges.

In dressing Eddie, costume designer Kate Main explains the difference between his look and that of Joe. "Eddie is classic. Where Joe is slightly more conservative, Eddie would wear Ted Baker suits, or he'd [be] slightly more sartorial."

WALLY WEST

KEIYNAN LONSDALE

Wally West, who starts out as Kid Flash, is the third character in DC Comics to wear the Flash cowl. *The Flash*'s Wally, Joe West's biological son, has so far only accelerated in his now-disavowed street racing career, though with his commitment to justice, his admiration for the Central City Super Hero who saved him from terrifying speedster Zoom, and his exposure to dark matter, he'll likely be running soon. "We always had plans for Wally," agrees Geoff Johns. He may only have turned up in Central City in Season 2 of *The Flash* but, "He's a huge character."

On the domestic side of the show, Carl Ogawa notes that another purpose for Wally "was to broaden Joe and Iris' family life, because of this backstory first season with what happened to Iris' mom. There were little hints of where she went, but we never really dove into that story. In Season 2, they chose to really go into that story and reveal that there was another child, and finally introduce Wally into the mix. And that created a great dynamic within the family. You really see how Wally is his father's son."

There was a lot of discussion of what Wally's passion should be before the writers settled on racing, Ogawa adds. "It always had to be something with speed. Was it going to be planes, was it going to be cars? Because again, he is an emerging speedster. We always wanted to hint at that."

HENRY ALLEN

JOHN WESLEY SHIPP

Wrongly convicted of murdering his wife/Barry's mother, Barry's father Henry Allen spent many years in prison before Barry cleared his name. Henry then went off for some contemplative time, before returning to his son in Central City, where he was tragically murdered by Zoom, but seemed to be a man at peace.

"Henry is a great believer in fate," says co-producer Carl Ogawa. "He believes things happen for a reason. He really seems to have come to terms with what his life is, and he's Zen about it. When you see him and Barry and their interactions, he's not bitter about spending that time away. He's sad that it happened, but he can't change the past, nor does he want to, because he's trying to enjoy the time that he has."

Henry also has a doppelganger – Earth 3's Flash, the real Jay Garrick. John Wesley Shipp, who portrays both, had previously starred as the Flash in the nineties TV series. Super Hero costume designer Maya Mani says Shipp's Earth 3 costume is "the blue and the red with the lightning bolt and the helmet. We had our first fitting, and he was worried I was going to put him in a onesie. I said, 'Only if I'm mad at you'," she laughs.

Shipp and Greg Berlanti had worked together before, Ogawa notes. "There was already that relationship set up, and John is such a sweet, genuine person, and such a fatherly guy, so caring and attentive with the people on the set."

PATTY SPIVOT

SHANTEL VANSANTEN

Patty Spivot is a great cop. She's able to take down King Shark all by herself, she's able to persuade Joe to accept her as his partner in investigating metahuman crimes, and she's also able to open up even Barry's guarded heart.

Co-producer Carl Ogawa says that Patty, like Eddie Thawne, was a character designed to unknowingly come between Barry and Iris. "Patty was brought in as a love interest for Barry. And Joe had to have some partner, he couldn't be off operating on his own. With the death of Eddie, we had to bring somebody in. And she was a great mix-in to the group."

Once Patty learns that Barry is the Flash, it breaks her heart that he didn't trust her enough to tell her, so she leaves Central City. While Patty's there, though, Barry's double life keeps ruining their dates. When Barry races to bring Patty an apology bouquet, he runs so fast to deliver it to her that, by the time he arrives, the flowers ignite. "It was a controlled fire," says Michael Walls. "We put real flowers in the fuel. We had electric matches buried within the flowers, and a little bit of accelerant right around the match with a firing battery system. [Grant Gustin] pushed the button, the flowers went up in flames, and then they stamped them out."

Kate Main recalls, "Shantel VanSanten called her character 'Pants Suit Patty.' To her, earning the [detective] pants suit is probably the best thing she ever could have done."

JESSE QUICK

VIOLETT BEANE

Jesse Wells, Earth 2 Harry Wells' daughter, is destined to become the speedster Jesse Quick, but when Season 2 ends, she doesn't realize she's been changed by the dark matter.

"She's a nice counter-balance to the team," says co-producer Carl Ogawa. "She brings this innocent charm. Because she's from Earth 2, when she comes to Earth 1, where she has multiple (college) majors, everybody looks at her like she's an octopus, she's this strange creature, because nobody on our planet has those kinds of multiple majors. She doesn't think of it as odd. But she's intrigued by our pop culture, because it's all different."

Jesse also has a complicated relationship with her father. On the one hand, Jesse is appalled that Harry's protectiveness extends to killing for her; then again, she is ultimately a loving daughter.

"She's like any young adult trying to spread their wings," Ogawa relates. "She wants her independence, and she wants to be able to fail on her own, but the stakes are much higher for her. She's living in a world where metas exist. It's not like you and I would go out and buy our first car or rent our first apartment. She's literally dealing with somebody that is coming for her life."

"We're gradually changing her look," explains makeup designer Tina Teoli. "At first, we kept her really neutral, so it didn't look like she was wearing a lot of makeup. But as time goes on, she's becoming a woman."

LINDA PARK

MALESE JOW

Linda Park works as a reporter at the Central City Picture News, where she is Iris' colleague and confidante. Linda is also briefly Barry's girlfriend, though that ends when she senses that her forensics analyst beau and Iris aren't done with each other. While our Earth's Linda has no actual superpowers, she rises to the occasion when she must impersonate her Earth 2 doppelganger, Dr. Light, to deceive Zoom.

Practical effects supervisor Michael Walls recalls her training scene with Team Flash, "when she was learning how to control her powers, how to control the light beams, and she was firing at the cardboard cutouts of the different characters." Linda had to use light beams the way a trainee cop would use a gun at a firing range. "She would point and we (the practical effects artists) would fire, and we had all sorts of different little sight gags that went on in that sequence," Walls explains: "There was one effect where we blew a perfect circle in (the cutout of) Cisco. We did that with a little charge behind, and put a fuel accelerant around the edges of it, and lit it with a spark, and kicked the whole thing with a spark. We had all of the cardboard cutouts on moving rigs of different styles. We had plenty that popped out, some that popped up, a couple that slid in, and two that swung down."

TEAM ARROW

O liver Queen, played by Stephen Amell, is a wealthy young man whose secret identity is the crime-fighting Green Arrow in Starling (now Star) City. When Barry Allen becomes the Flash, Oliver is Barry's most trusted advisor regarding Super Hero ethics.

Green Arrow has his own team – his younger half-sister Thea Queen/Speedy, beloved tech genius Felicity Smoak, the late Laurel Lance/Black Canary, John Diggle/Spartan, and Lyla Michaels – who are always there for him, and also there for the Flash when he needs them.

JJ Makaro, who has served as stunt coordinator on *The Flash*, *Arrow*, and *Legends of Tomorrow* and is Amell's stunt double, talks about Arrow's physical style.

"Stephen's different from almost everybody else. We'd started off training with him before the series started. He was down in L.A. with a fight coach before he came up [to Vancouver], and he started taking parkour lessons. He did that on a whim, and it turned out he was very talented in that direction, so he ended up doing a lot of his own work."

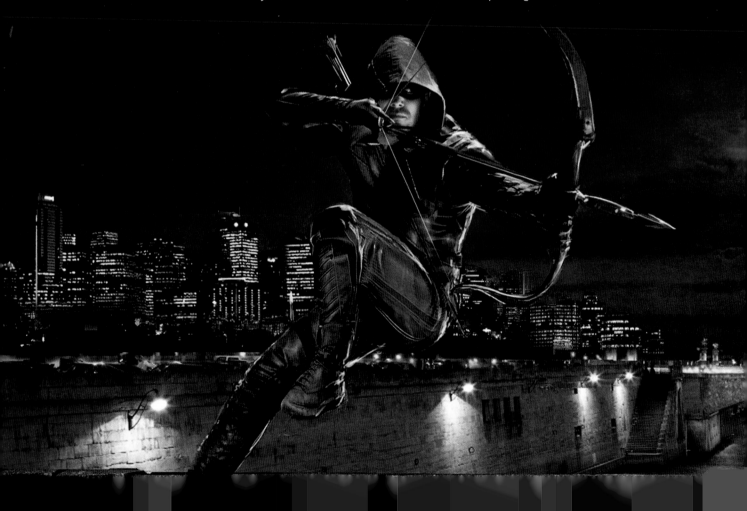

As for Arrow's bow work, Makaro says, "We had him with an archery coach right from the beginning. We went with a more traditional [archery] style, because we wanted it to be as clear-cut as possible." More recently, "We've considered compound bows and, on occasion, we've started going in that direction."

Maya Mani, costumer for *Arrow* who also designs much of *The Flash* and *Legends of Tomorrow*'s Super Hero garb, explains that Arrow's original costume, like the one for the Flash, was designed by Colleen Atwood. "We maintained that look for the first season. The costume's evolved over the years. I use a lot of leather and textures. There are various panels that stretch that allow for movement. In Season 4, we decided to do a switch-up to the Green Arrow costume, which meant that his arms were exposed. I was going for more of a tactical armored look, a little streety. From Season 1, once he has the suit on, there was no idea that he could remove his outer layer and there was anything underneath. When he comes into the lair, I [wanted him to be able to] remove the outer vest and still be in a version of the Arrow suit. The under-parts are Kevlar, so it seems a little more grounded. I always look at the comics, because I want to be true [for] the fans, but I like to open it up to new fans. And it has to function. Stephen can kick, jump, punch, pull his arrows out of his quiver, in that one costume. Functionality is very important."

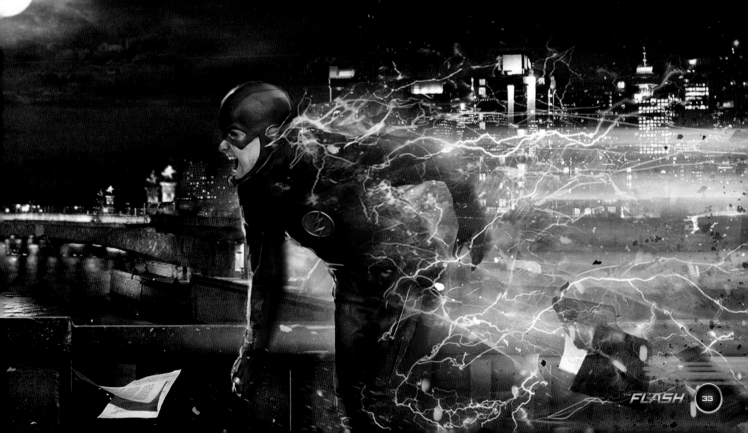

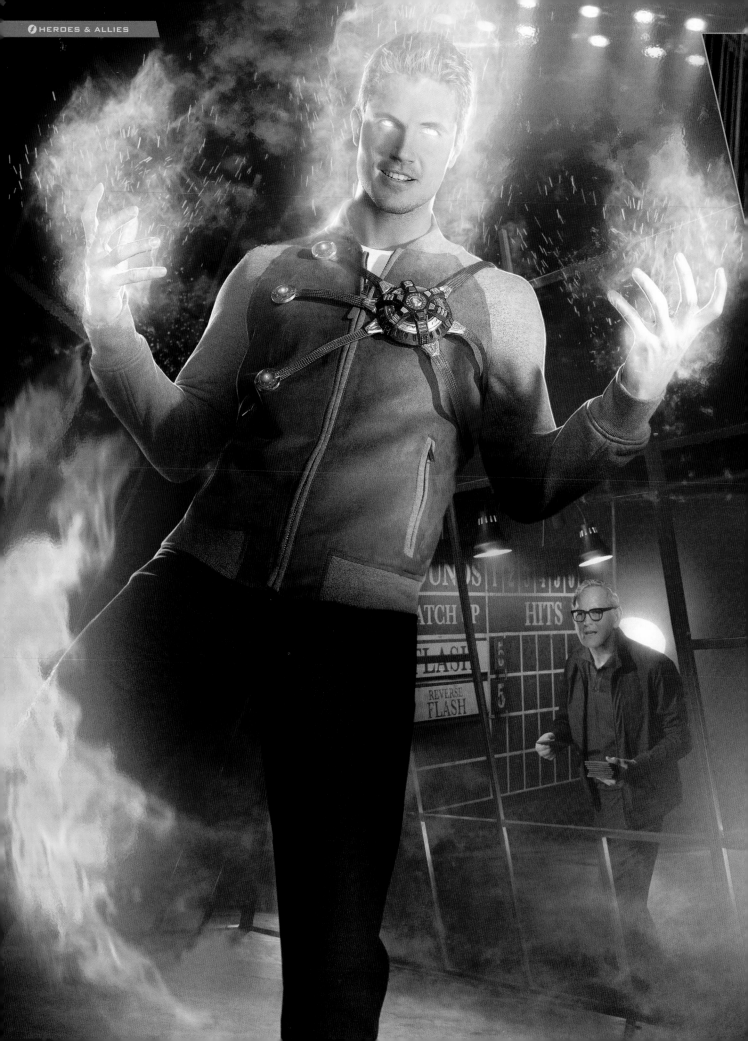

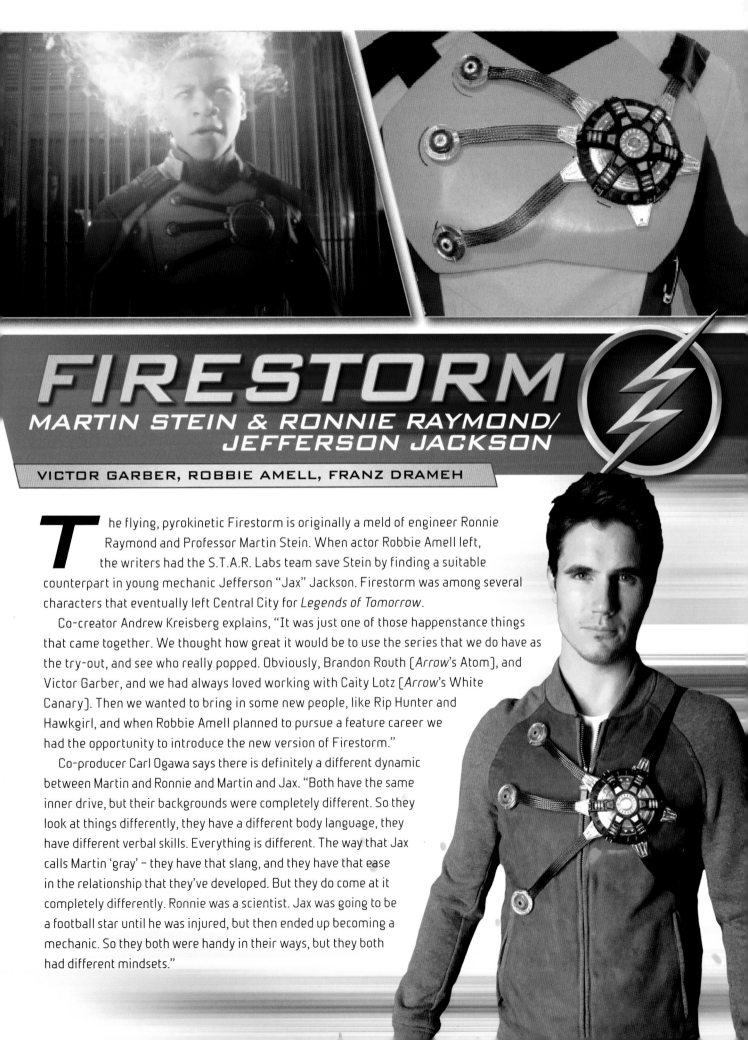

FIRESTORM
MARTIN STEIN & RONNIE RAYMOND/ JEFFERSON JACKSON

VICTOR GARBER, ROBBIE AMELL, FRANZ DRAMEH

The flying, pyrokinetic Firestorm is originally a meld of engineer Ronnie Raymond and Professor Martin Stein. When actor Robbie Amell left, the writers had the S.T.A.R. Labs team save Stein by finding a suitable counterpart in young mechanic Jefferson "Jax" Jackson. Firestorm was among several characters that eventually left Central City for *Legends of Tomorrow*.

Co-creator Andrew Kreisberg explains, "It was just one of those happenstance things that came together. We thought how great it would be to use the series that we do have as the try-out, and see who really popped. Obviously, Brandon Routh (*Arrow*'s Atom), and Victor Garber, and we had always loved working with Caity Lotz (*Arrow*'s White Canary). Then we wanted to bring in some new people, like Rip Hunter and Hawkgirl, and when Robbie Amell planned to pursue a feature career we had the opportunity to introduce the new version of Firestorm."

Co-producer Carl Ogawa says there is definitely a different dynamic between Martin and Ronnie and Martin and Jax. "Both have the same inner drive, but their backgrounds were completely different. So they look at things differently, they have a different body language, they have different verbal skills. Everything is different. The way that Jax calls Martin 'gray' – they have that slang, and they have that ease in the relationship that they've developed. But they do come at it completely differently. Ronnie was a scientist. Jax was going to be a football star until he was injured, but then ended up becoming a mechanic. So they both were handy in their ways, but they both had different mindsets."

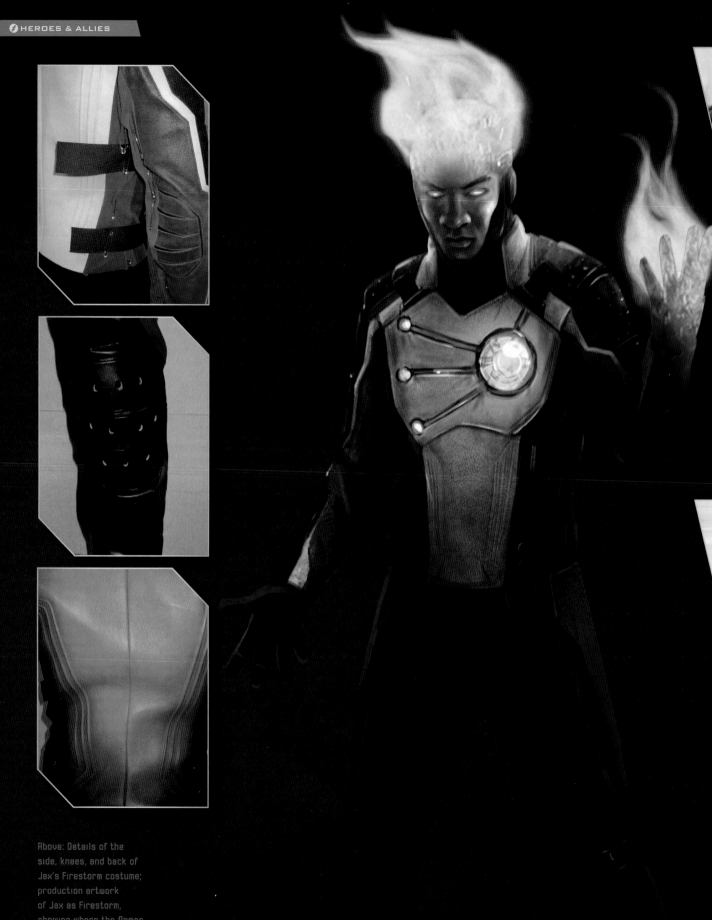

Above: Details of the side, knees, and back of Jax's Firestorm costume; production artwork of Jax as Firestorm, showing where the flames will be on his body and how the harness should fit and be lit.

Firestorm sees plenty of action. Stunt coordinator JJ Makaro recalls, "We did one particular gag where [Firestorm] was up in the air with the Flash, so we ended up dropping our Flash double down from about fifty feet, and swinging him over the top of a van where he ended up connecting with the van and, from there, bouncing down and tumbling across the ground.

"It was a real vehicle. The rigging was set up so that he stopped just as he got close to the top of the vehicle, got the hit, and then tumbled for a little bit, and then fell off the back end, and then we did a cut where we actually took him off the wires and had him bail out the last part of it. We did it practically with the wires, all in one [take]." The stuntman avoids tangling in the wires, because, Makaro relates, "If you feed out the lines quick enough, they'll just roll up around you."

Sometimes Firestorm is entirely live action, and sometimes he is augmented, or entirely CGI, says VFX supervisor Armen Kevorkian. A VFX character modeler makes an "action figure" of the character within the computer. "We'll animate the character if he's flying, and then we will generate the fire coming from his hands and his head based on that animation. We do the white eyes as well. [VFX takes] the character as an action figure and says, 'This is how it's going to move.' So if he's flying forward, the wind would be blowing the fire back."

Above: The Central City celebration in the Season 2 premiere "The Man Who Saved Central City".

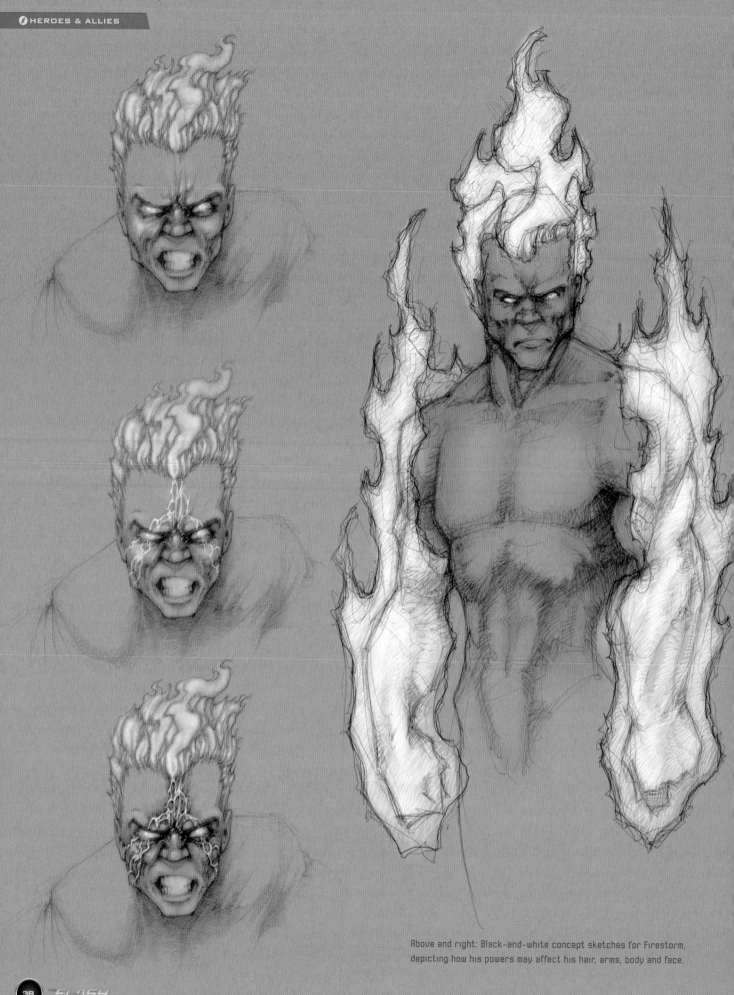

Above and right: Black-and-white concept sketches for Firestorm, depicting how his powers may affect his hair, arms, body and face.

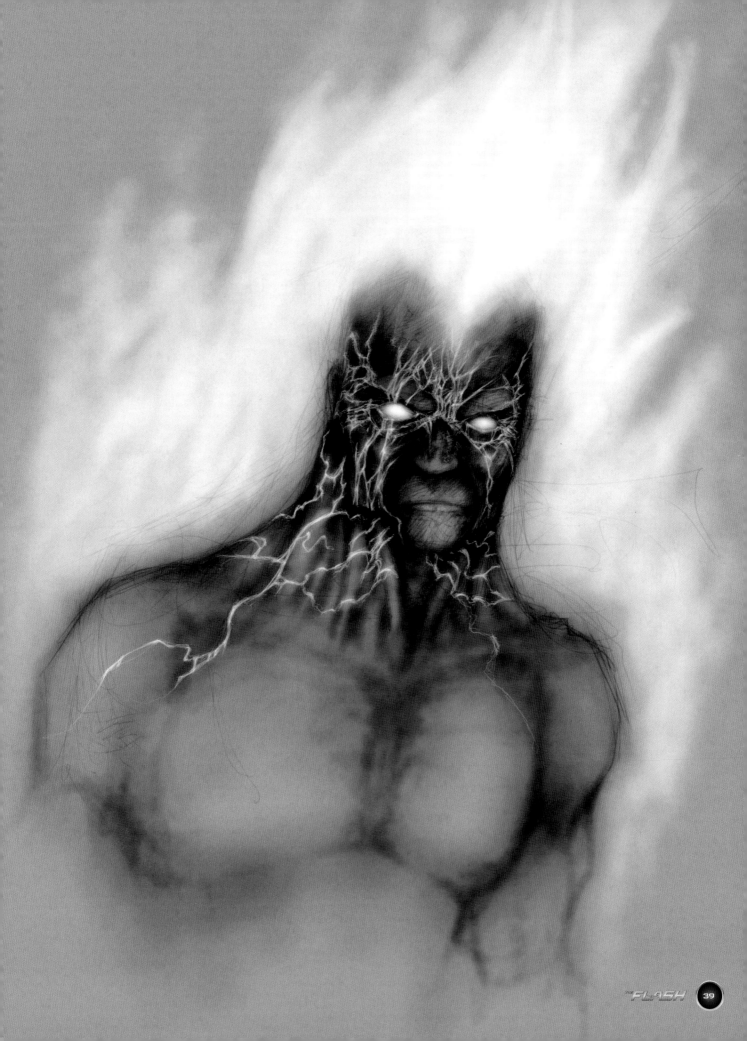

JAY GARRICK

TEDDY SEARS/JOHN WESLEY SHIPP

Jay Garrick is the first Flash, introduced in *Flash Comics # 1* in January 1940. In *The Flash* series, he at first appears to be Earth 2's Flash, a noble if defeated hero. However, it turns out that the man we've met is not really Jay Garrick at all. Instead, he's serial killer Hunter Zolomon, aka Zoom, who has stolen the name of (and imprisoned) the actual Jay Garrick, Earth 3's Flash.

Co-producer Carl Ogawa observes, "The Jay Garrick who's the golden boy, he's the person that you're going to bring home and introduce to your parents, unaware that he is Zoom. He plays the game very well."

Super Hero costume designer Maya Mani says, "In the comic books, [Jay Garrick] has this huge lightning bolt coming out on the front of his jacket. I was trying to make it more subtle. So it's there, but it's an outline, [instead of] a solid piece."

Makeup designer Tina Teoli notes that, because actor Sears "has a very kind, open face, we try to make him a little more sinister, [add] a little darkness around his eyes."

There's a statue of Garrick at Earth 2 CCPD, built over four days when Andrew Kreisberg requested it, so that Barry could use its helmet to deflect Deathstorm's rays. Per production designer Tyler Harron, "We dressed the mannequin in a Jay Garrick costume, and positioned him [like] Garrick. My construction and paint team built the Art Deco-style base, making it feel like a statue of the 1920s."

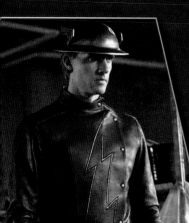

Above: Teddy Sears' character had everyone fooled into thinking he was the heroic Jay Garrick, when in fact he was serial killer Hunter Zolomon.

Right and opposite inset: Production art of various costume possibilities for Earth 2 Flash, with and without gloves, with different lightning emblems and with different boots.

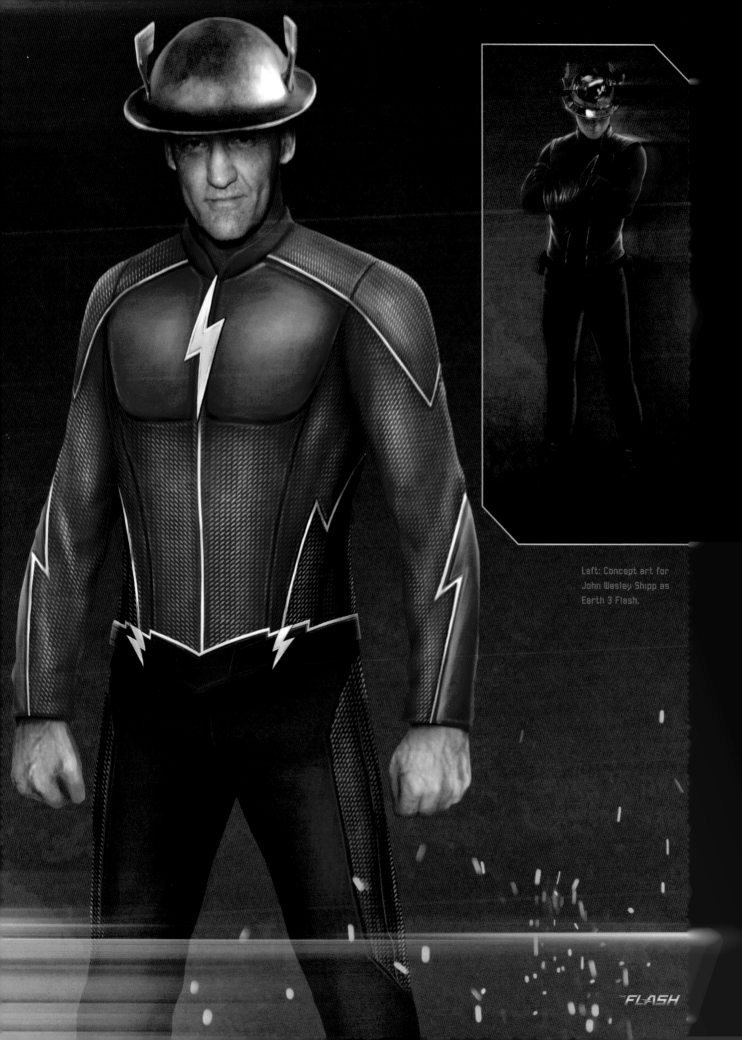

Left: Concept art for
John Wesley Shipp as
Earth 3 Flash.

THE FLASH

⚡ HAWKGIRL
KENDRA SAUNDERS

CIARA RENÉE

Hawkgirl starts out as Jitters barista Kendra Saunders, drawn to Central City without knowing why. Kendra starts to fall for Cisco, but discovers that she is the current reincarnation of Egyptian priestess Chay-Ara, destined to fall in love in each lifetime with soulmate Hawkman. Currently, Hawkgirl and Hawkman are part of the *Legends of Tomorrow* team.

Super Hero costume designer Maya Mani says, "In the comics, Hawkgirl's usually done in primary colors. I wanted to desaturate that and give her more of an armored look. It's a leather costume (with elements of printable Goma fabric). The lines of the sleeve are like the wings are wrapping around her." When Kendra has actual wings, "Her clothes have to be bigger to accommodate the (flying) harness."

The wings are added via CGI. VFX supervisor Armen Kevorkian notes, "Someone (digitally) built every feather, so it doesn't look like exactly the same feather, and did the whole wing on each side, and we textured it afterwards, and did tests of how it opened and closed."

The body-to-wing proportions are different than those of a real hawk, Kevorkian acknowledges. "A lot of times, we do start with the science and the reality of things, but if it doesn't work visually, then we play with it."

Above: Ciara Renée as Kendra Saunders, in her Jitters barista uniform.

Opposite: Hawkgirl concept sketch; production art of Ciara Renée in her Hawkgirl costume, with wings extended.

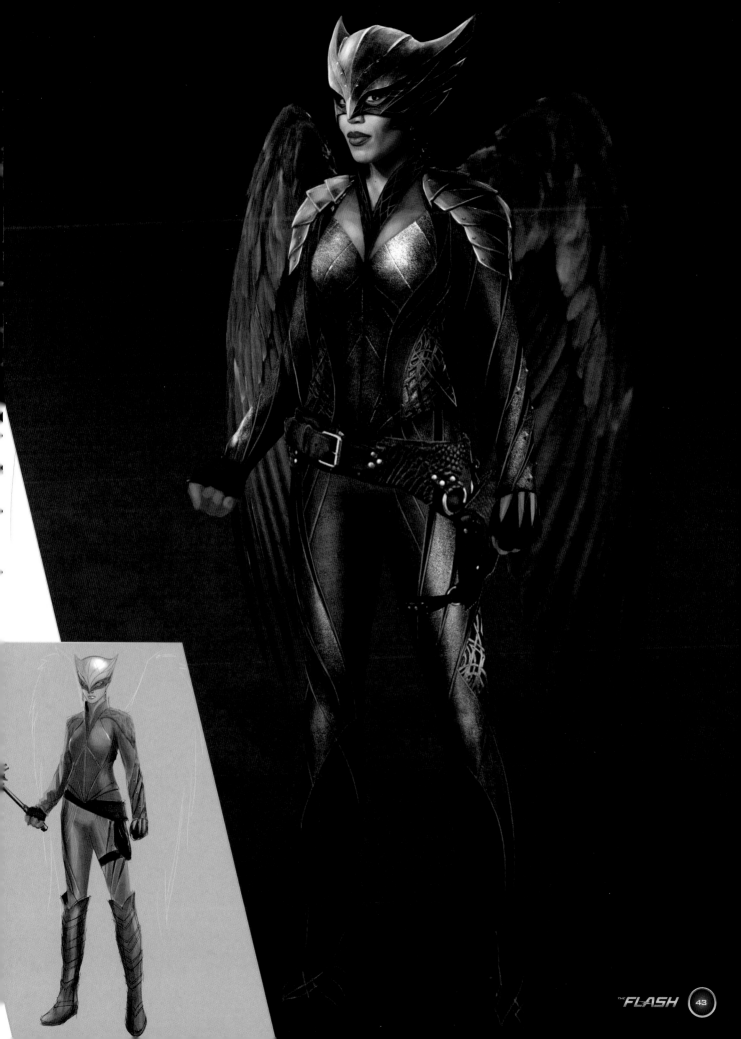

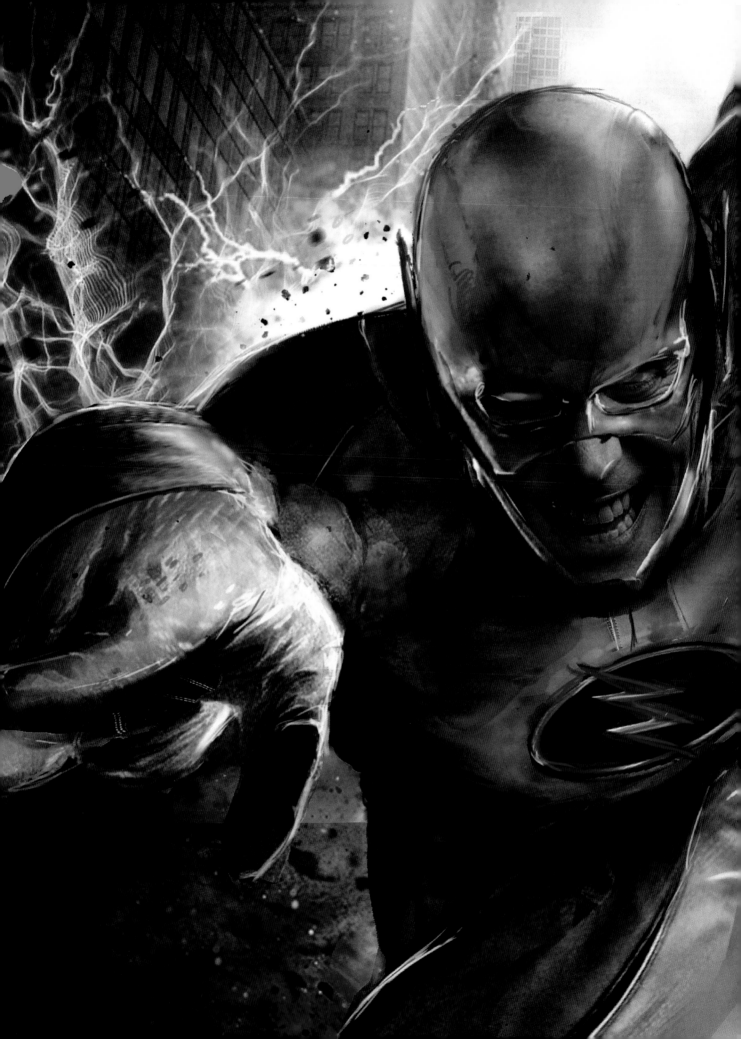

CENTRAL CITY
POLICE

3·1·2·6·1·8·7·4·1·7

WEATHER WIZARDS
THE MARDON BROTHERS

LIAM MCINTYRE, CHAD ROOK

Above: Liam McIntyre as Mark Mardon and Chad Rook as Clyde Mardon in the bad boys' respective mug shots.

Opposite: McIntyre as the surviving Mardon brother. The siblings share the villainous moniker of Weather Wizard.

The Mardon Brothers, Mark (played by Liam McIntyre, of *Spartacus* fame) and Clyde (Chad Rook), created a dangerous atmosphere as Weather Wizards. Clyde died in the *Flash* pilot, but Mark survived to make more trouble. He devastated the Central City Police Department, says stunt coordinator JJ Makaro, "throwing people around and pulling Joe through the door. He just about killed Captain Singh (played by Patrick Sabongui), who is a local (Vancouver) actor. Before he became recognized for what a great actor he is, he was actually supplementing his income by being a stunt guy, with (Makaro's company)." When Mardon's wizardry battered Singh, Sabongui did his own stunts, "and they were fairly big (with) ratchets, but he had the skills for it."

When Clyde was brought back for a flashback, Rook had gotten a haircut. Hair designer Sarah Koppes explains that a wig had to be built to match his look in the pilot. "Then they had this giant storm, so they had water flying through the plane's windshield, so both of those poor guys were completely soaked to the skin. But nobody knew it was a wig."

Co-producer Carl Ogawa relates that it was always intended for there to be two Mardon brothers, and that we'd meet Clyde before Mark sought vengeance for his sibling's death. "It gives more color to your character. You understand the motivating factors, you find a little more sympathy within the character."

THE MIST

KYLE NIMBUS

ANTHONY CARRIGAN

Opposite right: Anthony Carrigan as Kyle Nimbus/ the Mist, and VFX showing him mid-transformation.

Below: Concept art of the Mist in phases, including the spectral look at left. "In one shot," Armen Kevorkian reveals, "we did a little bit of a skeletal structure to his Mist look."

Kyle Nimbus, aka the Mist, is a metahuman who is able to turn himself into a state that is both gaseous and toxic.

Makeup designer Tina Teoli says, "The Mist was fun, because [actor Anthony Carrigan] has got such incredible facial features that we just basically played that up. So I super-highlighted all of his higher planes, and then shaded everything out to make all of that stuff shine and bounce out, and then highlighted around under his eyes, and he was a lot of fun to do."

In his Mist form, Nimbus inhabits the CG realm. When he's transitioning, Carrigan is an ideal subject for CG, due to his bald head. As VFX supervisor Armen Kevorkian explains, every individual hair of a character being rendered in CG must be developed and tracked separately, so "Bald is the best."

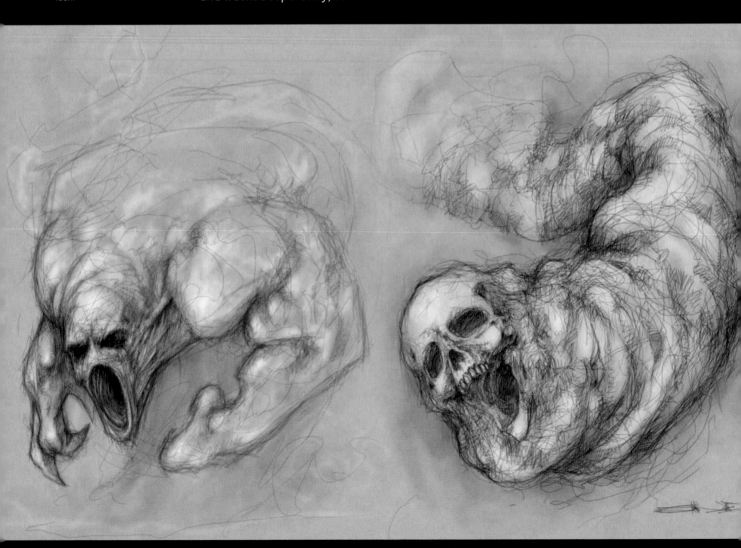

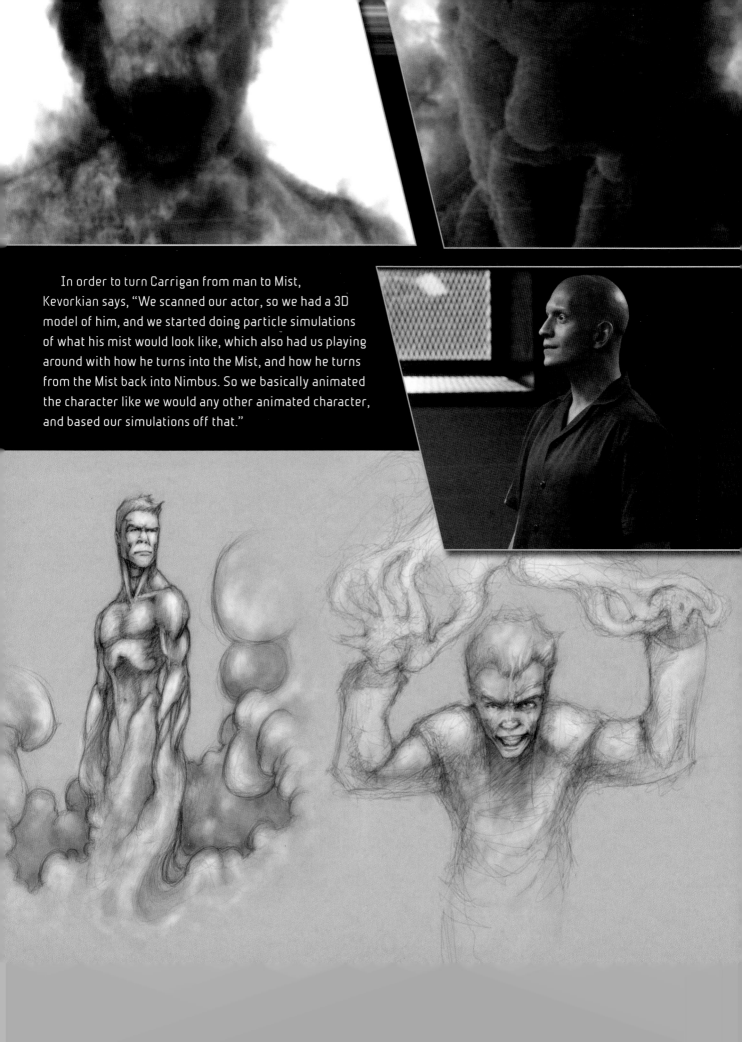

In order to turn Carrigan from man to Mist, Kevorkian says, "We scanned our actor, so we had a 3D model of him, and we started doing particle simulations of what his mist would look like, which also had us playing around with how he turns into the Mist, and how he turns from the Mist back into Nimbus. So we basically animated the character like we would any other animated character, and based our simulations off that."

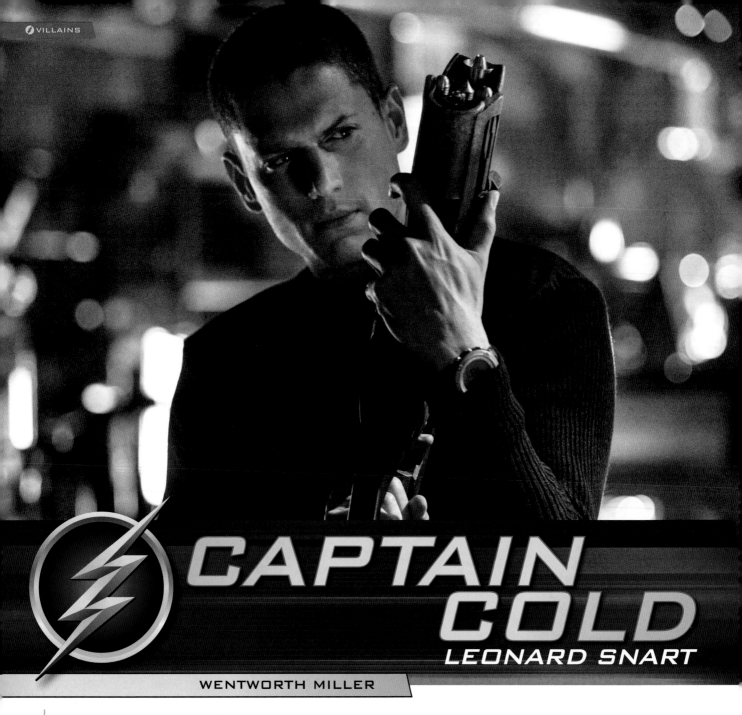

CAPTAIN COLD
LEONARD SNART

WENTWORTH MILLER

Above: Wentworth Miller as Leonard Snart/ Captain Cold, cradling his signature weapon, the Cold Gun, invented by Cisco Ramon at S.T.A.R. Labs.

Opposite: Captain Cold modeling a variety of different jackets with different Cold Gun holsters.

O f all the Flash's relationships with his various nemeses, perhaps none is quite as complex as the one between him and Captain Cold, aka Leonard Snart. The snarky villain, played by Wentworth Miller, doesn't want anyone telling him what to do – Super Hero, law enforcement, his own family – but he also has his own code of honor. We see Leonard's loyalty to his sister Lisa, aka Golden Glider, his rebellion against his horrible father, and his bond with Heat Wave, aka Mick Rory, played by Dominic Purcell.

Miller and Purcell starred together as brothers for four years on *Prison Break*; Purcell has said it was Miller who suggested that his *Prison* sibling play his *Flash* partner in crime.

For co-creator Andrew Kreisberg, Captain Cold typifies the ideal *Flash* adversary. "The best villains are the ones who are a match for him. That was one of the things that we had to do. It wasn't just having the Flash utilize his powers every week. Every week, we had to come up with a different villain, do the research and development on the visual effects, come up with a costume and then cast them every week. So far, we've been so incredibly

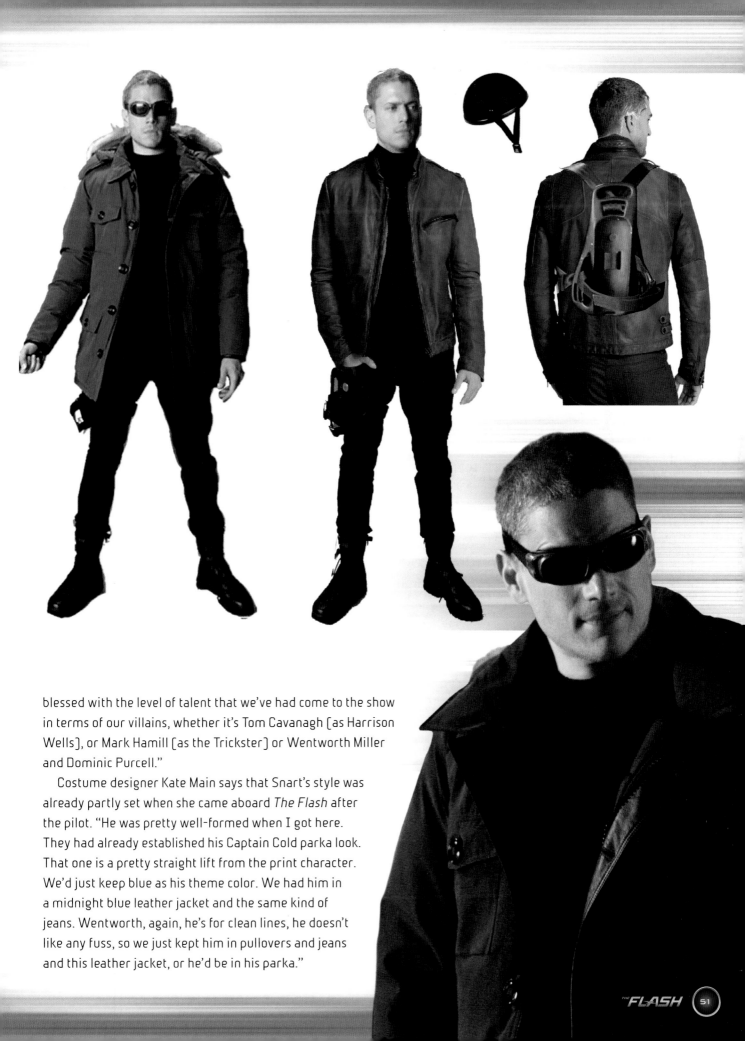

blessed with the level of talent that we've had come to the show in terms of our villains, whether it's Tom Cavanagh [as Harrison Wells], or Mark Hamill [as the Trickster] or Wentworth Miller and Dominic Purcell."

Costume designer Kate Main says that Snart's style was already partly set when she came aboard *The Flash* after the pilot. "He was pretty well-formed when I got here. They had already established his Captain Cold parka look. That one is a pretty straight lift from the print character. We'd just keep blue as his theme color. We had him in a midnight blue leather jacket and the same kind of jeans. Wentworth, again, he's for clean lines, he doesn't like any fuss, so we just kept him in pullovers and jeans and this leather jacket, or he'd be in his parka."

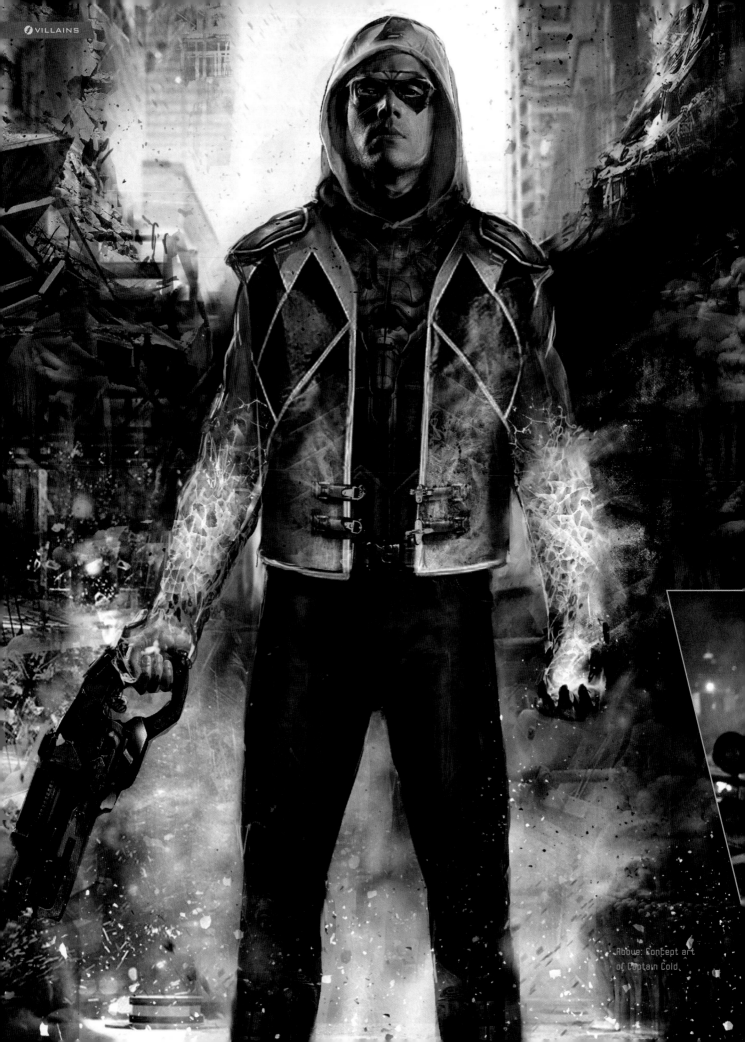

Regarding Leonard's brutal father Lewis Snart, played by Michael Ironside, Main relates, "I was looking at the aesthetic of these guys who always have a wad of twenties in their pocket, just disgusting, awful people. But he's got a nice leather jacket, he's got some good slacks, he's got his tailor. It was just an old school mob boss look, even though he's not a mob boss, but he's a despicable human who takes care of himself first."

All that outerwear is to shield the Snarts from the effect of the Cold Gun. When it fires, that's the VFX department; the aftermath is the responsibility of practical effects supervisor Michael Walls, who explains, "We used a lot of silicone and a few other silicone-like products to create the look and put a little bit of wax over the top of [frozen items] to give that frosted look. We would [also] do a wax dressing on clothing."

Above: Doug Jones as Deathbolt modeling Cold Gun injuries; Reese Alexander as an unlucky museum guard; Sarah Hayward as a likewise victimized tour guide.

Below left: Cisco faces down Captain Cold.

Below right: Captain Cold and Heat Wave pose in one of their hideouts.

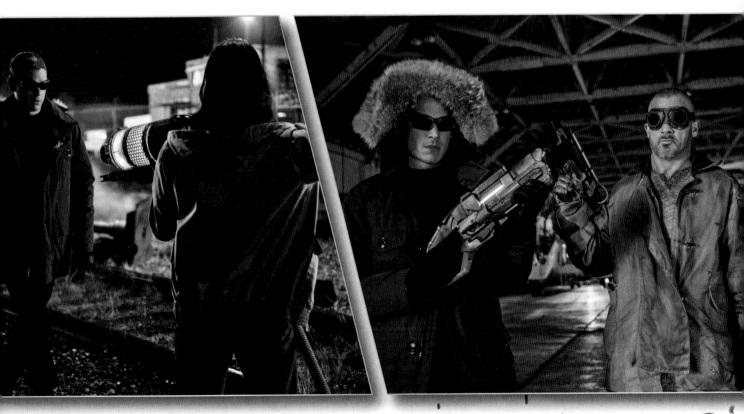

This spread: VFX stages of the Flash being hit by the Cold Gun's freeze ray, with both a live reference model and a CG Flash in a live-action background, then the composite completed image.

"[Captain Cold is] a really fun character," says Carl Ogawa. "Based on the way he was raised, Cold is the way he is, but he's really not a bad guy. He doesn't want to kill anybody. He's not in the game to hurt people, per se, he just wants to get ahead himself. Occasionally, yes, he has killed people, those things have happened, but he would prefer not to go that route. And I think you've seen his character evolve, based on the influence that Barry has had on him."

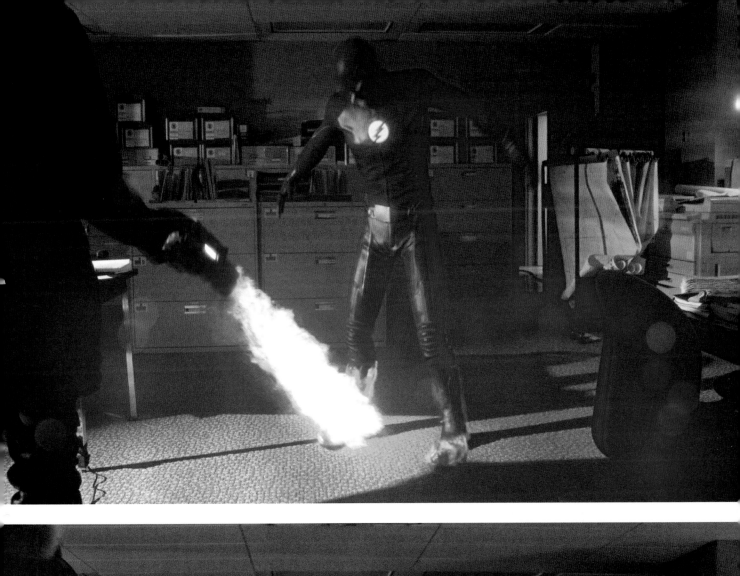

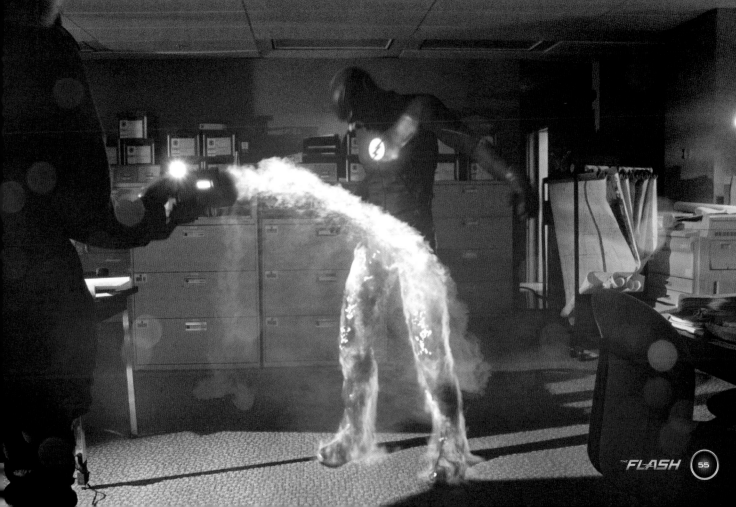

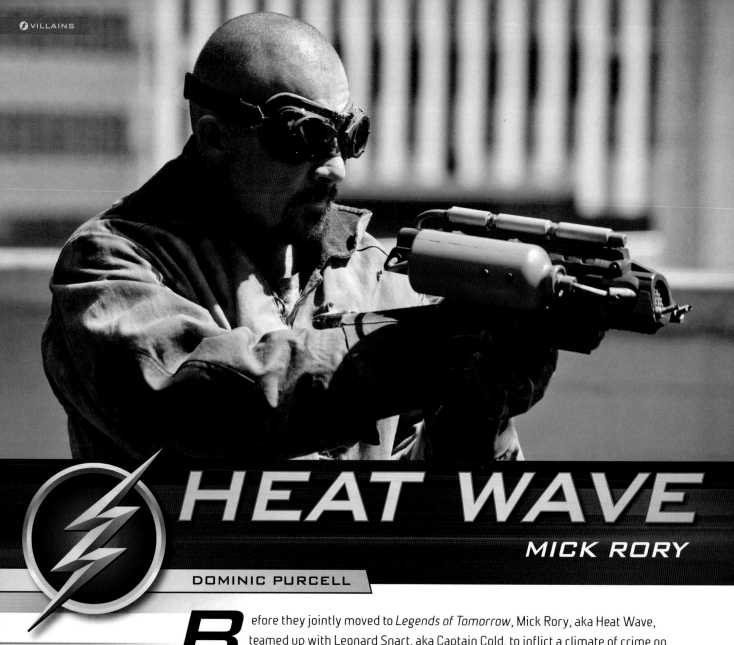

HEAT WAVE
MICK RORY

DOMINIC PURCELL

Before they jointly moved to *Legends of Tomorrow*, Mick Rory, aka Heat Wave, teamed up with Leonard Snart, aka Captain Cold, to inflict a climate of crime on Central City. "Heat Wave is Captain Cold's best friend," observes Carl Ogawa. "He's like the big brother. He doesn't need a reason to take you down. If you're coming after him or who he considers his family, he will hurt you."

"[Heat Wave] is just anger on wheels," says costume designer Kate Main. "While we had him, he was still in the throes of [being] Mr. Anger Management, so I decided, in the name of irony, that he stole a [fire] chief's turnout gear, and burned the crap out of it. I liked Mick, I think I was able to inform that character by pointing him in that direction of having taken the fire gear and appropriating it for his own ill use."

Makeup designer Tina Teoli notes, "When we first saw him, Heat Wave had full-on body burns on both arms. Those were [makeup applied] out of the kit on our show – I think they're appliances on *Legends*."

Practical effects supervisor Michael Walls relates, "When Captain Cold and Heat Wave were in their hideout, we did a couple of gags showing fire, and trying to figure out different levels of fire that we could do, and fixing his gun, and having things fire off on it prematurely." However, actually firing the gun, Walls adds, is not something anyone wants on set. "It's all done digitally."

Above: Dominic Purcell as Mick Rory/Heat Wave, who with Captain Cold is one of *The Flash*'s relatively rare villains who isn't a metahuman; Heat Wave's passion for burning things down and Captain Cold's penchant for freezing them over make them a good team.

GOLDEN GLIDER

LISA SNART

PEYTON LIST

The Golden Glider, aka Lisa Snart, shares her brother Leonard Snart's passion for theft, but she's got a soft spot for Cisco. "She does," co-producer Carl Ogawa points out, "because for one thing, I think he's the first person who's genuinely shown her kindness." For another thing, Cisco gives Lisa her golden gun – and her nickname.

Also like her brother Leonard, Lisa Snart is not a truly bad person, Ogawa explains. "Lisa is a product of her upbringing. Her father was not the best person, so the kids didn't turn out to be the best people. You learn from your parents, and her best ally is her brother. She and her brother will do whatever they have to do for each other, to save each other."

When we first meet Lisa, she's disguised in a blonde wig, which she pulls off to reveal her own dark hair. Hair designer Sarah Koppes explains that she piled actress Peyton List's real hair under the wig, but left it loose. "I matched the wig to the same length as her own hair, pulled it back, and wrapped it around my hand. I let her brown hair fall underneath the blonde wig. You could see it a little bit – it just looked like part of the wig. So when she pulled the wig off and shook it out, everything worked out perfectly."

Below: Peyton List as Lisa Snart/Golden Glider, in a variety of costumes and footwear with gold highlights. Costume designer Kate Main says: "Peyton is another one that's completely easy to dress. She's sleek, athletic."

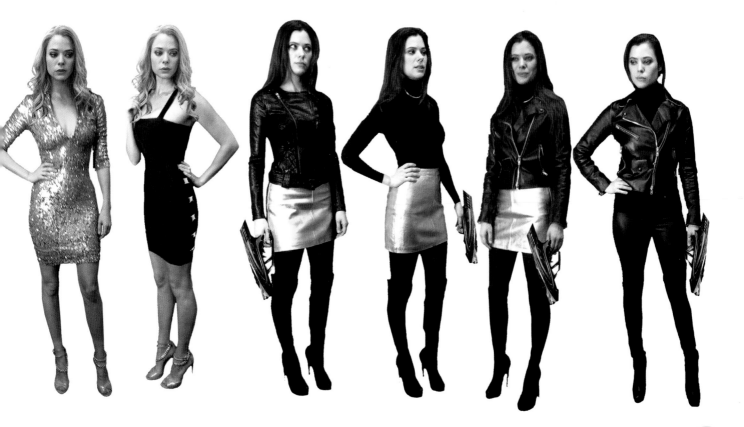

MULTIPLEX
DANTON BLACK

MICHAEL SMITH

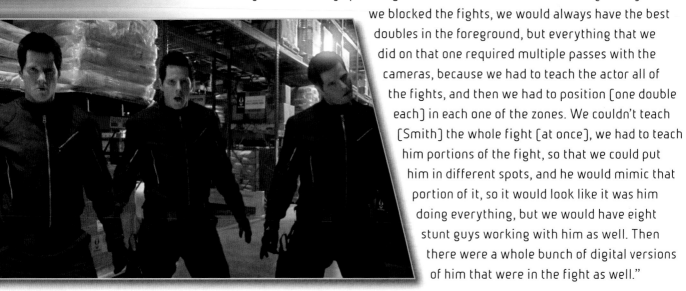

Danton Black, aka Multiplex, could spontaneously replicate himself. Stunt coordinator JJ Makaro recalls those fight scenes as particularly complicated. "I think we had eight guys who were comparatively built to [actor Michael Smith]. He was a well-coordinated gentleman and took direction well.

"We lined [the stuntmen] up and figured out who looked the most like [Smith]. As we blocked the fights, we would always have the best doubles in the foreground, but everything that we did on that one required multiple passes with the cameras, because we had to teach the actor all of the fights, and then we had to position [one double each] in each one of the zones. We couldn't teach [Smith] the whole fight [at once], we had to teach him portions of the fight, so that we could put him in different spots, and he would mimic that portion of it, so it would look like it was him doing everything, but we would have eight stunt guys working with him as well. Then there were a whole bunch of digital versions of him that were in the fight as well."

PLASTIQUE
BETTE SANS SOUCI

KELLY FRYE

In the legend of King Midas, everything the king touched turned to gold – including other people. Bette Sans Souci, aka Plastique, played by Kelly Frye, is a metahuman with a similar problem. Everything she touches turns into a bomb and blows up, whether she wants it to or not.

Practical effects supervisor Michael Walls notes, "We did a bunch of small explosions for her. We blew up the ground in front of the army vehicles, we blew in windows, we did a couple of debris cannons."

VFX then makes the explosions larger, explains Armen Kevorkian. Often, "[practical effects] will do a controlled explosion that we enhance, but having the start they give us helps us a lot."

Kevorkian relates that, by now, it's always clear to him when reading the script how it will break down. "'Okay, this can be done practically, this needs enhancement, this is all CG.' We have concept meetings, then we have the effects meeting, then you have the production meeting, [all] where people brainstorm and make sure that every department knows what they're doing."

RAINBOW RAIDER
ROY G. BIVOLO

PAUL ANTHONY

Roy G. Bivolo is the real identity of Rainbow Raider. As has been pointed out elsewhere, "Roy G. Biv" is an abbreviation for all the colors of the rainbow (assuming one includes indigo between blue and violet). He has the power to manipulate human emotions, making people feel blue, go green with envy, and, dangerously, see red with fury.

Andrew Kreisberg cited Rainbow Raider as one of the characters who required some fine-tuning to make him a worthy villain. Raider is also an unsuccessful artist, something Kate Main wanted to allude to with the costume for actor Paul Anthony. "I just wanted to touch on the classic American artist," Main says. "So I looked at what classic American artists were wearing, and at [American painter] Andrew Wyeth. I looked at his old boots and his old duster coat. I took those as references that I then imposed on Bivolo."

The Raider's makeup was not very complicated, adds Tina Teoli. 'A little bit of eye work, some contouring around his eyes."

GIRDER
TONY WOODWARD

GREG FINLEY

Tony Woodward, aka Girder, has superpowers, but this doesn't protect him from being killed by Blackout. "When we introduce Girder," Tyler Harron says, "he's a metahuman who can turn into metal, but Barry at the time realizes he isn't super-strong, and he needs a way to defeat this super-strong metahuman. So Cisco develops a metal dummy for the Flash to learn to punch, and in order to do that, he needs to learn how to supersonic punch. We welded up this dummy, modeled after a DC Comics group of characters called the Metal Men."

Actor Greg Finley came with a couple of tattoos, reports Tina Teoli. "We kept the bear claw, and the other ones we had to cover. But because we kept the bear claw, we then had to duplicate the bear claw on all of the stunt doubles and photo doubles. We basically trace out the design of the tattoo on the tattoo transfer paper, flip the image, and then use that to apply it to the stunt double, and then paint over the top of that. And this is all alcohol-based product, so it should stay on through sweat."

GORILLA GRODD

"**G**orilla Grodd is a classic," Geoff Johns says of one of the Flash's most iconic antagonists. Johns feels Grodd epitomizes the uniqueness of *The Flash*. "The most important thing is obviously Barry Allen, and the Flash, and Iris, and the whole mechanics of the show. But the nuances of some of the other things – people would call them Easter eggs, we call them foreshadowing – are as small as setting up the Gorilla Grodd cage in the pilot, knowing that we eventually wanted to introduce a character like Gorilla Grodd, who seemingly would be impossible to do on television, into the show. We had to educate and explain to everybody why that was such an important thing, and why Grodd was such an important character in the Flash mythology."

Gorilla Grodd is a prime example of an all-CG character that required collaboration between many different departments.

Kate Main says, "Tyler Harron printed up an eight-foot Grodd to scale that we stuck up on a wall. We knew our actor Dan Payne, the main person in that Grodd suit, is six-foot-four, so we put him up on stilts to get him that extra two feet, and then [wardrobe cutter] Druh Ireland and I built this whole eight-foot Grodd suit, including that big belly, long hair, and

Below: Production art shows two different sizes of Grodd to compare to the Flash to help the producers decide how big their gorilla should be.

Opposite: Concept art of Grodd attempting to flatten the Flash with a handy truck.

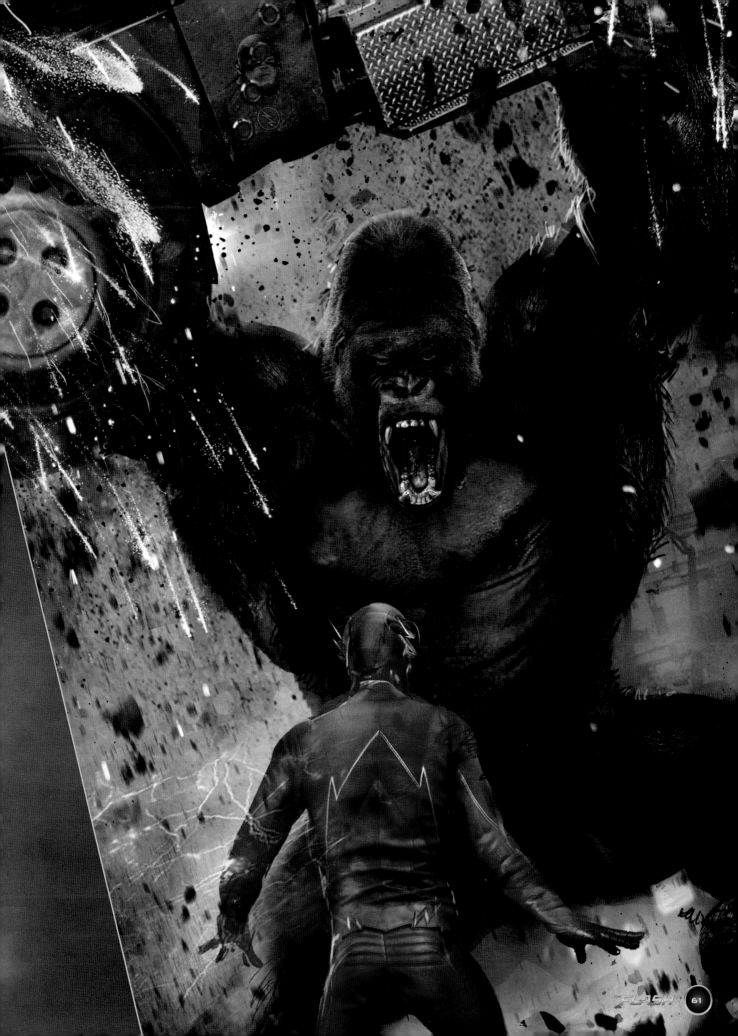

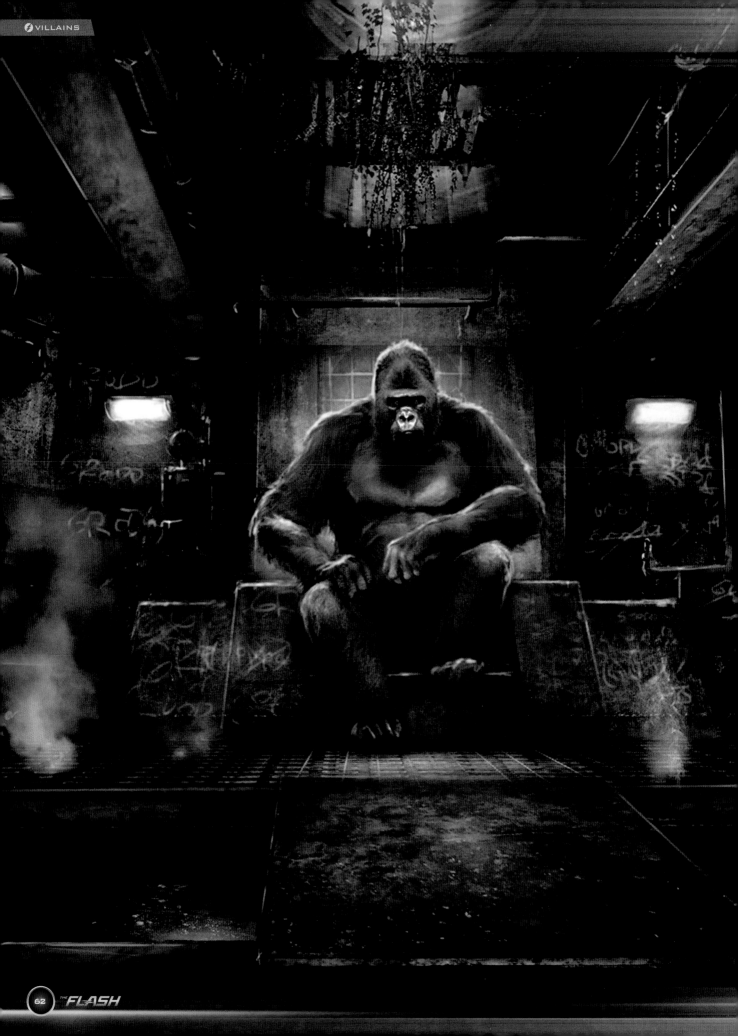

gorilla hands, that is just made out of blue [material]. He put on hockey shoulder pads and we added his torso front and torso back, and then his arms and his hands, and built everything scaled up. With a stuntman and stilts, [the suit] has since become what we use for Atom Smasher and King Shark, whenever we need to have visual reference for visual effects."

The viewers never see a live-action Grodd, though. VFX supervisor Armen Kevorkian explains that the wire-frame CG image is "a version of how the model exists in our world at a certain point. The person in the suit was for camera framing, and camera movement. That way we know how tall he is, how high the camera needs to frame it. Grodd is all CG."

The concept pictures of Grodds of different sizes, Kevorkian says, are from "conversations that we had with our producers early on of, 'This is in proportion to Barry, this is what it would look like if he was this tall, this is what it would look like ...' Just to give them an idea of what the final was going to be, so we could build the CG model to scale."

CG models are constructed one layer at a time, Kevorkian relates. "We build our models pretty much like the real thing would exist, towards a bone structure, muscle system, skin, fur.

"I was happy with how he came out, and how he interacted with the real actors. It also helped that they did a great job in selling something that wasn't there [on set].

"We definitely study everything that's out there to see what the standards are. Grodd is based on real gorillas, and then the research that we did from the comic books of what his character would be like. His look was all developed internally here at [VFX studio] Encore."

Because of the primate's evolved state, Kevorkian adds, "It's not one of those situations where you're actually trying to portray a gorilla as it exists as we know it, you're trying to portray him as a super-intelligent gorilla who's also a metahuman who's gotten telepathic powers, so his stature, his walk, his facial expressions would be in accordance with that."

Kevorkian notes that it's a digital Barry, not the actor or a stuntman, that Grodd grips by the throat, but sometimes CG Grodd *is* battling a live actor. When that happens, says stunt coordinator JJ Makaro, "There are all sorts of tricks. Usually, if it's a bigger creature, you need to be picking people up and pulling them around, so we'll have wires coming from all

Opposite: Concept art of Grodd in his sewer throne room — note his efforts at writing on the walls.

Below: CG image of Grodd with an equally CG Flash.

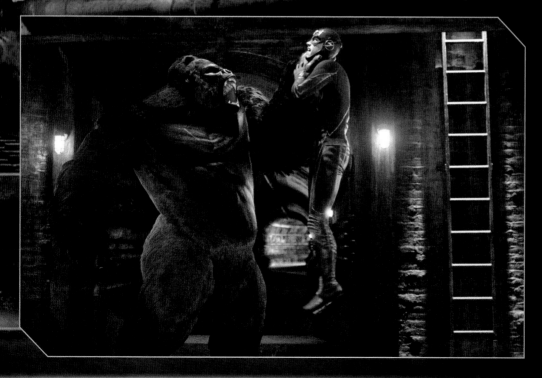

different directions on them. We have a really big stunt guy who we put in a Gorilla Grodd-y kind of basic form. Then he's on drywall stilts, so that he can move around. He's super-tall, so that we have reference to where everything needs to be. But at some point, we have to actually get that guy out of the shot to make sure that [VFX] can drop the creature over the background. So most of the stuff has to be handled by wires, or by editing tricks. Part of the fun of the show, really, is the complex chess game we have to play to actually make everything work out.

"Grodd's lair was a difficult place for throwing people around with this imaginary creature, because it had such low ceilings. So we had to design the set in a way that we could get the wires in, so we could lift people off the ground and send them flying. Because Grodd is big, so he's going to throw them at least twelve to twenty feet. We had one section where we had to build a Styrofoam wall, clad it with a little bit of cement mortar, to make it look like it was actually cement, but just enough so that it was weak enough that it would actually shatter when Grodd threw a guy through it."

Tyler Harron says there are some rewards for diligent viewers. "In the [sewer] grating behind what I call Grodd's throne is a symbol of the gorilla city built into the ironwork at the top, being very similar to what Grodd's telepathic crown looks like. And then, being that he is just a sentient gorilla who's learning to communicate, we scratched his name into the wall as if he was learning how to write an alphabet."

In the end, Grodd is sent to Earth 2's Gorilla City, which we glimpse in some all-CG shots. Depending on what's going on, a number of other Grodd shots are all CG as well. Kevorkian says, "In the visual effects world, when you do something all CG, at that point, you're every department. You're the construction department, where you're building the assets of a

Opposite top: Composite CG image of Grodd being sucked into the breach.

Opposite bottom left: Basic CG model of Grodd and basic CG breach.

Opposite bottom right: Fully-realized CG Grodd with no background.

Both pages: Grodd rages against the trap set by Team Flash.

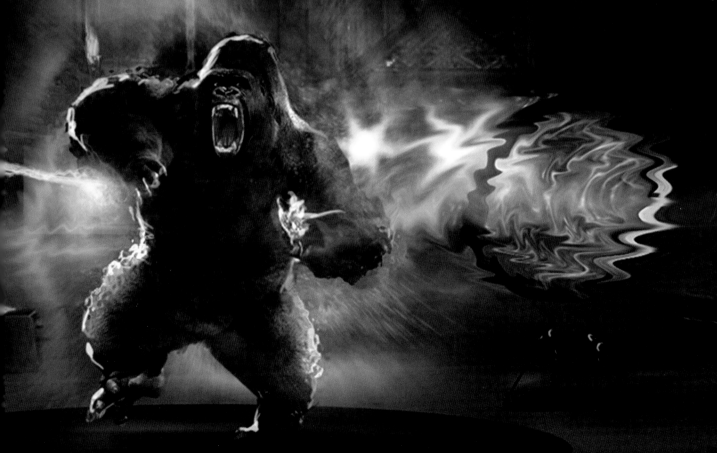

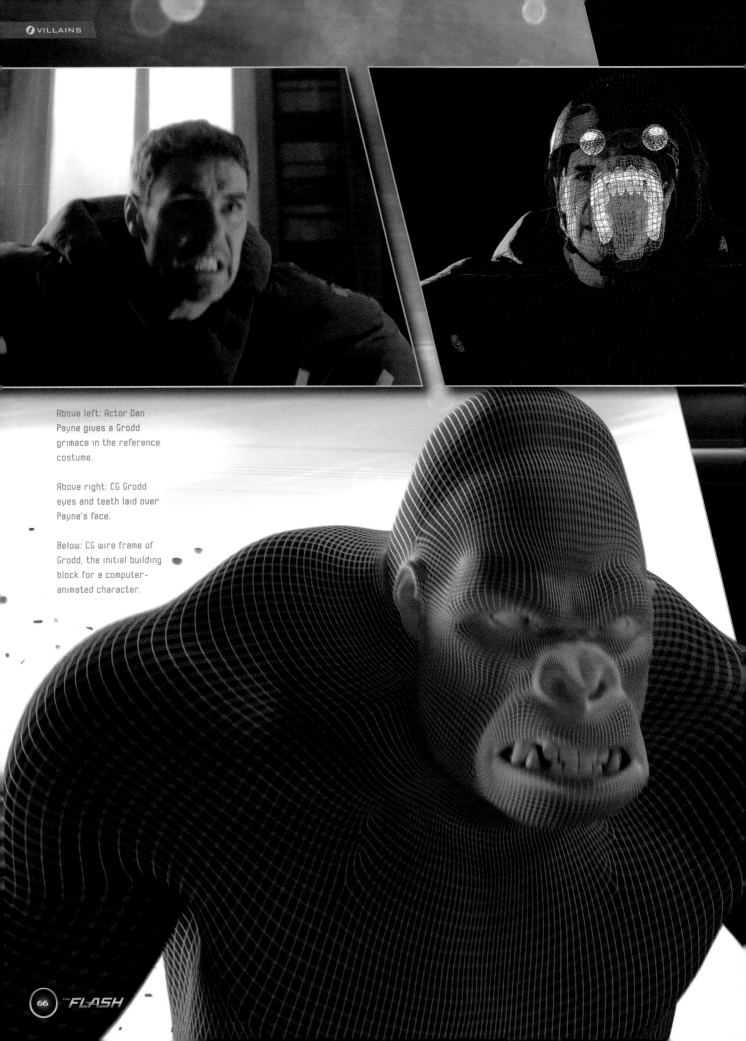

Above left: Actor Dan Payne gives a Grodd grimace in the reference costume.

Above right: CG Grodd eyes and teeth laid over Payne's face.

Below: CG wire frame of Grodd, the initial building block for a computer-animated character.

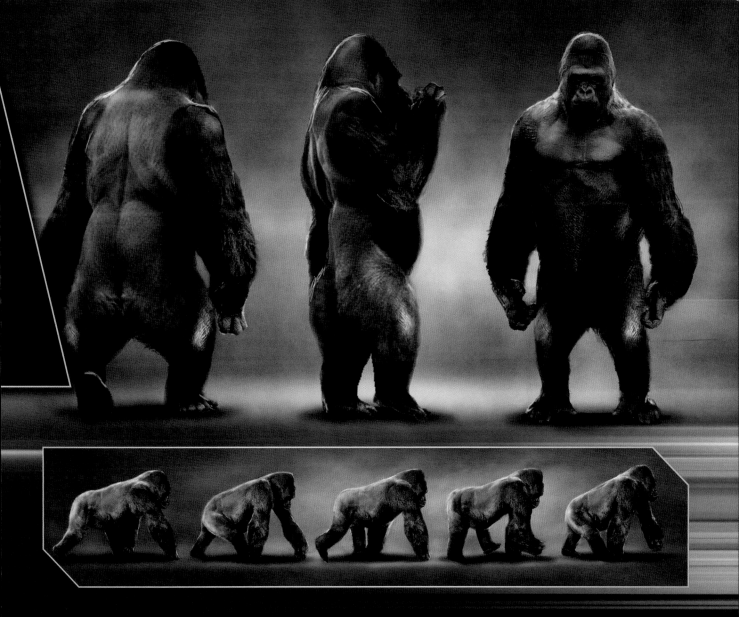

building, whatever it may be. Then you bring in your 'actor,' which is your digital double. You block him. You say you want this shot to be seven seconds long and he needs to start at this level of the [set], and end up at this [other] level, and then you go in and you animate his arms moving and his legs moving and add some facial animation if necessary. I'll explain to the animator where I picture our virtual camera to be, and what it's doing, and they'll go back and start animating it, roughing things out for me. You do a camera push-in, or a one-eighty.

And then I'll take a look at it and give them notes.

"It's set up like any other production shot. When you do that in the computer, you block everything and everybody in place, and then as far as what my job is [as senior visual effects supervisor], I explain to the animators, 'This is how I'd like the camera to move, and as the camera moves a certain way, this is how I'd like the characters or the set pieces to move.'

"Then they'll animate according to those instructions, and they'll do a rough blocking, and once we like the rough blocking, then they'll go and refine the animation."

Kevorkian points out that even the most sophisticated computer can't do VFX on its own. "It's the person behind the computer, the animators animating every single frame to do what it needs to do."

Above: Concept art of real-world gorillas, upright and knuckle-walking. Even though Grodd is evolved, Armen Kevorkian says, "He's based on real gorillas, and then the research that we did from the comic books of what his character would be like."

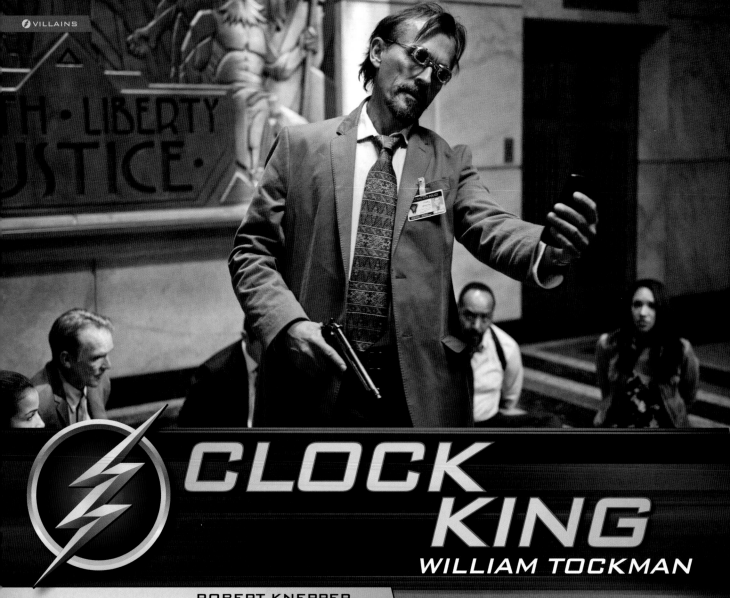

CLOCK KING
WILLIAM TOCKMAN

ROBERT KNEPPER

Above and below: Robert Knepper as William Tockman/the Clock King, a character first introduced on *Arrow*. In the top image, he is in control in the CCPD.

Opposite: Knepper, in the soundstage between takes, modeling the Clock King's spectacles.

William Tockman, aka the Clock King, started out on *Arrow*, where he was thrown into Iron Heights. The Clock King then escapes from prison on *The Flash*. Co-producer Carl Ogawa explains, "He is very precise, but he is completely driven by love of family. The reason that he broke out was because his sister was dying. He was pulling off these capers to get money to help pay for her care. The system didn't help her, and then they kept him from her when she was dying. So now he hates the system, he hates the government, he hates the police." Tockman demonstrates these sentiments by taking the entire Central City Police Department hostage.

Costumer Maya Mani reminds us, "He had lots of watches and clocks and pocket watches and those upside-down watches that nurses used to have. He worked with computers. And then he was taken out of Iron Heights on *Flash*, and that's where Kate [Main] took over."

Flash costume designer Main elaborates, "When we met him [on *The Flash*], he was a prisoner, so we did him completely tucked in, done up, and then he acquired clothes from a hostage detective, so we didn't really style him. Rob Smith, our props man at the time, built him these brilliant glasses that were made out of watch pieces."

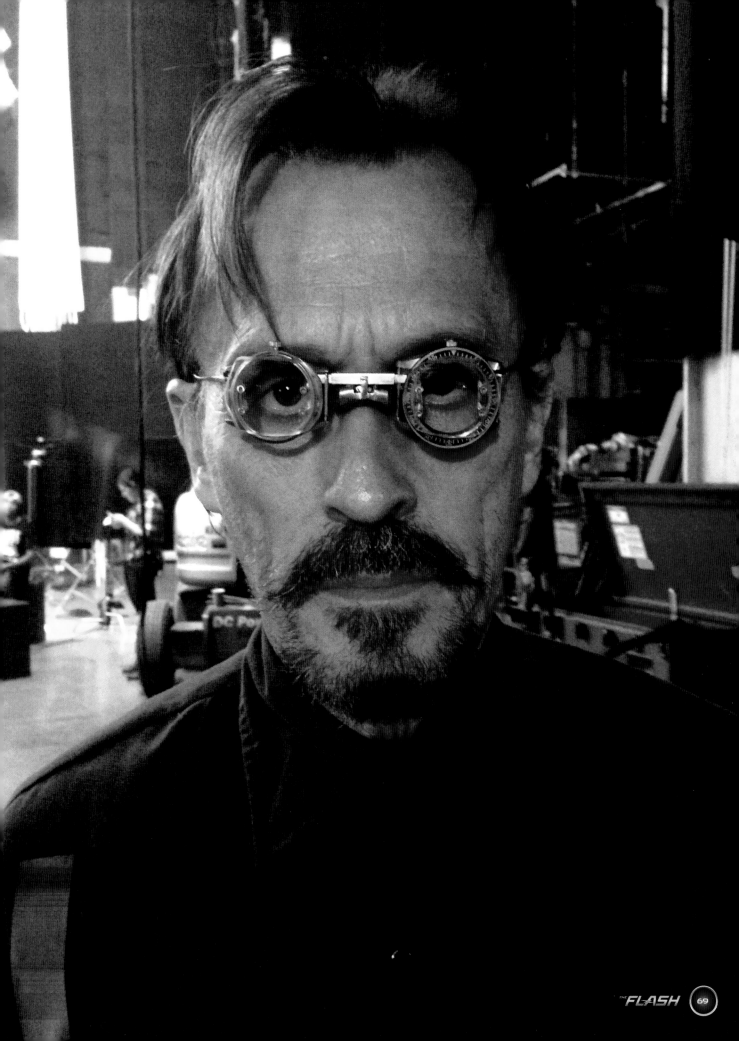

REVERSE FLASH

EOBARD THAWNE

TOM CAVANAGH/MATT LETSCHER

Above: Concept art of the Reverse Flash in S.T.A.R. Labs.

Right: Concept art of the Reverse Flash costume — note the raised areas on the chest that are reminiscent of raised veins from steroid abuse (also seen on Zoom's costume).

Andrew Kreisberg opines, "The Reverse Flash is one of *The Flash*'s greatest villains. Harrison Wells, this wheelchair-bound mentor figure to Barry, is something we came up with. The name Harrison Wells is a nod to H.G. Wells.

"We tend to have a pretty good idea of where we're going. We don't really know how to do things otherwise. We always like to have a plan. We might throw out the plan, we might do a course-correction midstream. The idea that Eobard Thawne had stolen the original Harrison Wells' body was something that we came up with midstream. That was the wrinkle which allowed us to bring Matt Letscher [as the original Eobard Thawne] onto the show.

"We're actually very proud of our work in the first season, because you can almost watch the pilot and then watch the finale, and it all adds up together in an odd kind of way.

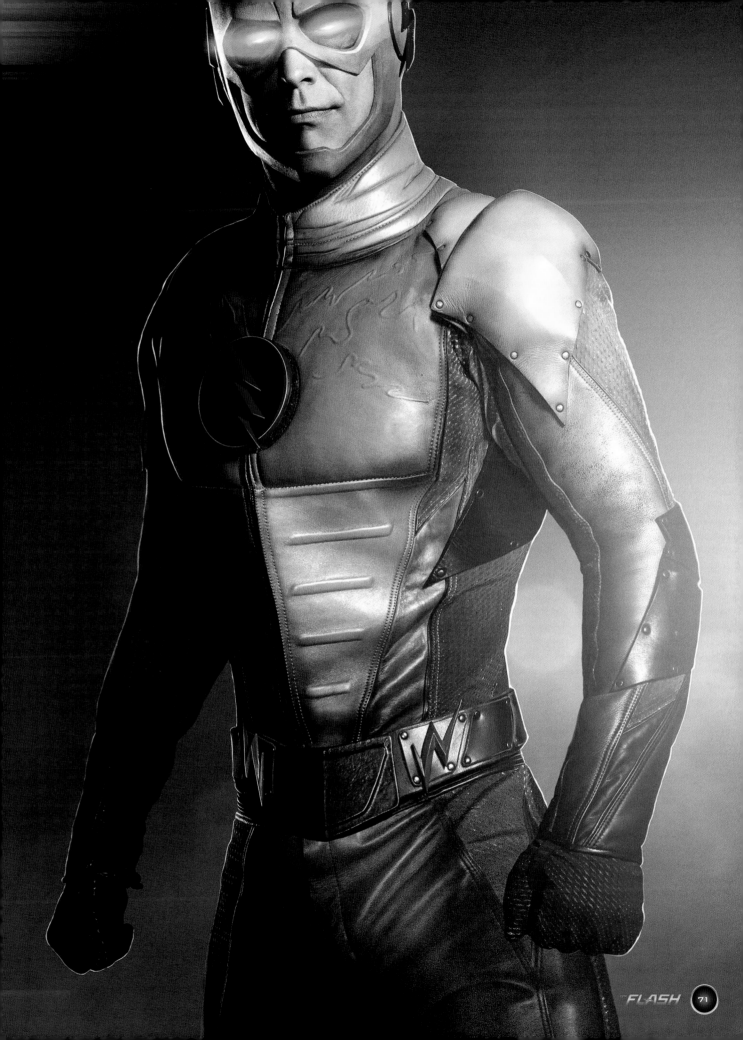

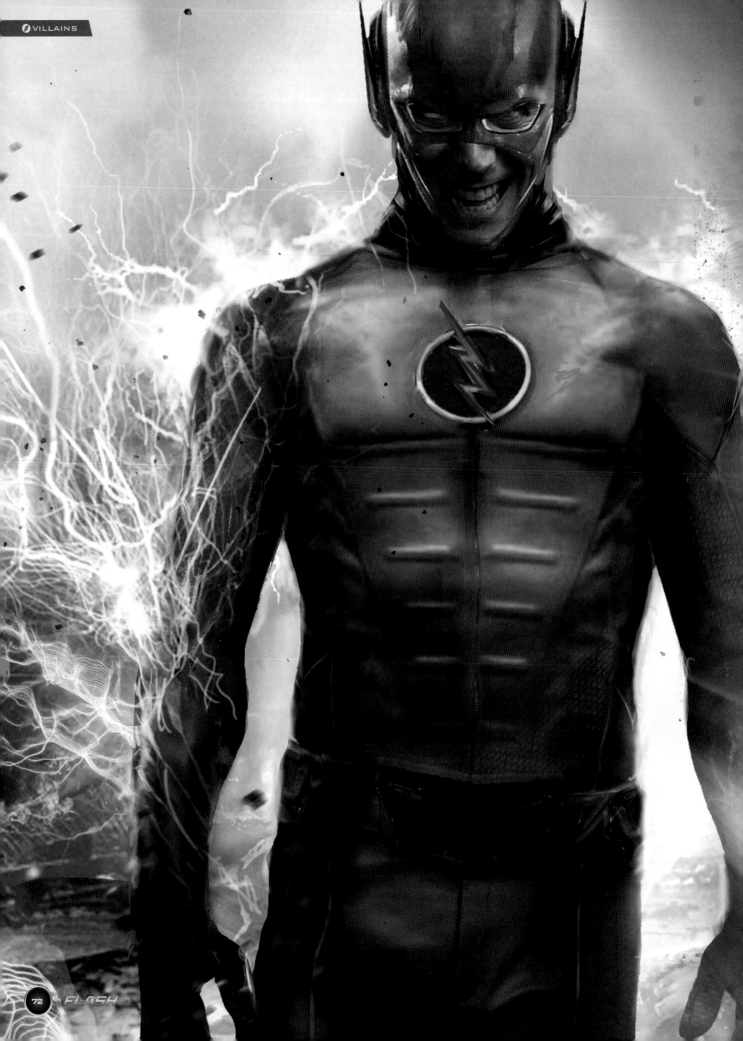

When [Wells] stood up, and you saw glimpses of the Reverse Flash in the past, and Wells interest in Barry in the first place, it was all seeded in that first episode, and in subsequent episodes.

"It's also fun to write for Harrison Wells because, in that first season, everything he said was just leaving out the part about being the bad guy. Once the audience knew that, every line had a double meaning to it."

In designing the Reverse Flash costume, Maya Mani says that, as with Zoom, she wanted the suggestion of manic steroid abuse with vein-like lines showing in the leather.

In terms of makeup, Tina Teoli explains, "There is a difference around his eyes. We try to blend it so it's not quite as stark with his skin showing through, and mottle a bit of yellow, green, and black in there, so that it smokes out the eye area, and you get a little more darkness around his eyes to make him a bit more sinister."

For his Wells' persona, Kate Main says, "Original Wells is a brilliant, stylish scientist. He has a fantastic Tom Ford suit on, and looks crisp and clean and approachable. Then

Opposite: Tom Cavanagh as the Reverse Flash/ Harrison Wells/Eobard Thawne, crackling with malicious power.

Below left: Wells pretending to be paraplegic in order to stay close to the tachyon collector he keeps under his wheelchair.

Below right: Cisco and Wells share a pensive moment.

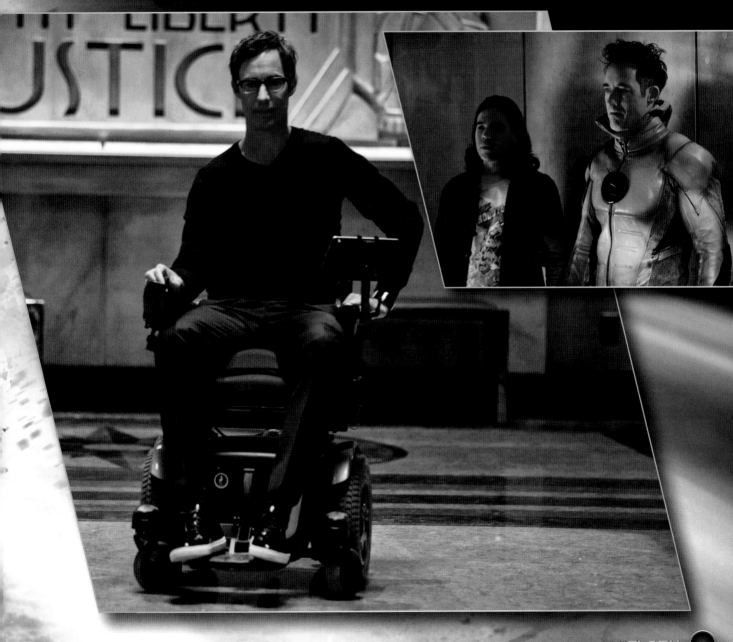

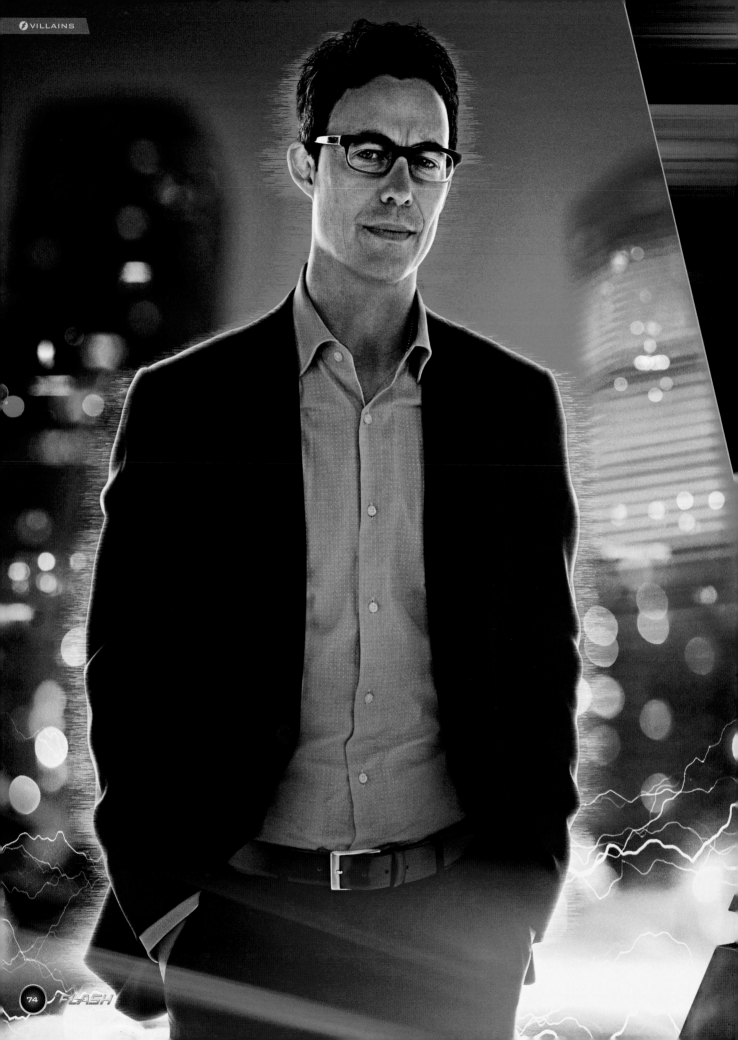

we go into the darker days (when he's really Thawne), where we think he's been relegated to his wheelchair, and it's almost like a man mourning his own life. He's got his uniform. He wears black. You think in terms of who the character is, the logistics of losing his mobility, the things that he'd use to get his sneakers on, his pants and his sweater."

For sequences when the Flash and Reverse Flash are racing through Central City, Armen Kevorkian reveals, "As far as the lightning, we generate it off of the animation that we do for the shot. So it's not a 2D trick, where we use a lightning plug-in and just add some lightning; it's really based on the movement of the CG character. If there's a live-action moment where (a speedster) is taking off, we need to add the same lightning to kind of match-move his moments for the CG version of him, so he can generate lightning."

The racing shots are entirely CG, rather than being based off live-action running. Kevorkian adds. "For those really wide shots that almost feel like bird's eye views of the city, we do still animate the character going around, so we can generate the lightning from it, so it has the same look as the other shots when we're up close. But the run is less important in that. It's almost like we put a run cycle (of the character within the VFX computer program), and then just create the path that we want and generate off of that."

Above: Matt Letscher as Eobard Thawne/Reverse Flash.

Below: Harrison Wells plots his next move.

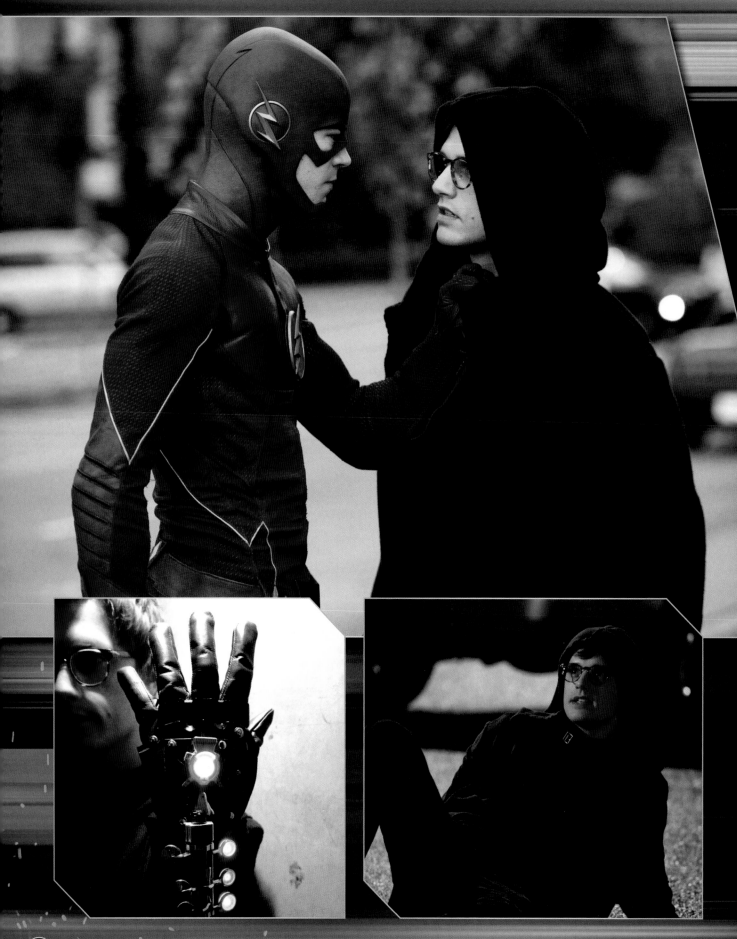

PIED PIPER
HARTLEY RATHAWAY

ANDY MIENTUS

Hartley Rathaway, aka the Pied Piper, is one of those characters who required a little extra work in the writers' room, says Andrew Kreisberg. "We always like there to be a little bit of basis in the comic books, even if it's tangential, and some villains are pretty fully realized in the comic book, but characters like Rainbow Raider and the Pied Piper could be a little bit silly in the comics. We took great pains to make both of those characters scary and formidable, whereas they had come across as comical in the comics."

Tina Teoli says, "Although you couldn't see a lot of it, because his glasses were on the entire time, I did a burgundy around his eyes, to darken them. We did make him a tone paler than his normal skin. He's not from California, he's from New York, so he didn't come with a tan anyway." Even his lips were made paler. "I did actually matte out his face."

Pied Piper broke a lot of glass, remembers Michael Walls. "Most of the glass that we did with him was real tempered glass. We'd get the pieces tempered and then we'd put charges on the tempered glass, and it shattered into little tiny shards. We put stunt guys right through it. We'd blow the charge as they hit the glass and then they'd just go right through, so it would look like they'd broken it. We'd blow the blown-out glass, the tempered glass, using the air cannons, just to help push it further and around stunt performers. Tempered glass is always around stunt performers."

Opposite, top: The Flash tries forceful persuasion on the Pied Piper, aka Hartley Rathaway.

Opposite bottom left: The Pied Piper displaying his flute-like left-hand glove.

Opposite bottom right and below: Andy Mientus as Hartley Rathaway/ Pied Piper, falling foul of the Flash.

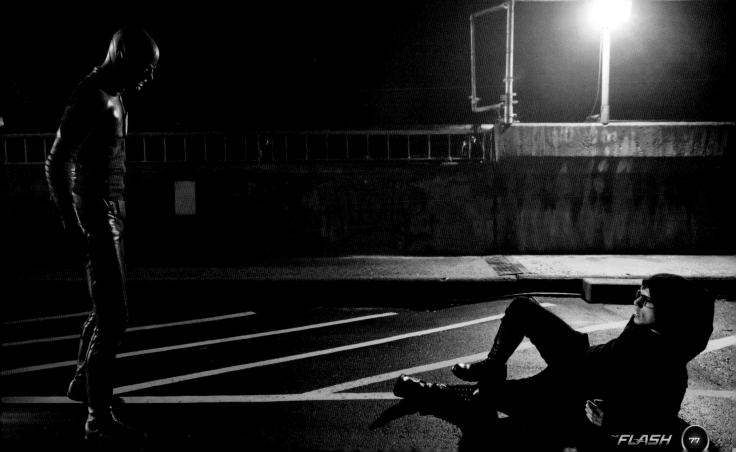

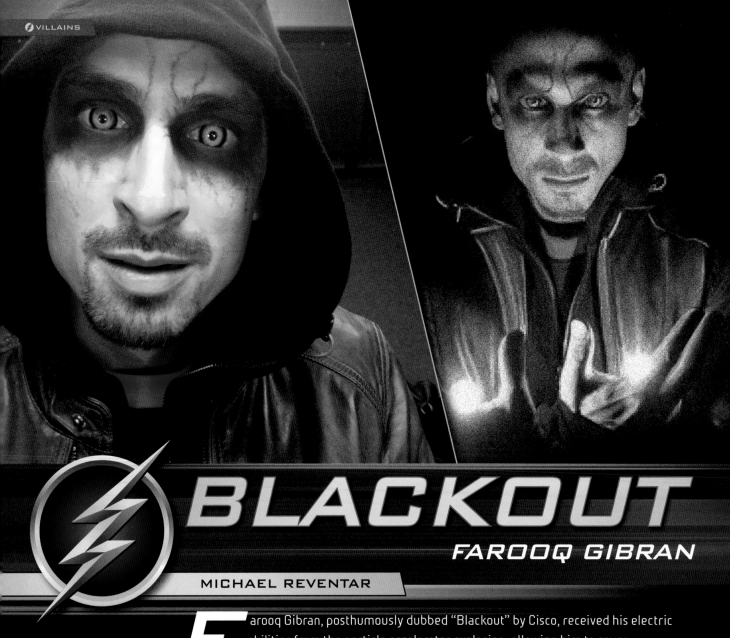

⚡ BLACKOUT

FAROOQ GIBRAN

MICHAEL REVENTAR

Farooq Gibran, posthumously dubbed "Blackout" by Cisco, received his electric abilities from the particle accelerator explosion, allowing him to cause electrocutions and power outages.

Makeup designer Tina Teoli says she particularly enjoys working on metahuman characters like Blackout, played by Michael Reventar, who require special creativity. "They're all really fun makeups, and fun actors, and super-patient if they have to sit in the chair for longer than normal.

Blackout was about an hour and a half in the chair. You could actually see some of his veins – his skin was quite translucent. So I traced around a lot of his own veins and then added some of my own in, blacked out his eyes with sort of a dark, dark brown and red, and then did some raised veins. I basically used a glue product to draw and to sculpt in some veins, so that it was three-dimensional, and then painted over those ones. I wanted him to look like energy was running through his body."

It's not, Teoli adds, that Reventar has notably prominent veins. "I just could see some underneath, and then just went with that and branched out. And we had contacts made for him. I really want things to be original. I don't want off-the-rack contacts, especially for meta characters. We try to design colors and textures that are different and new so they're specific to our show."

DEATHBOLT
JAKE SIMMONS

DOUG JONES

Jake Simmons, aka Deathbolt, teams up with Captain Cold, but the annoyed Snart kills his new ally with the Cold Gun.

"He was so awesome," Tina Teoli says of actor Doug Jones. Still, Teoli loved creating the look of Cold's victims. "I wanted something that hadn't been done before. Then I started thinking, 'Gemstones.' I got this poor guy to beat down a bunch of rocks for me," she laughs. "We found some of the sparkliest things we could, and he had to grind them by hand."

Telesis, a clear silicone adhesive, is used to attach the crystals to skin. "It's not a regular burn, you had to black out the area that he'd been shot in. Round that area, you laid the crystals in, [so] it looked like it was frostbite."

With Deathbolt, "We'd been waiting to do this effect all day long, it was 4:30 in the morning, and they went, 'Okay, now.' So I think I did an effect that should have been done in an hour in probably fifteen minutes. [Doug Jones] was totally down for it. That's what I loved about him."

PEEK-A-BOO
SHAWNA BAEZ

BRITNE OLDFORD

Shawna Baez, aka Peek-a-Boo, got powers of teleportation when the particle accelerator exploded. She loyally used her abilities to break boyfriend Clay Parker out of Iron Heights but, when things got dangerous, Shawna struck out on her own, only to wind up in the Pipeline. Shawna gets the drop on Caitlin, which then earns her the distinction of being the first woman to be knocked unconscious by Iris West.

"Shawna's a fun character," says Carl Ogawa. "She's got one of those powers that most people would want. I mean, who wouldn't want to be able to see some place and then blink into it? Especially if you hate driving, or walking."

And if you hate paying for things, adds costume designer Kate Main. "Shawna's a young woman with a lot of power, and so if she wants to nip into her favorite store and grab her favorite boots, she can do that."

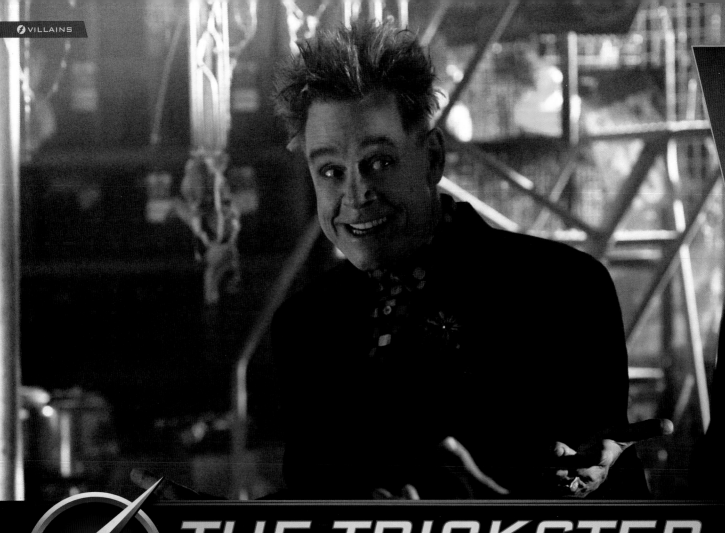

THE TRICKSTER
JAMES JESSE

MARK HAMILL

"Obviously," says Andrew Kreisberg, "everybody knows Mark as Luke Skywalker from *Star Wars*, but not everybody knew that he played [James Jesse, aka] the Trickster on the old nineties *Flash* show. We always knew we would love to have Mark Hamill reprise his role as the Trickster, and he was kind and open and generous enough to join us [for what] were a few of our best episodes."

For the Trickster's face, Tina Teoli notes, "We wanted to make him crazy, and he was right into it. So we gelled his eyebrows up, we darkened everything, did a lot of liner around his eyes, and a little bit of brown shadow."

"When he was in prison," Kate Main adds, "we covered all the sides of his prison pants as though he'd been writing notes, all his terrible conceptions and ideas all over the side of his pants."

Production designer Tyler Harron relates that, for a scene that was deleted, he built a portion of the Gazinga Gum Company, as the Trickster had used the gum to stop the Flash in the earlier series. Hamill was delighted at the nod to his first Trickster portrayal. "It makes him feel like he can portray the Trickster even better, because it brings him back to that moment. It's very important to the storytelling, having the actors react to your sets so that they evoke their characters."

Above: Mark Hamill as James Jesse/the Trickster. Hair designer Sarah Koppes says: "Mark Hamill is a blast to work with. He wanted something super-crazy, so we gave him a really bizarre undercut and then stuck it up all over the place."

PROP
WAREHOUSE

AGIT PROP HOUSE

Above: Devon Graye as
Axel Walker, John Wesley
Shipp as Henry Allen and
Mark Hamill as James
Jesse in "Tricksters"

Left: Production artwork
of Hamill/the Trickster as
a clown advertising the
fictional Agit Prop House.

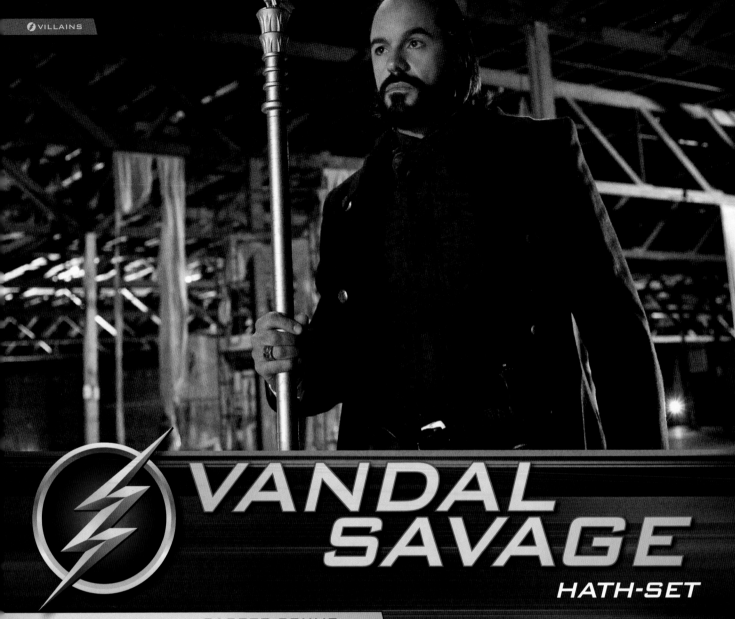

VANDAL SAVAGE
HATH-SET

CASPER CRUMP

The immortal Vandal Savage, once an Egyptian priest called Hath-Set (he has a different backstory than Vandar Adg of the comics), has chased Hawkman and Hawkgirl over many incarnations, into *Flash* and *Arrow* and finally *Legends of Tomorrow*.

Makeup designer Tina Teoli says of actor Casper Crump, "He's so not his character. He is jovial and funny and fun-loving, and not sinister in the least. He was already established [for *Legends*]. His eyebrows were brought down and darkened, and he had liner around his eyes, and lots of cheek contouring, and contouring on the insides of his eyes."

While he was there, Savage made his mark on Central City. "We did a lot of stuff that was the result of his actions," Michael Walls relates, "blowing up park [benches], doing air cannons with a bunch of debris behind them as they jump over different things, the blood from him stabbing and killing everybody. [For] the air cannons we have mortars that attach to the front, and we load those mortars with all of our different debris, lots of cork and dust, anything lightweight that we can use that's close to looking like what it is that we're trying to affect, and then we treat it just like an air shot after that. You fill it full of air, and fire it off, and it pushes all the stuff out."

BUG-EYED BANDIT
BRIE LARVAN

EMILY KINNEY

"Brie Larvan was a lot of fun," says Tina Teoli of the mad scientist, played by Emily Kinney, who invents a colony of robotic bees. "I just thought of Catherine Deneuve. I sent a couple of photos off to Andrew [Kreisberg] and said, 'How about something like this?' And he said, 'Awesome, go for it.' So I did a Catherine Deneuve 1960s-ish makeup on her."

Sarah Koppes takes up the tale. "Because she has long, blonde, straight hair, and because she's a bee lady, we decided, I decided, that I wanted to have a beehive look. So we did a bunch of different tests on her. I did a full sixties beehive that was really big and crazy, and then they decided that was a bit too much, so we took it down a notch and we just gave her a really high crown, just to give her that feel, because she had the glasses and the great jacket that Kate [Main] had designed with the honeycomb feel to it. So it was fun. Just left her really cool-looking, kind of like scientist chic, with that little step into the beehive look."

TOKAMAK
HENRY HEWITT

DEMORE BARNES

When Dr. Martin Stein needs someone who is a molecular match to save his life by joining him as the other portion of Firestorm, the S.T.A.R. Labs team finds two candidates, Henry Hewitt (Demore Barnes) and Jefferson "Jax" Jackson (Franz Drameh). As a scientist, Henry at first seems the ideal candidate, but when he's rejected, he becomes the incendiary Tokamak.

In the real world, a tokamak is a highly developed magnetic confinement system that provides the basis for the design of fusion reactors. In *The Flash*, there's a nice-guy Earth 2 version of Henry who never erupts. Kate Main says of the Earth 1 and Earth 2 editions, "They were both sort of collegiate. Earth 2 is just distinguished by [being] more buttoned up, he's more of a fifties/sixties aesthetic. Tokamak here was a guy who was again fairly conservative, contemporary Ivy League, whereas on Earth 2 he had more of an old-school All-American wholesomeness. That was just to make that nice contrast."

ATOM SMASHER
ALBERT ROTHSTEIN

ADAM COPELAND

Below: Adam Copeland as Al Rothstein/Atom Smasher, with and without hooded coat.

Inset: Atom Smasher prepares to smash!

Opposite: Close-up of the villain's trademark mask and collar.

Costume designer Kate Main says Atom Smasher's armor was based on an unused image for another character sent to her by Andrew Kreisberg. The huge Grodd suit was again used for visual reference, although "We didn't do the extra-long arms."

Production designer Tyler Harron recalls that Atom Smasher's was the first mask he did for Season 2. "It's made out of rubber and plastic. We had to cast [actor/wrestler] Adam Copeland's head and sculpt on top of it, so that it fit right."

Stunt coordinator JJ Makaro says one big Atom Smasher moment was "when he sent the big police car flying into a bunch of people. The [practical] special effects department put a big ratchet on the car and pulled it, so instead of the people being motivated into the vehicle, the vehicle got motivated into them." Makaro adds that the stunt people are wearing protective gear. "You know the vehicle's coming so, when it gets to you, you take all the weight off the ground, so that you can get pushed easier, you get your knees bent out of the way, so you just roll as you take the hit."

The practical effects department also helped Team Flash trap Atom Smasher. Michael Walls relates, "We had to make the set doors able to slide up and down on a cue relatively quickly. The doors that we built were one person triggering them with a pneumatic solenoid, so it was all on a ram to make it move up and down."

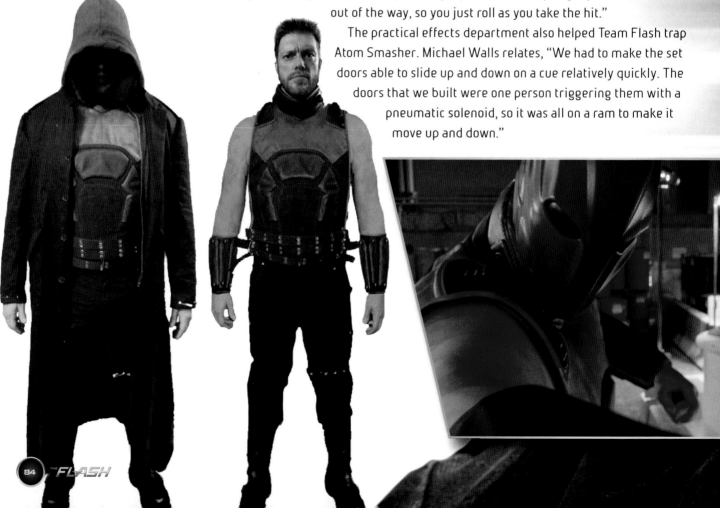

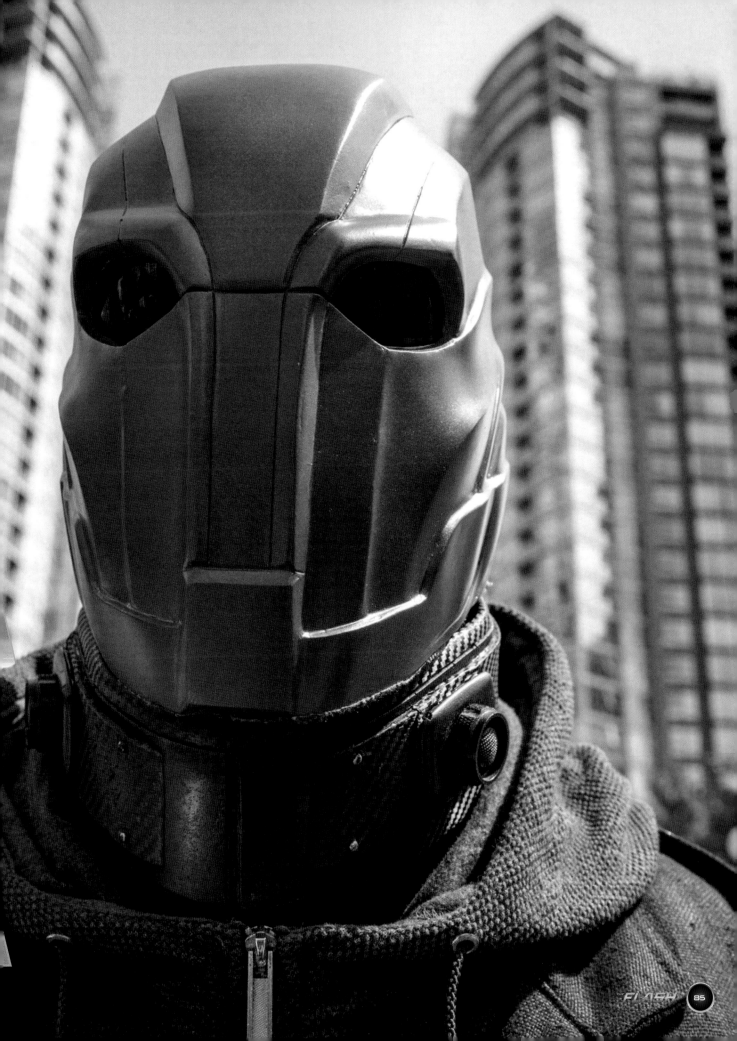

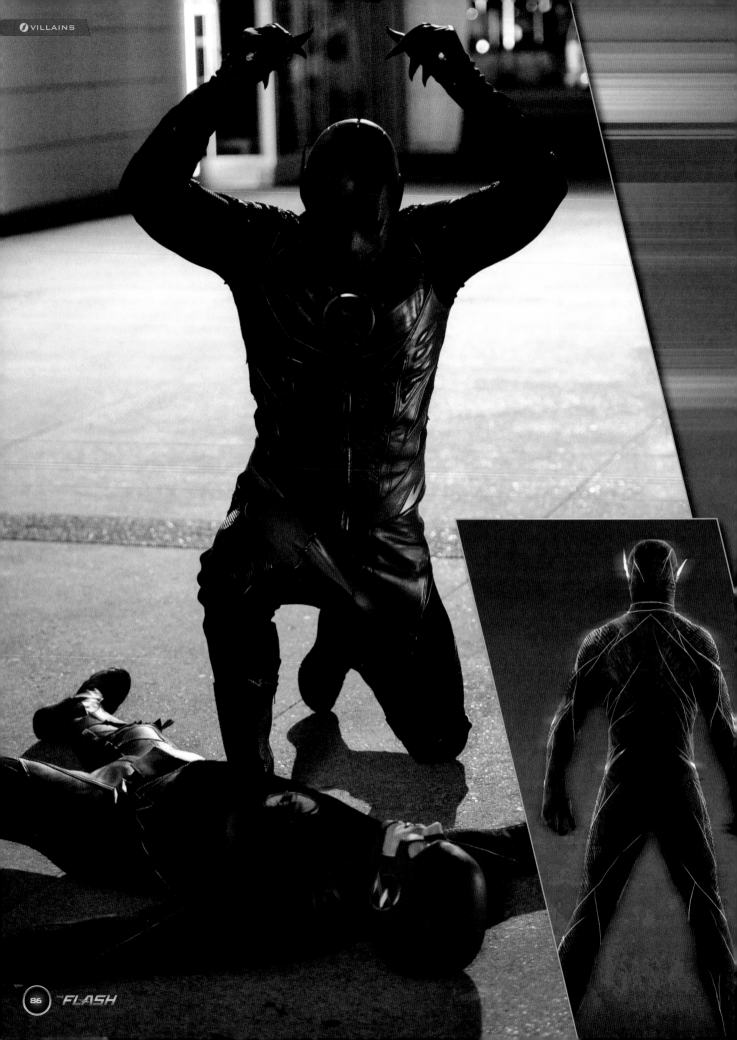

ZOOM
HUNTER ZOLOMON

TEDDY SEARS

When Earth 2's heroic Jay Garrick revealed himself as the monstrous Zoom, aka serial killer Hunter Zolomon, it was a moment the writers had long prepared for. "We always knew who Zoom was," says Andrew Kreisberg, "we were always cognizant of that revelation, we always knew we would be going to Earth 2 in a two-parter, so we (had) a lot of signposts along the way to help us out."

So why was someone other than actor Teddy Sears in the costume for so long? Kreisberg laughs. "Because we knew we were going to have multiple episodes where we'd need Zoom (but not Jay), and we weren't going to pay a highly priced actor to stand in a suit."

Designer Maya Mani says of Zoom's costume, "There's pewter piping, to make the lightning bolts. There are different textures of leather. I went with corrugated leather, run like a person's muscles would run, so you get those different lines. With all those different

Opposite left: Speedster vs. speedster: Zoom prepares to strike the Flash.

Opposite right: Production sketch of the back of Zoom's costume.

Above: Production sketch of Zoom – note lightning-like striations

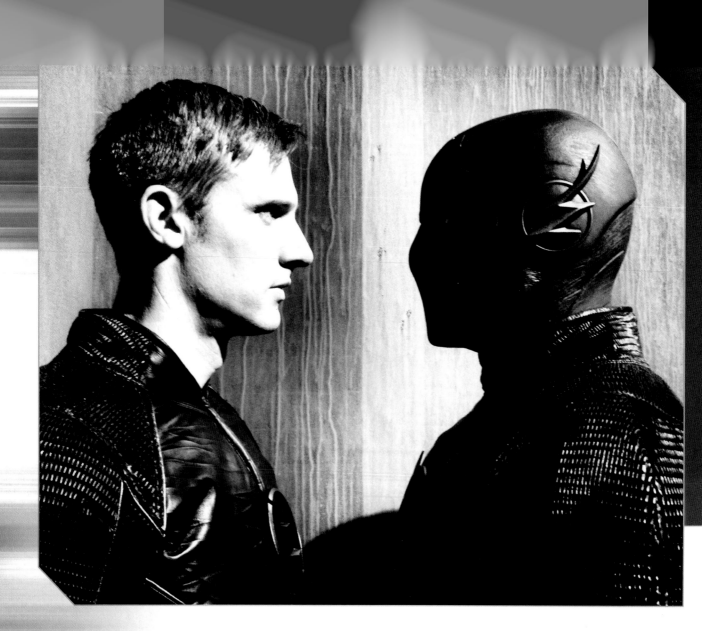

Zoom's cowl goes down to his chest, Mani adds. "We'll put the jacket on over the cowl, and that's what keeps it down. The cowls are done by an extremely talented special effects makeup artist by the name of Bill Terezakis."

Terazakis also made Zoom's claws. "We attach them through the gloves," Mani notes. "It's like having [fingernail] extensions. I [do the concept sketches] and then turn them over to him. Bill knows facial structure way more than I do. So he'll take them and suggest things. I tried to remove as much humanity from Zoom as possible. His mouth was meant to [have] that stringy tar quality. [With] Zoom and Reverse Flash, you'll see these little lines [in the leather]. I wanted that kind of manic, steroid look. In the case of Zoom, they're a bit more like lightning."

Makeup designer Tina Teoli says when Teddy Sears is playing Jay Garrick in the Zoom suit – Tony Todd does the booming Zoom voice – there's also a Zoom stunt double on hand. "When Zoom has the mask on, we black out his eyes, his mouth, his teeth. If we were to black out Teddy's eyes when he was playing Zoom, we would have to spend all that time removing all the black from his teeth, from his mouth, from the eyes. So we usually have Teddy's stunt double in the mask with the blacked-out eyes, and Teddy will be [in the shots] with the mask off doing the dialogue."

Above: Teddy Sears as Jay Garrick/Hunter Zolomon/Zoom, with cowl down, facing Zoom stunt double Ryan Handley, with cowl up.

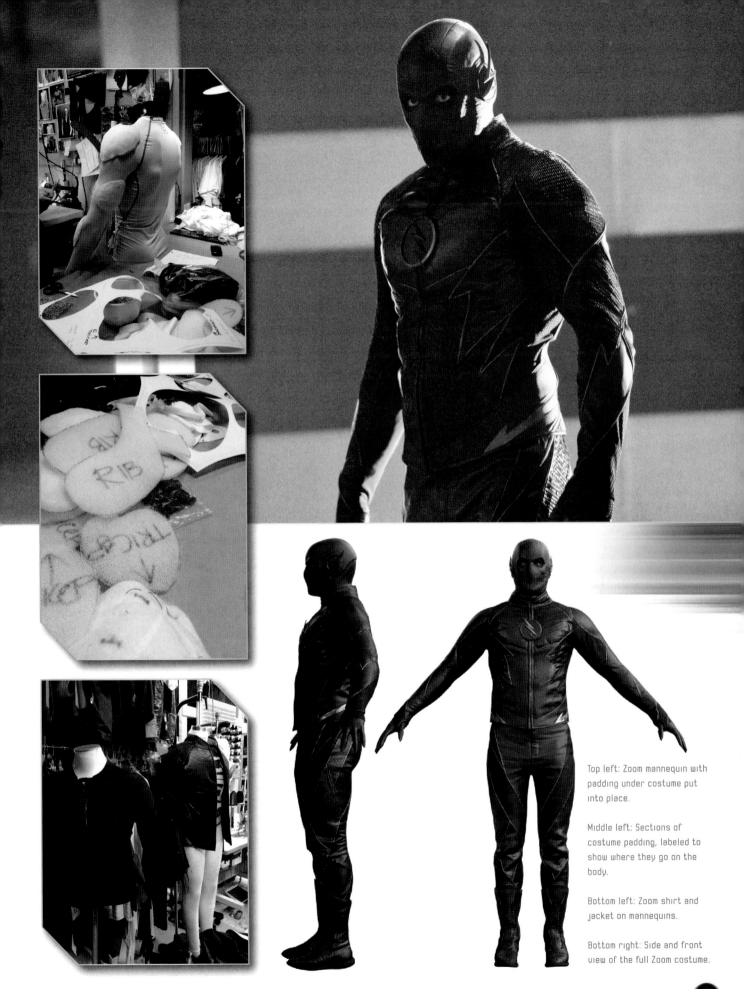

Top left: Zoom mannequin with padding under costume put into place.

Middle left: Sections of costume padding, labeled to show where they go on the body.

Bottom left: Zoom shirt and jacket on mannequins.

Bottom right: Side and front view of the full Zoom costume.

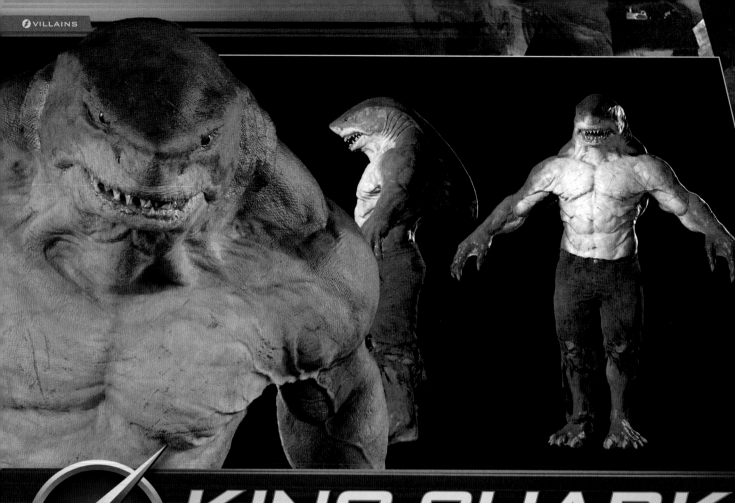

KING SHARK
SHAY LAMDEN

VFX supervisor Armen Kevorkian recalls, "I was in post[-production] and Andrew [Kreisberg]'s office is in the same building, and Andrew said, 'We're thinking about doing King Shark.' I said, 'Oh, cool,' and got a bunch of references of how King Shark had been portrayed in the comics, and then brought in my conceptual artist/storyboard artist, Tom O'Neill, and I brainstormed with him for how we could make it a little different for our world. So in a matter of a few days, I was able to casually then go back to Andrew and say, 'Is this what you're thinking?' 'Yes, it is.'"

Kevorkian observes that this is often how *Flash* VFX characters and sequences get their starts. "Sometimes it's literally we walk by each other, 'Hey, we're thinking about doing this, what do you think?'" Getting the early heads-up "allows us the best possible product at the end."

As to the differences between the comics King Shark and the *Flash* character, "Ours, we gave more humanistic muscles, just to ground him in reality, just like a human body, just really big, ten foot tall. Once that [concept art] was done, I went ahead and showed it to the producers, they approved it, and then we gave it to one of our character modelers here, who built him."

Costume designer Kate Main says her sole contribution to King Shark was, for the actor in the visual reference outfit, "I got to build a pair of jeans with a seventy-two-inch in-seam."

Above: Side and front views of King Shark, head to clawed toe.

Opposite: King Shark ripping through the West house roof.

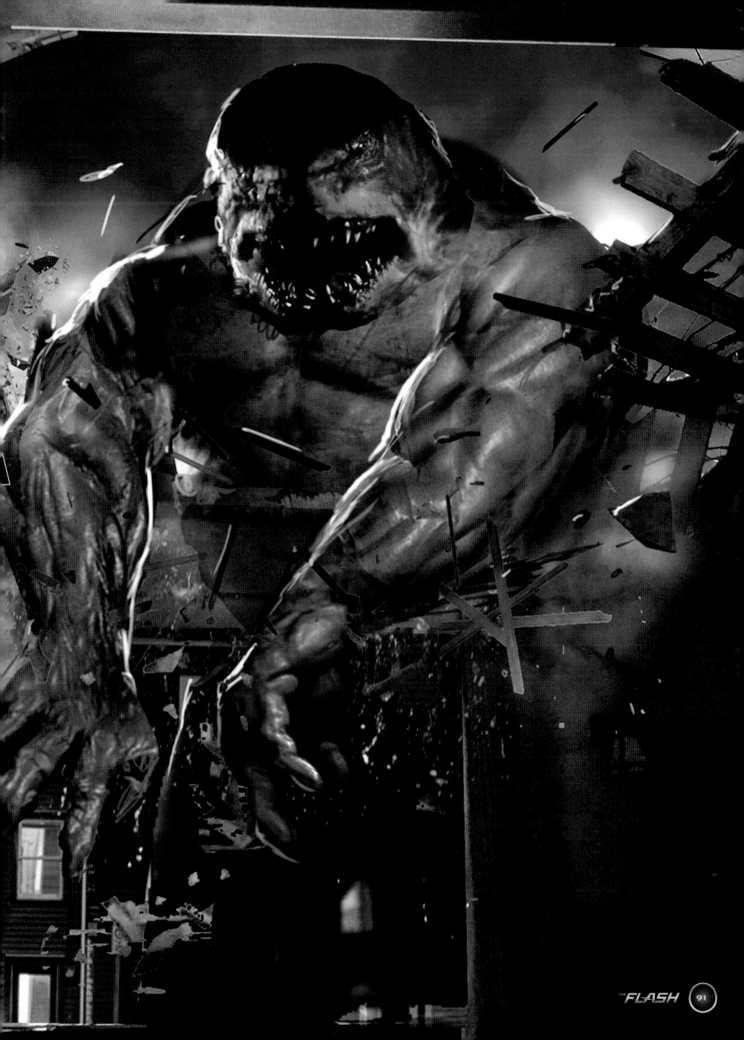

TAR PIT
JOEY MONTELEONE

MARCO GRAZZINI

Small-time criminal Joey Monteleone is dropped into a vat of boiling tar by his former cohorts at the same moment the particle accelerator explodes. Joey emerges two years later from under the ground as Tar Pit, able to transform his body into actual tar, which he uses to cover and kill his enemies.

For metahumans like Joey Monteleone, aka Tar Pit, makeup designer Tina Teoli explains, "Tar Pit was a physical makeup, and then the visual effects department did a scan of him, and then a scan of the enlarged Tar Pit, and merged between all three of those images. They wanted [actor Marco Grazzini] to look like there was tar oozing out of his eyes, mouth, ears, and through his skin. [I used] a combination of a special effects makeup that was semi-permanent to give the dripping effect. Then I put over the top of that a more textured makeup to give it some body, and I put an iridescent blue-green makeup over the top of that to give it that oil slick look."

For Tar Pit's CG state, VFX supervisor Armen Kevorkian says, "We referenced the comic books, drew up some conceptual art for our producers. Once that was approved, we built the CG model of him when he was full Tar Pit, and then we started researching and developing what the lava element within him would look like. We kept it subtle, but still in the realm of what was established in the comic book world."

RUPTURE
DANTE RAMON - EARTH 2

NICHOLAS GONZALEZ

Rupture is Earth 2's scythe-wielding version of Dante Ramon (both played by Nicholas Gonzalez), Cisco's brother.

Visual effects supervisor Armen Kevorkian directed the "Rupture" episode. He says this doesn't mean anything different was done with VFX, except that "Obviously, you don't have to explain to someone on set how [the VFX will] be done, so you save time."

For Rupture, Kevorkian continues, "He has energy that flows through the scythe, [which] he uses as a conduit to shoot out his powers." The crackling energy is a major part of the episode's VFX.

Rupture battles a holographic Flash in Jitters. Stunt coordinator JJ Makaro says, "Rupture had a scythe, so we used one of our stunt doubles from *Arrow* who is pretty good with a staff, and we started inventing ways so we could actually use this thing like a staff. The blade itself would be rubber [or] plastic. It is a regular blade when they're just standing there talking, but not when they're actually doing the fights."

BLACK SIREN

LAUREL LANCE · EARTH 2

KATIE CASSIDY

Black Siren is the malevolent Earth 2 twin of Laurel Lance/Black Canary. Super Hero costume designer Maya Mani relates, "If you look at DC Comics, most of the women have fishnets, [White] Canary and Black Canary and Black Siren. I do like to nod at that, because you can't pretend they're not there. In the case of Black Siren, you can see there's a fishnet on her upper arm. And you can see that it's on her leg when she bends her knee. So I like to put in those little elements, again. It's a very, very sexy costume, but it's not over-cleavage.

"Black Siren has a beautiful long coat. When Tyler [Harron] and I were talking, that was one of the things he drew up for me. All of the seams are outlined in black patent leather. It's very geometric and a little Deco. Subtly so, though. There's nothing overt. When she spins, it's like helicopter blades going around." The coat also has sections of Goma fabric, like much of Mani's other super-garb. "It's the same formula. She's going to go rolling on the ground, and then she has a really big fight. So again, it has to be able to withstand [the action] choreography. They don't work around the costume. We have to keep up. They're not going to slow down."

DOCTOR LIGHT
LINDA PARK - EARTH 2

MALESE JOW

O n Earth 2, the counterpart of intrepid Central City Picture News reporter Linda Park is the amoral Dr. Light. When Dr. Light comes to Earth 1 Central City, she understandably wants to get away from Zoom – but her plan is to kill Linda and usurp the other woman's identity.

One of Dr. Light's signature pieces is her helmet. Production designer Tyler Harron incorporated grey and silver, signature Earth 2 hues, into the headgear. He relates, "I wanted it to feel like ... [a] metallic, a robotic face. How it's structured on *The Flash* is [that] Maya Mani does the Super Hero suits, but we work together because a lot of times they'll integrate a prop or a helmet, and I ended up designing the helmets on the show, as well as all the hand props and gauntlets, or gloves, for people. When Dr. Light's helmet came through, it was really our first time to see a villain from Earth 2 upfront, and give a backstory to Earth 2, or to start to imply the Deco design elements into the costumes and into the helmets. So I really wanted to make a statement helmet."

Mani says of the Doc's overall costume, "It's very geometric and a little Deco. Subtly. There's nothing overt. As [with] Dr. Light [herself]. She was kind of

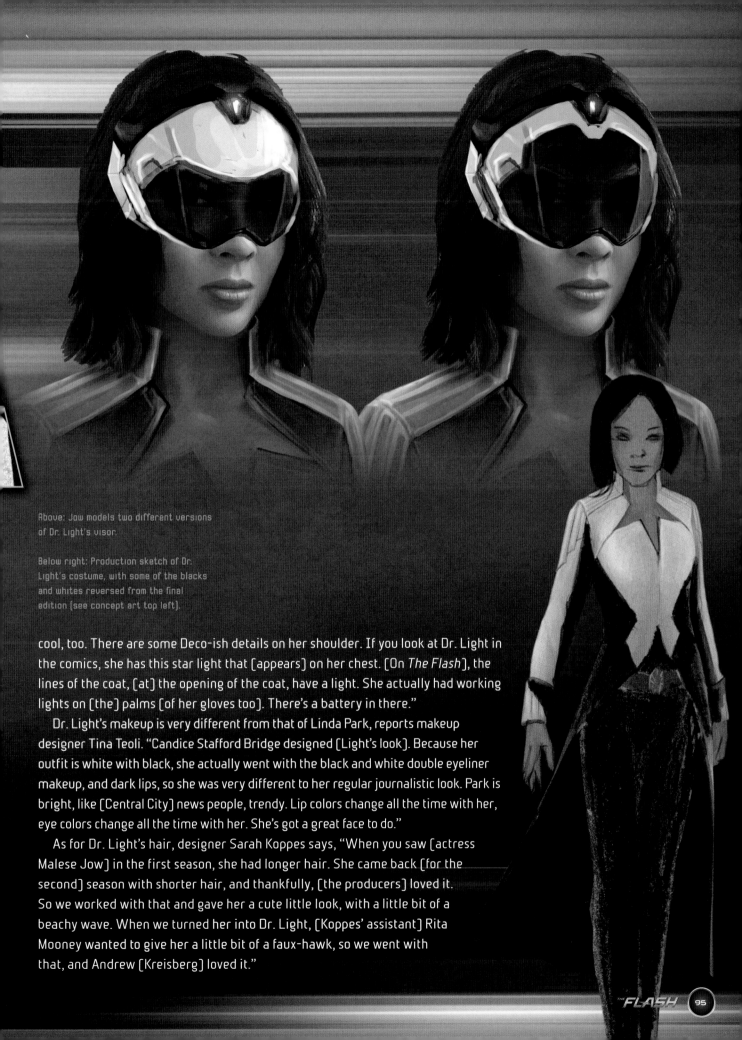

Above: Jow models two different versions of Dr. Light's visor.

Below right: Production sketch of Dr. Light's costume, with some of the blacks and whites reversed from the final edition (see concept art top left).

cool, too. There are some Deco-ish details on her shoulder. If you look at Dr. Light in the comics, she has this star light that [appears] on her chest. [On *The Flash*], the lines of the coat, [at] the opening of the coat, have a light. She actually had working lights on [the] palms [of her gloves too]. There's a battery in there."

Dr. Light's makeup is very different from that of Linda Park, reports makeup designer Tina Teoli. "Candice Stafford Bridge designed [Light's look]. Because her outfit is white with black, she actually went with the black and white double eyeliner makeup, and dark lips, so she was very different to her regular journalistic look. Park is bright, like [Central City] news people, trendy. Lip colors change all the time with her, eye colors change all the time with her. She's got a great face to do."

As for Dr. Light's hair, designer Sarah Koppes says, "When you saw [actress Malese Jow] in the first season, she had longer hair. She came back [for the second] season with shorter hair, and thankfully, [the producers] loved it. So we worked with that and gave her a cute little look, with a little bit of a beachy wave. When we turned her into Dr. Light, [Koppes' assistant] Rita Mooney wanted to give her a little bit of a faux-hawk, so we went with that, and Andrew [Kreisberg] loved it."

REVERB
CISCO RAMON - EARTH 2
CARLOS VALDES

Carlos Valdes says of playing Cisco's Earth 2 persona, the psychically powerful Reverb, "I had a blast, because we've had a lot of time to get to know these characters, and challenge them by putting them in these larger-than-life situations. It was a perfect opportunity for me to lend an experience of Cisco for viewers, to see what Cisco's life would have been like if things would have turned out differently. It's an alternate-reality version of Cisco. Anything could have happened in this reality. And so I got to color him in a completely different way. It's always so refreshing, not just to be able to stretch as an actor, but also to play with the audience's expectations of a certain character."

For Reverb's look, Tina Teoli relates, "Vibe gets heavy contouring, some guy-liner, and we colored out his lips a bit, so that he was very monotone-looking, almost non-human, android. We wanted him to look sort of model-perfect."

Hair designer Sarah Koppes adds, "We saw him as this supervillain, so we made him darker. I think they initially wanted him in a ponytail, but when you put Carlos in a ponytail he looks like he's a fifteen-year-old boy. We wanted him to look a bit edgier, so we just pulled half his hair back."

DEATHSTORM
RONNIE RAYMOND - EARTH 2
ROBBIE AMELL

Had Robbie Amell not left *The Flash*, would Ronnie Raymond still have died, would he have stayed with Caitlin, or would he have gone to *Legends* as half of Firestorm? Andrew Kreisberg says, "I don't know what would have happened. Robbie has returned, playing Deathstorm, which is a lot of fun."

Earth 2's Deathstorm has literal firepower. Michael Walls explains how this was done on set. "When he was throwing fireballs, we did some practical fireball effects on the ground that were enhanced with CG to give a bigger look. We take flash paper – paper that's been soaked in a fuel and then dried – we wrap that up into balls, we put smokeless powder in with it, and ignite it with an electric match, and it gives you a big fireball for a split second and then goes out."

KILLER FROST
CAITLIN SNOW - EARTH 2

DANIELLE PANABAKER

Tina Teoli says actress Danielle Panabaker contributed to Caitlin Snow's Earth 2 twin Killer Frost. "She found these blue, crystally nails. Kari Anderson and Danielle and I developed that look. Her facial color was brought down two to three tones, her lip color was developed out of blues and silvers, and she has [custom-painted contact lens] violet eyes."

Sarah Koppes relates, "[Frost's] wig is almost white/grey, but it reads on camera as white. I airbrush the front of her hairline into a lighter color, and then we put the wig on her."

Armen Kevorkian explains that CGI created "the cold gusts coming out of her hands and sharp icicles that she [could] form and shoot at people. With some of the software that we [use for] our fire and ice and cold and air, [we] play with the parameters as far as the physics of it, and then the shaders we add give it the look of the fire and ice."

Above: Production art of
Adam Stafford as Adam
Fells/Geomancer.

Opposite top left: Close-
up of the Geomancer's
upper-body costume.

Opposite top right: Adam
Stafford as Adam Fells/
Geomancer.

Opposite bottom:
Preliminary production
sketch of the Geomancer
costume.

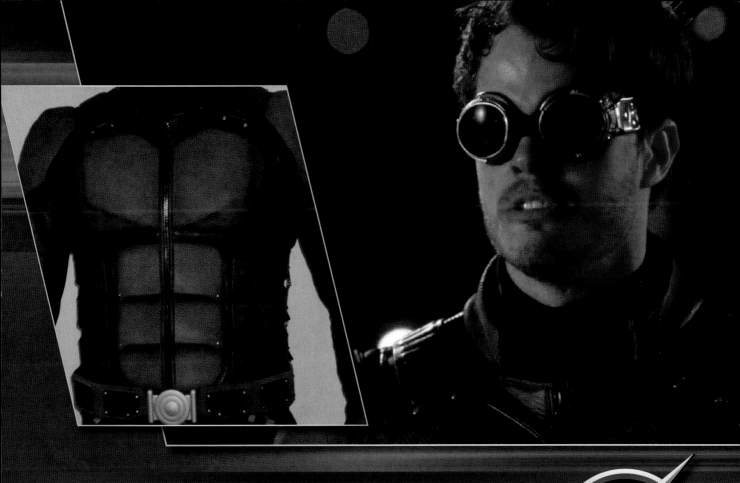

GEOMANCER
ADAM FELLS

ADAM STAFFORD

In designing the costume for Adam Fells, aka Geomancer, Maya Mani says she wanted to emphasize his ability to cause earthquakes. As with many other Super Hero and villain costumes, Geomancer's suit is mainly a combination of leather and printable Goma fabric.

"Tyler [Harron] designed the gauntlets and goggles. I wanted to give [the suit] an armored feeling, like there were wires running through his costume that powered these gauntlets." To simulate wires, "I found bound elastic that could run through the costume." The elastic goes between the costume's outer layer and the fabric inner lining. "You can see them, just as you can with the Atom costume on *Arrow* and *Legends*. They looked like bungee cords, but they were meant to be steel cables. Anyway, they stretch, so that you can see the functioning of the costume."

Geomancer also has beard stubble, which is artificially maintained by the makeup department. Tina Teoli explains, "It's actually made out of hair. Sometimes it's human hair, sometimes it's yak hair. If you're doing a beard shadow, you take the right color hair and chop it up extremely fine, and then you punch it through a lace piece. You lay down [adhesive], put a piece of raw lace over the top of the glue, and then you punch the hair through the lace and pull the lace off, and it stands the hair up."

TRAJECTORY
DOCTOR ELIZA HARMON

ALLISON PAIGE

Trajectory, aka Dr. Eliza Harmon, is *The Flash*'s first (though not last) female speedster. Super Hero costume designer Maya Mani observes, "Women have different body parts and they carry their weight in different areas. Because it's a closed-up suit, if you look at a speed-skating suit, they're not the most attractive," she laughs. "I wanted a head-to-toe, seamless look, but we needed to break it up, and make sure that [it had] big shoulders, a little waist. It's how I like to present Super Heroes. So with her it was a lot of shading and emphasizing her ridiculously small waist – she's a tiny, tiny person – and giving her long legs [by] where you cut it and how you seam it and how you curve the seams and how you airbrush it."

Armen Kevorkian says that long hair is an issue when it comes to VFX, as the movement of each hair must be tracked and replicated, so the producers requested another kind of look.

"They wanted Carrie-Anne Moss from *The Matrix*, slicked back," says hair designer Sarah Koppes, "but [actress Allison Paige] has longer hair. I wanted to add texture, not just a straight box, so I did a bunch of twists in her hair, and then twisted everything in the back and had a little bun at the back of her hair, so she could still have her mask, and everything was streamlined, but it gave some dimension to her hair."

Above: Production art of Allison Paige as Dr. Eliza Harmon/Trajectory.

GRIFFIN GREY

HAIG SUTHERLAND

Griffin Grey, played by Haig Sutherland, has super-strength, but using it causes him to prematurely age. In order to kidnap Wells, Griffin uses his own body to stop Harry's van.

Practical effects supervisor Michael Walls explains, "We build a lot of breakaway or soft pieces, everything from aluminum dumpsters to roofs of cars that we tear properly so that

Below: Haig Sutherland as Griffin Grey, aging as he uses his powers.

they can crash through, [with] what we call soft aluminum. It's a product I found while working on *Smallville*, basically like tin foil, only a little bit stronger. It looks like real metal, and you can crush it with your hand. We build the shapes and then they paint it or decorate it to be whatever they need." To get the aluminum to hold its shape, "Most of the time, we use foam insulation, the harder stuff, cut that up into ribs to use as our strengtheners, and it's nice and soft and breaks really easy. We're trying to make it as safe as possible for all of our stunt performers, and our actors."

TURTLE
RUSSELL GLOSSON

AARON DOUGLAS

Whereas speedsters accelerate through the normally moving world, the Turtle, aka Russell Glosson, played by Aaron Douglas, has the power to slow time around him.

Michael Walls reports, "We didn't do much with the Turtle. Everything was basically at frozen time, and that becomes the digital world."

Although they both move quickly compared to everything else in the environment, one thing the Turtle doesn't do that the Flash does is leave everything blowing in his wake, like paper, drapes, other people's hair ...

Walls laughs when asked about this. "It's all about wind with us. We have all sorts of different pieces of equipment. We have small air guns that we use for blowing on the actors' faces, which are just high-pressure air nozzles that we can get within five or six feet of them, just to give us good bursts within their frame, all the way up to different-sized cannons [that are] an air accumulator that we can hold in place and then trigger a valve, and it kicks open the entire accumulator for a split second, so you can deliver tons of nitrogen and compressed air. They're both inert, so it's the safest way to deliver large volumes of air. We have everything from thirty-pound bottles all the way up to three-hundred-pound bottles."

LOCATIONS

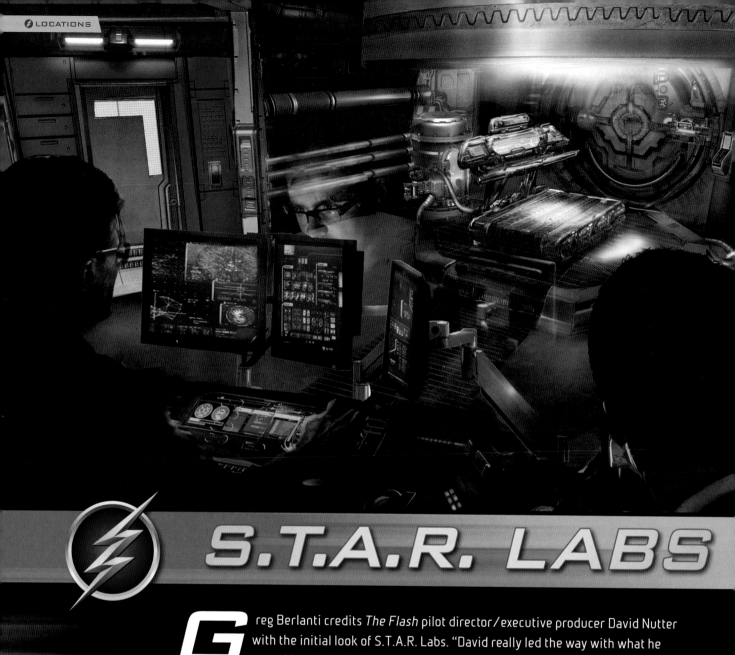

S.T.A.R. LABS

Greg Berlanti credits *The Flash* pilot director/executive producer David Nutter with the initial look of S.T.A.R. Labs. "David really led the way with what he wanted it to look like. It has sleekness, but still warmth, which is hard to do. Usually, you get one or the other. But this has both, which I think is great."

Tyler Harron says the design relied heavily on the VFX department. "They took the Cortex, which was designed by Ian Thomas, and the fundamentals that he had put into that set and augmented [it]. Originally, it was based on a stadium in Vancouver, but then they developed it further, where it became a 3D model of its own before I joined the project."

Harron points out that the Cortex and the Time Vault were the only portions of S.T.A.R. Labs featured in the pilot. "So there was a design language that was started, but it wasn't enough that we couldn't expand off of it. So within the first couple of episodes, I added the testing room with the Cosmic Treadmill."

Michael Walls reveals, "The Cosmic Treadmill was the first thing we built. It's basically an oversized aluminum real treadmill that we built from scratch. There's a traffic belt, a heavy plastic track that they use for food conveyor belts that has different patterns built into the design, and then [slightly] oversized motors to run the heavier belts. It's four feet wide and nine feet long. It goes up to what would be considered about a twelve on a regular treadmill, so

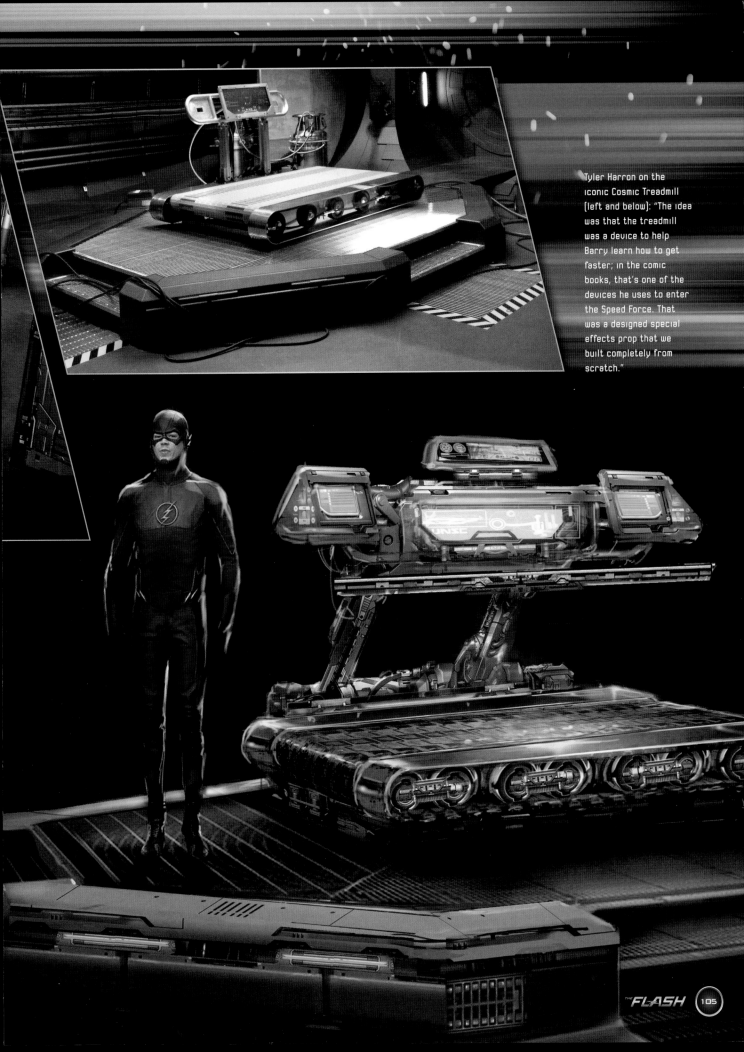

Tyler Harron on the iconic Cosmic Treadmill (left and below): "The idea was that the treadmill was a device to help Barry learn how to get faster; in the comic books, that's one of the devices he uses to enter the Speed Force. That was a designed special effects prop that we built completely from scratch."

The speed cannon is another key S.T.A.R. Labs component, Walls notes. "That was a working prop, a nine-foot circular diameter. We built a track system inside of it, and we ran the whole thing on a motor, so the inside track moved away from the outside track, so it looked like it created a different speed. And then they added light on the inside track. That was mostly a practical effect."

The Pipeline Intake is based on the interior of the CERN Hadron Collider, Harron explains, "using large, thick arches that could contain magnet systems, or high-voltage electricity. It's a very small set in its actual presence, but I wanted to give it that really foreboding, cavernous feel that was going to lead us eventually into our visual effects world of the larger Pipeline Intake."

Much of the Pipeline is computer-generated, Harron adds. "Other than the cell itself, any time the door between the Intake and the Pipeline [is seen], there's a visual effects shot there, because that is completely CGI from beyond the door. That being said, last season, for the final two episodes, I had to build a hundred-foot by sixty-foot section of the Pipeline. So that's another time where I developed the look of the Pipeline Intake with visual effects, and then I had to work off of their final model to work my physical build back to the original design."

This spread: "For [the first] season," says Tyler Harron, "we often would bring in a gurney and put it in the middle of the room. To me, it started to get a little arch and a little implausible that they've got to pull a gurney out and fix Barry up and then put it away. I wanted to define that space as this sort of an area where, if a character gets hurt, there's the equipment there to deal with them right away."

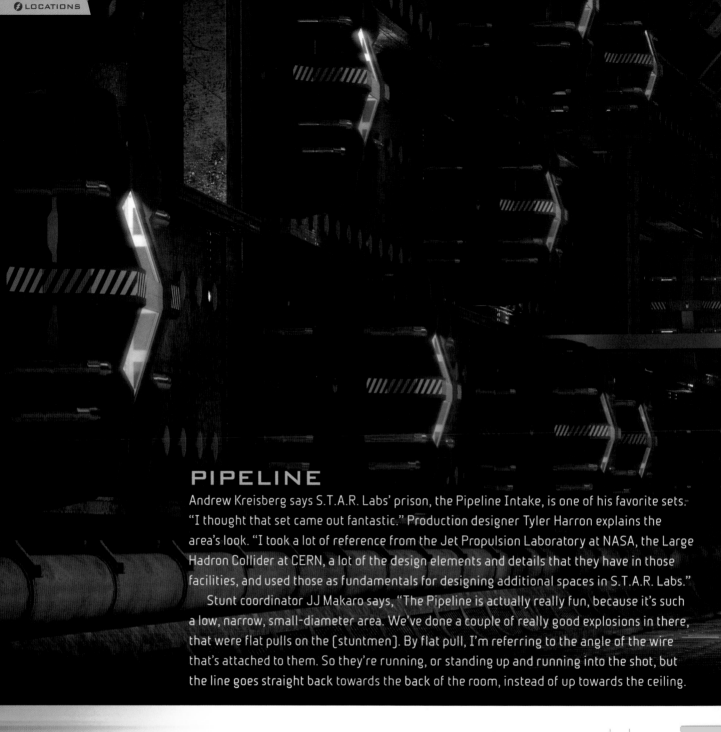

PIPELINE

Andrew Kreisberg says S.T.A.R. Labs' prison, the Pipeline Intake, is one of his favorite sets. "I thought that set came out fantastic." Production designer Tyler Harron explains the area's look. "I took a lot of reference from the Jet Propulsion Laboratory at NASA, the Large Hadron Collider at CERN, a lot of the design elements and details that they have in those facilities, and used those as fundamentals for designing additional spaces in S.T.A.R. Labs."

Stunt coordinator JJ Makaro says, "The Pipeline is actually really fun, because it's such a low, narrow, small-diameter area. We've done a couple of really good explosions in there, that were flat pulls on the (stuntmen). By flat pull, I'm referring to the angle of the wire that's attached to them. So they're running, or standing up and running into the shot, but the line goes straight back towards the back of the room, instead of up towards the ceiling.

Top: Concept art for the Pipeline.

Bottom: Production graphic of the Pipeline area with cell doors, showing the scale relative to the actors.

Opposite: CG animatics of the Pipeline space.

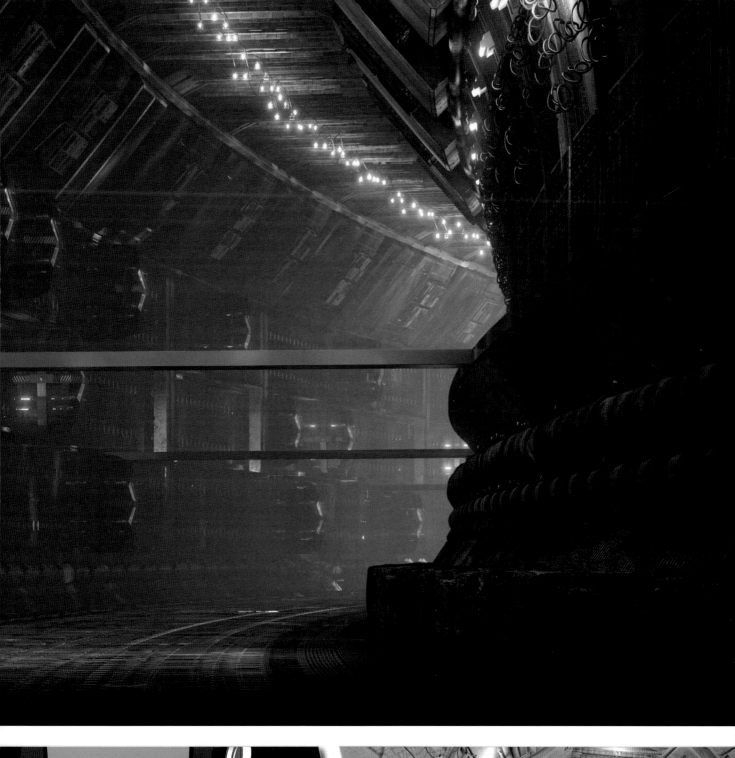

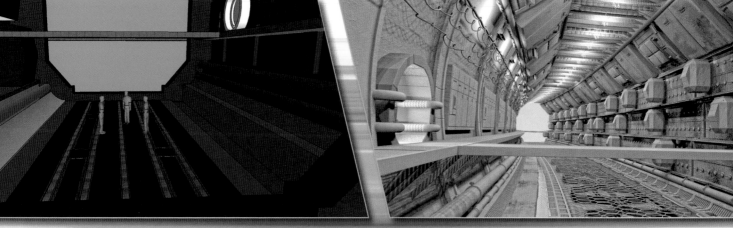

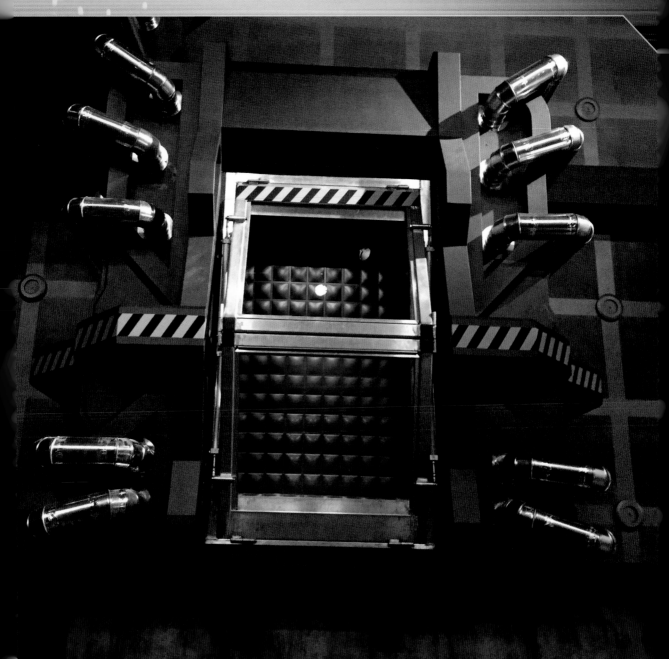

If you have a line that's coming off of you at a ninety-degree angle straight off your back, then you'll fly straight back, but if they make you go any distance, it takes a lot of pressure, so it ends up being a really, really fast ride, with a really hard stop at the end. So it takes a good stunt guy to be able to ride that.

"Normally, you try not to do a very flat pull on the lines, because the guys could get really hurt if you're not careful, but we've had some really good success, so one of my favorite explosions in the show had Cisco running towards the end of the Pipeline, and having it blow up in his face and blow him back to the other end. It's one of my favorite

Above: The view from outside a cell door in the Pipeline.

Opposite: Production

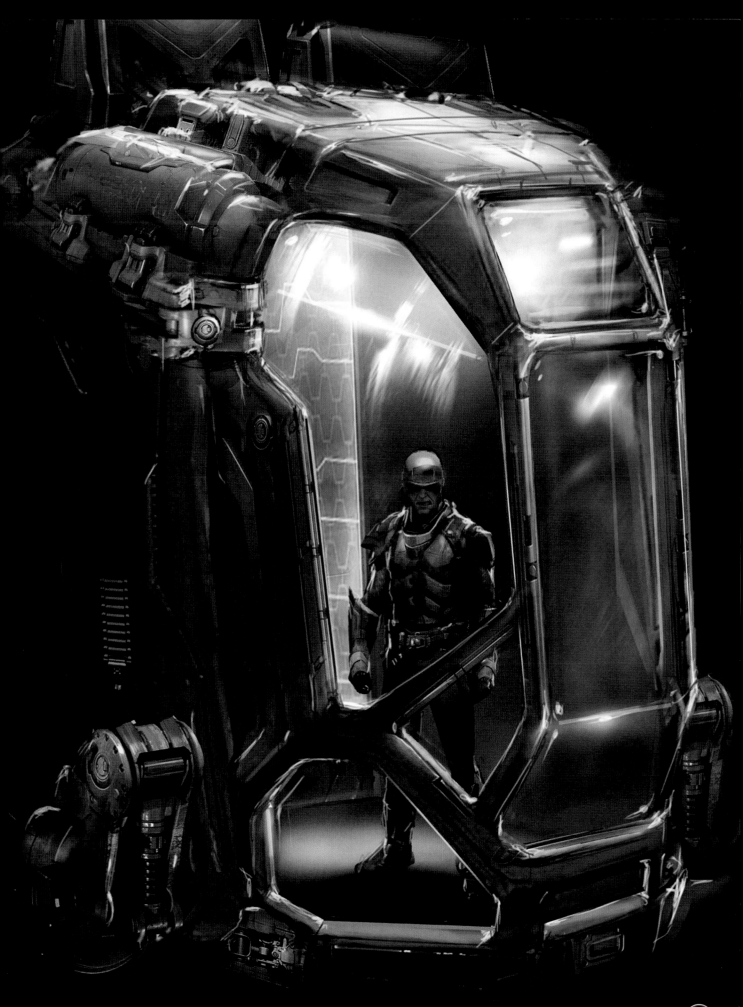

Tyler Harron on the bunker's construction (right and below): "Everyone has a little piece to do with those big builds, be it putting hosing and wiring and cables in, or having special effects go off with a spinning disc, or lights that have to move, or sparks that have to go off. We have the special effects team come in and handle that, as well as our electrics department. It's a big collaborative machine that has to work together."

THE BUNKER

Production designer Tyler Harron says, "The only note in the script was that it was using a magnetic field. So I researched a bunch of electromagnets that are being currently used in the world of physics, and upscaled them to something that was large and foreboding and looked like a serious piece of technology that could stop a speedster."

In making the bunker, "We don't actually use any magnets, but a lot of the super-structure is built out of structural steels and the magnets themselves were EPS Styrofoam, sculpted to the magnet shapes. Scenic paint is put on top of that to give it a metallic feel, and that's achieved through putting base coats in and coats of paint on top and burnishing and polishing." Other departments also participate. "There's the rigging, construction, paint, set decoration, special effects, and the electrical department."

CISCO'S WORKSHOP

Production designer Tyler Harron says Cisco's workshop began as "function over form. Instead of building the Time Sphere in the middle of the Cortex, I suggested we give Cisco a workshop to build it in. [That way] we could also justify how Cisco would [often] come in with new devices. Taking the fundamentals of S.T.A.R. Labs language, I gave him a room that felt mechanical, industrious, but was like his dirty bedroom, where there would be socks underneath things and he had projects going on everywhere."

Actor Carlos Valdes says he feels a sense of ownership over the workshop set. "It was difficult to feel that at first, because the space was introduced in the last episode of Season 1, but yes, more now than ever. That space has a circular structure that allows the energy of the room to generate an intimacy that I feel is necessary at times."

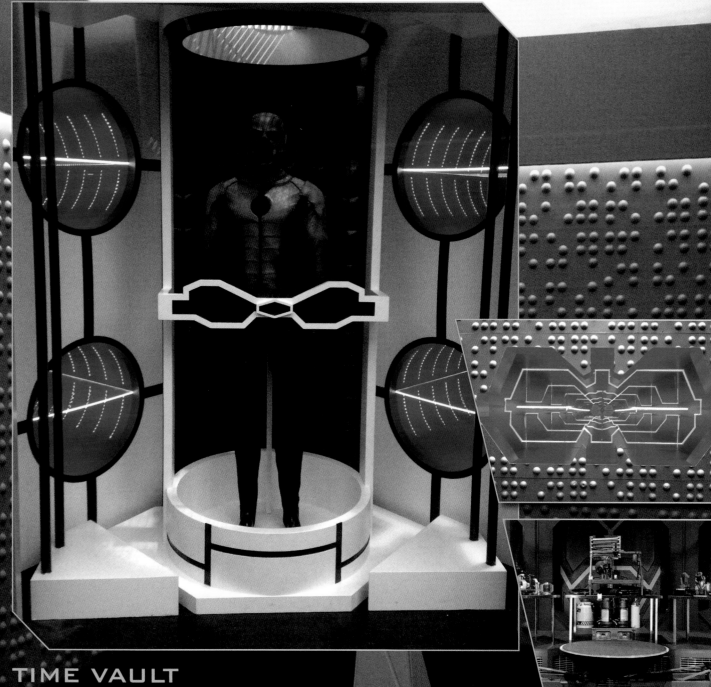

TIME VAULT

Andrew Kreisberg rates the Time Vault as one of the top Flash sets. "It feels very alien and futuristic, but in a very accessible way."

Despite its VFX elements, much of the Time Vault is practical, production designer Tyler Harron explains. "The Time Vault is a curved set with intricate Braille-style panels on it. We do a visual effect to get us in and out of the set, and to expose things like Gideon, which was actually a forced-perspective prop that was twenty-five feet long, although when you looked at it, it only appeared to be about three feet deep.

"Eobard Thawne [who designs the Time Vault within the story was] from the twenty-fifth century. My design philosophy for future technology is that everything's going to get very minimal, even a little more ergonomic than what we see today. Even the tones will be very organic and sculpted, a return away from being utilitarian."

Above left: "We use a visual effect to remove the door that covers the Reverse Flash suit," explains Tyler Harron. "My concept behind that particular portion of the closet was that it needed to look like it was [a futuristic design] outside of our science-fiction that I'd been trying to maintain."

CENTRAL CITY POLICE PRECINCT

The Central City Police Department and its metal mural depicting the seven gods of Truth, Liberty, and Justice – representing DC's Justice League – are two elements Tyler Harron says he's proudest of in his *Flash* production design.

"It started with me wanting to honor the history of the Flash character, who'd been around since the forties, so when I went to approach the design, I wanted to make sure all of our buildings and all of the sets appear to be from that age of architecture. It's a mix between Deco and what I call Federal Deco, which is a movement of post-war America, when a lot of the smaller towns suddenly became cities, because there was a surge of growth. I took a lot of examples out of Buffalo, New York, and St. Louis, Missouri, cities that I find about the size of Central City, and the elements of their building practices, which were inspired by the Deco movement, but then simplified to a large-skyscraper society, or the beginning of what I would call our modern cities."

Vancouver, B.C., where *The Flash* is filmed, Harron notes, "shares a similar history to Central City in the lore – built about the same time, had a similar trajectory of growth – so we were able to find elements of what I was seeking to portray in Central City, a new city meeting an old city, so we have examples of buildings that I draw ideas from. The police set was actually inspired by our City Hall in Vancouver, which is in turn actually our establishing shot for the CCPD. That's actually the real City Hall."

Above: The exterior of the Central City Police Department, actually City Hall in Vancouver, British Columbia, Canada.

Opposite: Production designer Tyler Harron cites the Central City Police Department metal mural as one of his proudest achievements on *The Flash*.

Top and middle: CG basic renditions of the CCPD interior.

Bottom: Blueprint for the CCPD interior.

Opposite: The CCPD office bullpen area.

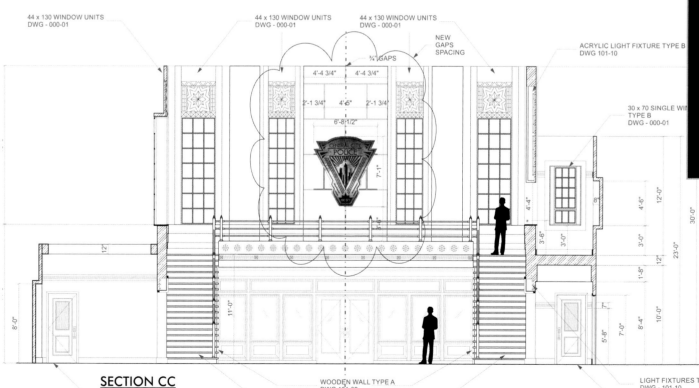

44 x 130 WINDOW UNITS
DWG - 000-01

44 x 130 WINDOW UNITS
DWG - 000-01

44 x 130 WINDOW UNITS
DWG - 000-01

NEW GAPS SPACING

¾" GAPS

ACRYLIC LIGHT FIXTURE TYPE B
DWG 101-10

30 x 70 SINGLE WIN
TYPE B
DWG - 000-01

4'-4 3/4" 4'-4 3/4"

2'-1 3/4" 4'-45" 2'-1 3/4"

6'-8-1/2"

7'-1"

4'-4"

3'-6"

12'-0"

30'-0"

4'-6"

3'-0"

23'-0"

11'-0"

12'

12"

1'-8"

7"

10'-0"

8'-4"

5'-8"

7'-0"

8'-0"

SECTION CC
¼" = 1'-0"

SINGLE DOOR DETAIL
- GLASS PANEL
- 3' x 7
DWG 101-11'

WOODEN WALL TYPE A
DWG 101-08

STAIR & RAILING DETAIL
DWG 101-09

LIGHT FIXTURES TYPE
DWG - 101-10

SINGLE DOOR DETAIL
- GLASS PANEL
- 3' x 7
DWG 101-11'

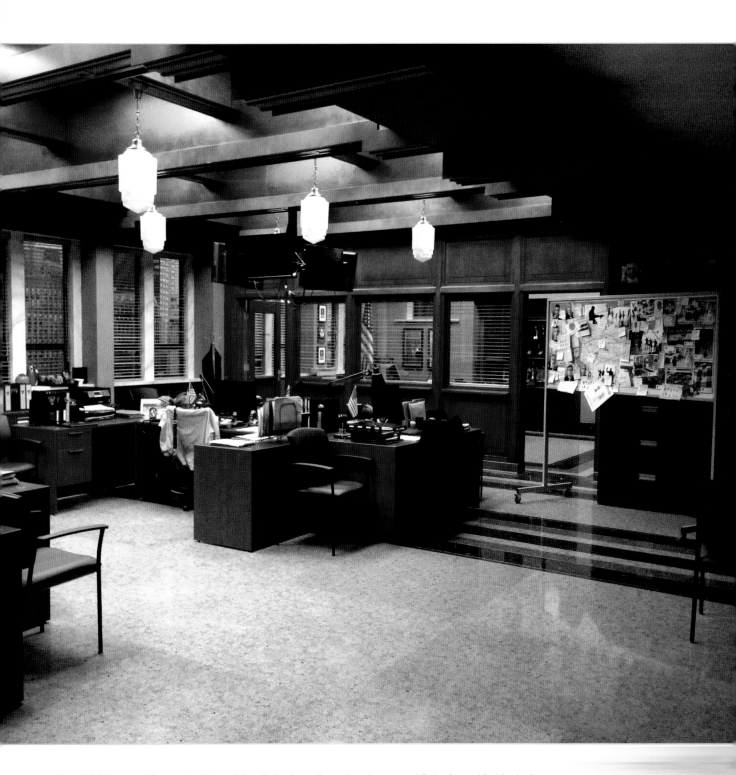

The CCPD mural "was the first thing I designed on the show, and I designed it kind of a little bit for myself, as a fan. I thought it was a great opportunity to bury an Easter egg into a set that was going to play very prominently, and that I was going to be able to put enough scale and scope into that it was going to be a showpiece for the show. I wanted to give that nod to the Justice League, and to the heritage of the building, and to the heritage of DC Comics.

"And then when we went to Earth 2, I had the opportunity to redo the mural for the Justice Society, in which I represented it with eight people, and that was also a nod to the eight founding members of the Justice Society of America."

BARRY'S LAB

We first see Barry's crime tech lab in a scene in Season 2 of *Arrow*, where, says Tyler Harron, "They had given him more of (a sense of) that scattered, troubled scientist who thinks in milliseconds and just puts something over here and he's got something going on over there, but he's really a genius on the inside. Through time, we've actually started to clean it up a little and organize him a bit more. As he's getting more mature, we're maturing his world around him."

When it's raining outside, says Michael Walls, "We have drip lines that are built in above the (lab) windows, so (the water) just goes down."

Barry's murder board, Harron adds, "was an established prop from *Arrow*, and has virtually remained unchanged. It became such a character of its own that any change would have immediately been noticed by the fans." On the board, "I believe there are around ninety separate items."

Top left: Wide view of Barry's lab at the Central City Police Department.

Top right: Barry's murder board, where in Season 1 he tries to piece together clues about the identity of his mother's killer, a project he hides from his colleagues.

BARRY'S APARTMENT

Production designer Tyler Harron on why these blueprints never became full sets: "When we started the prep on Season 1, I was asked to design a loft for Barry. So that (blueprint) was my original concept. And then when we went through the budgeting process and the story-arcing of the beginning part of the series, it was the first set to be put on the back burner, with the idea that we would get to it eventually. Well, about fifteen episodes in, we needed to add an apartment, but it was such a short scene that we decided to build him a small, one-bedroom single residence-type room. And then the question kept coming up, 'Well, where does Barry live?' We resolved that when Joe invited him to live at the house. So we actually never built the apartment."

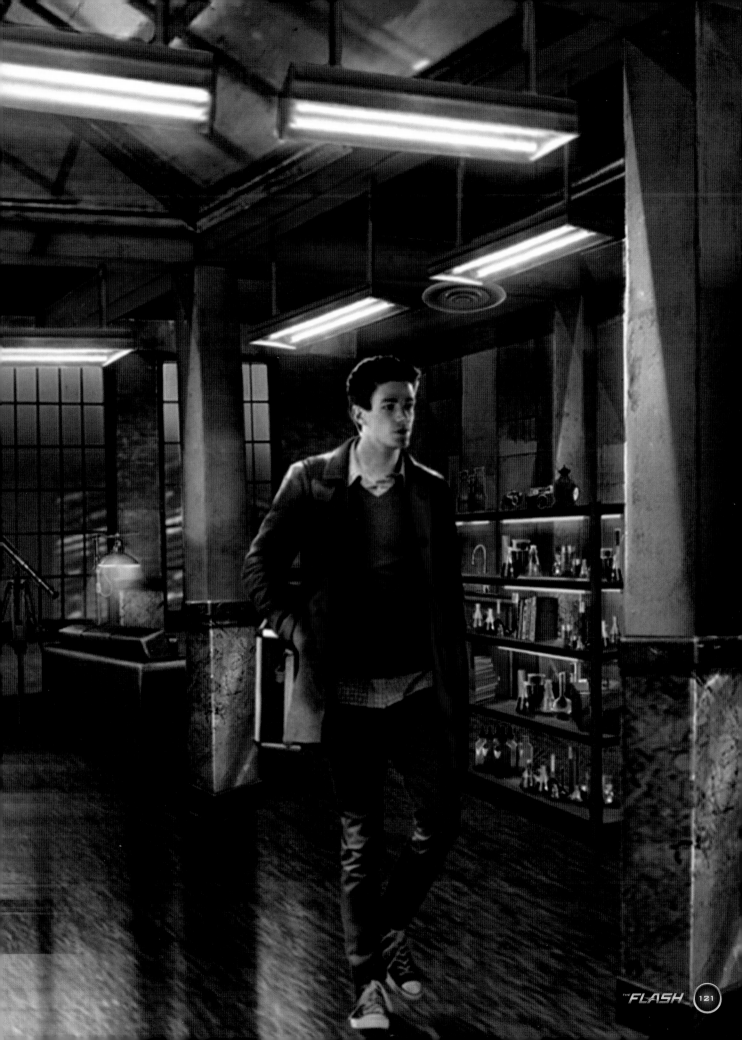

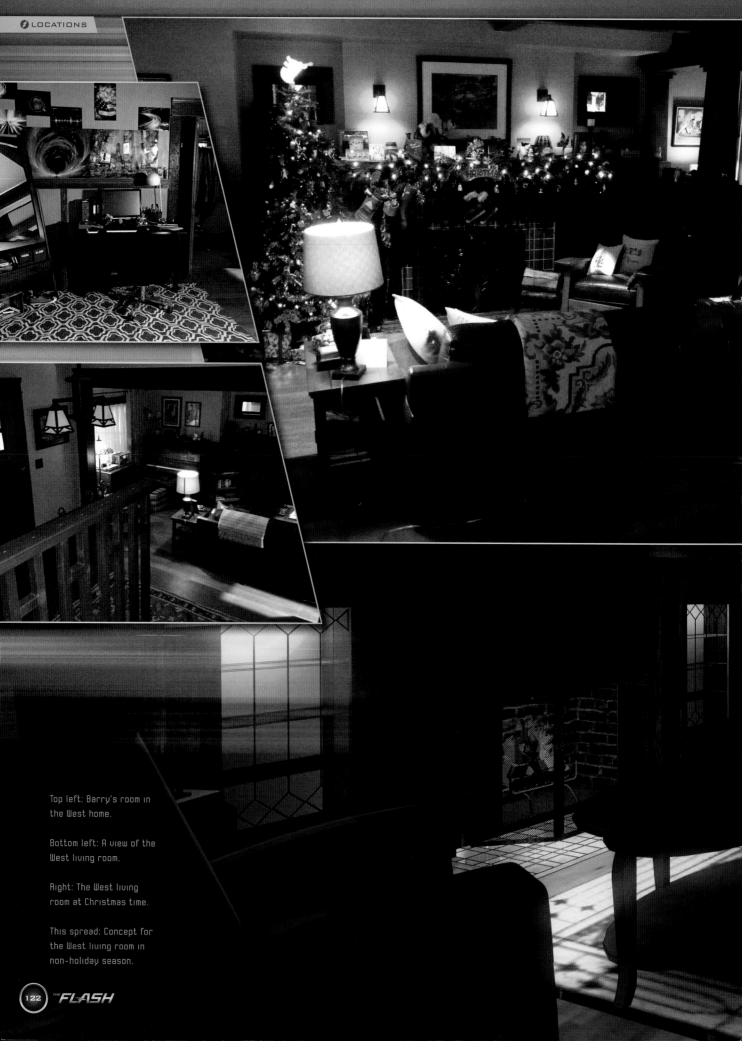

Top left: Barry's room in the West home.

Bottom left: A view of the West living room.

Right: The West living room at Christmas time.

This spread: Concept for the West living room in non-holiday season.

THE WEST FAMILY HOME

The West family home, where Barry and Iris grew up, is a place of warmth, says production designer Tyler Harron. "I wanted it to feel like a hug, I wanted it to feel like every time we went in there, that anything that happened there was always done out of love, and it was always the comfort of home. I didn't want a big, spacious place that just looked like anybody could live there, I wanted it to feel lived-in."

The architectural style is Craftsman, Harron adds. "It's a design that was very common in the [American] Midwest. So was the Allen house; we wanted to believe that they were in the same neighborhood."

Harron wanted the interior to show Iris' influence. "She added the softness to this house that the three of them grew up in together and learned to be a family in."

For Joe's style, Harron sought input from actor Jesse L. Martin. "Jesse and I spoke for about two hours one day, everything from baseball to black civil rights to music. There are a couple of baseballs and a glove that sit on top of the piano, and we did a couple of pictures of the Negro League baseball teams of the thirties in framed pictures around the mantel, elements that he felt portrayed Joe's backstory. It was a great collaborative effort."

CENTRAL CITY PICTURE NEWS

Production designer Tyler Harron says, "Picture News appears on fifty percent of the set to be a 1941 brick five-story structure, but when you turn around, the other [side] is a sleek, modern, backlit, Plexiglas drywall construction. It's a new-meets-old philosophy. I didn't have the real estate to do a large newsroom on the stages that we had. So instead of trying to cheat it, my pitch to Greg and Andrew was that nowadays newsrooms are done a lot from home. A lot of people blog from home, a lot of newspaper writers are out and about. It's no longer the big newspaper skyscrapers. So Picture News might have been at one time a large operating news hub, but they've downsized and the central writing area is now just a small corner of a building that used to be theirs."

As for the red highlights in the décor, "I wanted to give it pops of color. There was a bit of a nod to the Flash, but it was also a color that was starting to come up as a very modern, fresh office color within reality."

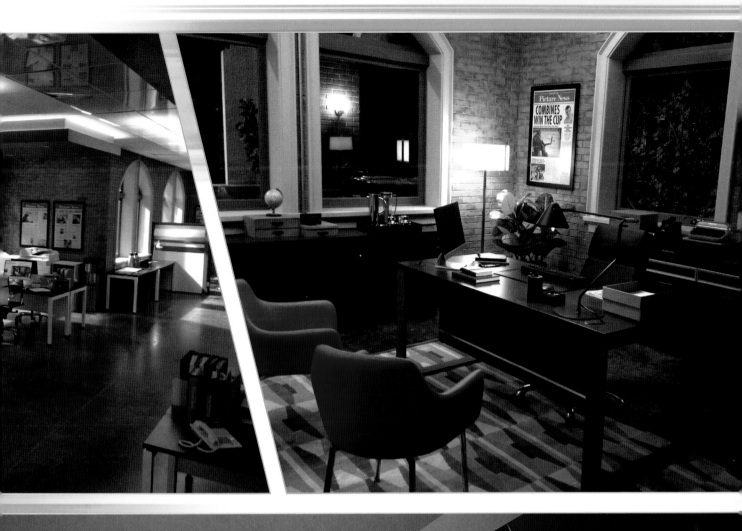

⚡ CC JITTERS COFFEE SHOP

"Jitters was one of my favorite places to design," says production designer Tyler Harron. He was inspired by Vancouver's Marine Building, which at one point was the tallest skyscraper in the city. "I wanted to honor Vancouver's history by using the building. There is a restaurant in that corner unit now that was never designed to have that. My concept was that Jitters is like a franchise, it's like a Starbucks, it has a corporate headquarters that would have taken a space like that and then brought all the modern touches to it. I wanted it to feel like what a real city has, which is a corporate branded coffee shop that people religiously go to."

Overhead lighting for production is usually off-screen, hanging from the soundstage ceiling, but the fifties-style hanging lamps in Jitters are of practical use to the *Flash* cinematographers.

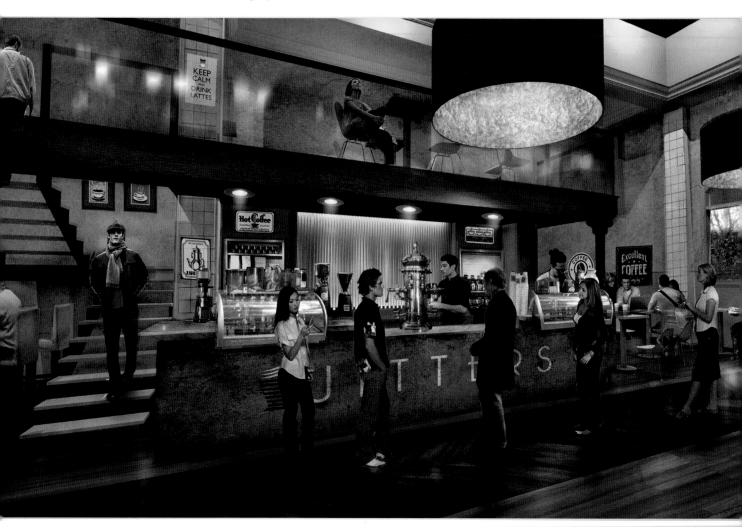

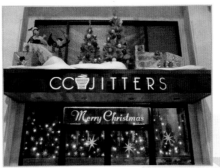

The cappuccino machine really can work, notes practical effects supervisor Michael Walls, "but it's noisy." To make it look like it's working when it isn't, "We plumbed the machine itself with a bunch of smoke tubes, so we can run small amounts of smoke through clear plastic tubing."

Earth 2's Jitterbugs is a redress of the Jitters set, Harron explains. "Instead of the people coming through the front door, I blocked the front door off with the bar. We covered all the windows with treatments of blinds to give it that smoky feeling. We cleared where the original Jitters coffee bar is. I've got that upper mezzanine, (so as) opposed to putting a stage in there, I made a little cave for the musician and the piano. The Jitterbugs sign (was) a really big, tall sign, with bright LED purple lettering, made (to) look like a piano."

Below and opposite: Tyler Harron says the Jitters floor is reflective on purpose. "In Season 1, we went back and added another layer of gloss on top of it, because the directors of photography really liked the initial kick we were getting off the floors, but asked if there could be more. Glossier surfaces reflect the light better, they refract better, there's just an overall real feel to them."

VILLAINS' LAIRS

GRODD'S HIDEOUT

When Grodd ruled the Central City sewers, production designer Tyler Harron says they didn't need a big set, but rather "an area where we could play light and shadow, and hide our gorilla. I came up with this concept [for] a junction in a pump station that connected two portions of the sewer and had a spillway of water coming down from above."

There's real water in there, reveals practical effects supervisor Michael Walls. "We have pumps that are in line behind the set. We built a circulating system for water, and there was a waterfall behind [Grodd's] chair that kept re-circulating the water through."

In Season 2, Grodd has moved to a belfry. Harron says, "We only built twenty feet of it high, but of course we had to add Grodd in the rafters, so, working with my illustrator John Gallagher, I provided the design of the 3D model [created by VFX] for the roof."

Below: The entrance to Grodd's sewer lair.

Opposite: Rainbow Raider's workshop — note the black and white paintings around the room.

RAINBOW RAIDER'S LAIR

The philosophy behind the Rainbow Raider's lair, says production designer Tyler Harron, came from the lore surrounding the character in the DC comics. When Roy G. Bivolo first appeared in the *Flash* Season 1 episode "Flash vs. Arrow," "He was really a character to drive the story forward, as opposed to being a typical villain of the week. In the [DC comic book] mythos, the Rainbow Raider is a colorblind artist. So I wanted to take that one step further and really embrace that mythos, and I wanted to give him the feeling like his place was a home, not dissimilar to [that of] Jackson Pollock or H.R. Giger."

This is why the Rainbow Raider's space is a workshop, filled with disturbing monochromatic artwork. "He is a tortured artist, who, once he gets his superhuman [powers], is drawn to his anger; that is his metahuman status. I really felt it was important to lean on that, to lean on the tortured soul, the tortured artist, so we commissioned those paintings of people and I particularly wanted all of those paintings to be done in black and white, to have a nod to the original concept that he's colorblind. That's why the paintings are done in black and white, and when we see at the very end that they use color to stop him, or to stop Barry from the rage that Bivolo has put into him, I wanted to make sure that we definitely followed the history of the character."

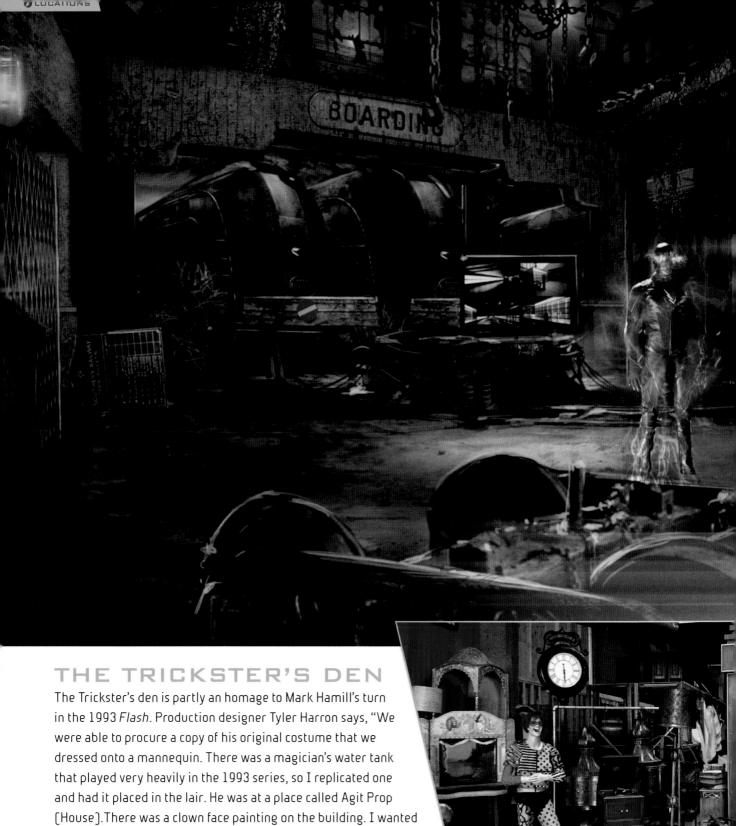

THE TRICKSTER'S DEN

The Trickster's den is partly an homage to Mark Hamill's turn in the 1993 *Flash*. Production designer Tyler Harron says, "We were able to procure a copy of his original costume that we dressed onto a mannequin. There was a magician's water tank that played very heavily in the 1993 series, so I replicated one and had it placed in the lair. He was at a place called Agit Prop [House]. There was a clown face painting on the building. I wanted to twist it and make it a little bit darker, a little more sinister. My illustrator John Gallagher and I reinvented that illustration (see p.81). There was a touch more Mark Hamill in that. Andrew and Greg wanted the Trickster to lean towards the original Trickster that he played. So all those little villain gags he has, we made them a little more over the top than we usually would."

ZOOM'S HIDEOUT

In early DC comics, Super Heroes were often shown racing against trains. "That's an image that's been around since the beginning of DC," relates production designer Tyler Harron, "because at the time, that was one of the fastest modes of transportation. I wanted to highlight trains with these speedsters, so I came up with the concept that Zoom's lair was in an abandoned train work yard, to showcase a steam-liner that was reminiscent of a lot of the Deco illustrations of the twenties, as well as paying homage to the DC Universe in relation to trains. I went from one train to three trains, because it actually felt better in the space, and I wanted a quality right out of a horror movie, lots of dangling chains and heavy equipment to make the place as scary as possible, because Zoom is probably the scariest villain, psychologically, that the Flash has ever faced."

THE HIVE

Production designer Tyler Harron recalls, "Episode director Kevin Tancharoen and I both wanted to give [Brie Larvan] an environment which felt very vacant and very open, but that she had full control over. So we created her hive within an actual greenhouse, forty-seven acres of enclosed space. That [set] was a small portion of the actual greenhouse, but because it was an empty corner, at night, when you struck light against the glass, it gave the optical illusion that the rest of the place was empty."

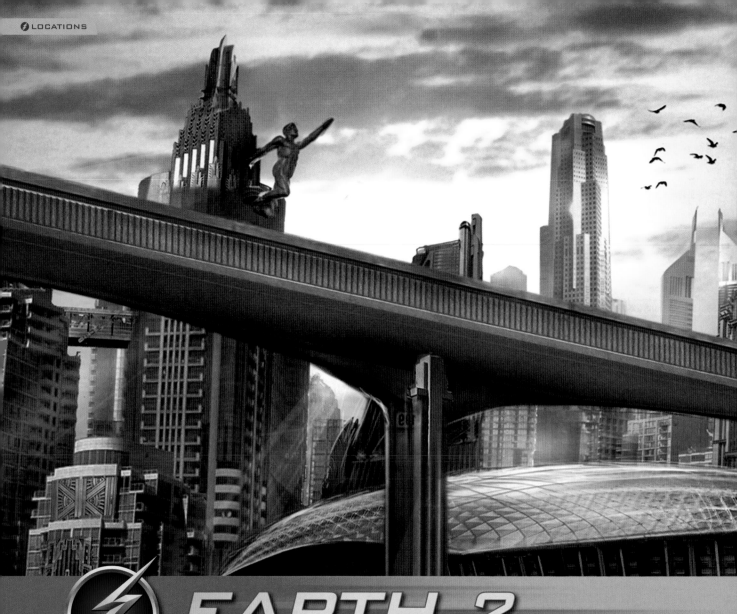

EARTH 2

"I love Earth 2," declares Carlos Valdes, and it's not just because he gets to play the dangerous Reverb there. "Earth 2 has this beautiful balance, I think, because the people on Earth 2 have figured out how to use technology and honor the humanism of their past, and balance that expertly. I also love the way Earth 2 looks."

Production designer Tyler Harron says that his design for Earth 2 was partly inspired by dialogue referring to that world's War of the Americas. "Obviously, an event that had happened to cause a War of the Americas might have been an internal struggle within the country itself. We have design nods to some of the World War II regimes through Europe, where there were a lot of hard lines and a lot of symbolism. I wouldn't call it fascist design, but I would say that it had a very almost Russian post-war presence, [so] there might be something a little bit different with how Earth 2 operates…. Everything [on Earth 2] was so idyllic that maybe there was something a little more sinister going on behind the scenes of the geopolitical landscape. So the Police Department crest became very hard-lined, very angular, very questionable – is this a military state that they live under? Is this why the people of Earth 2 are slightly more in that idyllic Deco world?"

Above and opposite: Production art of an establishing shot of Earth 2, featuring its monorail transportation.

Opposite: Production art of the exterior of Earth 2 S.T.A.R. Labs and the interior of Earth 2 S.T.A.R. Labs entrance lobby.

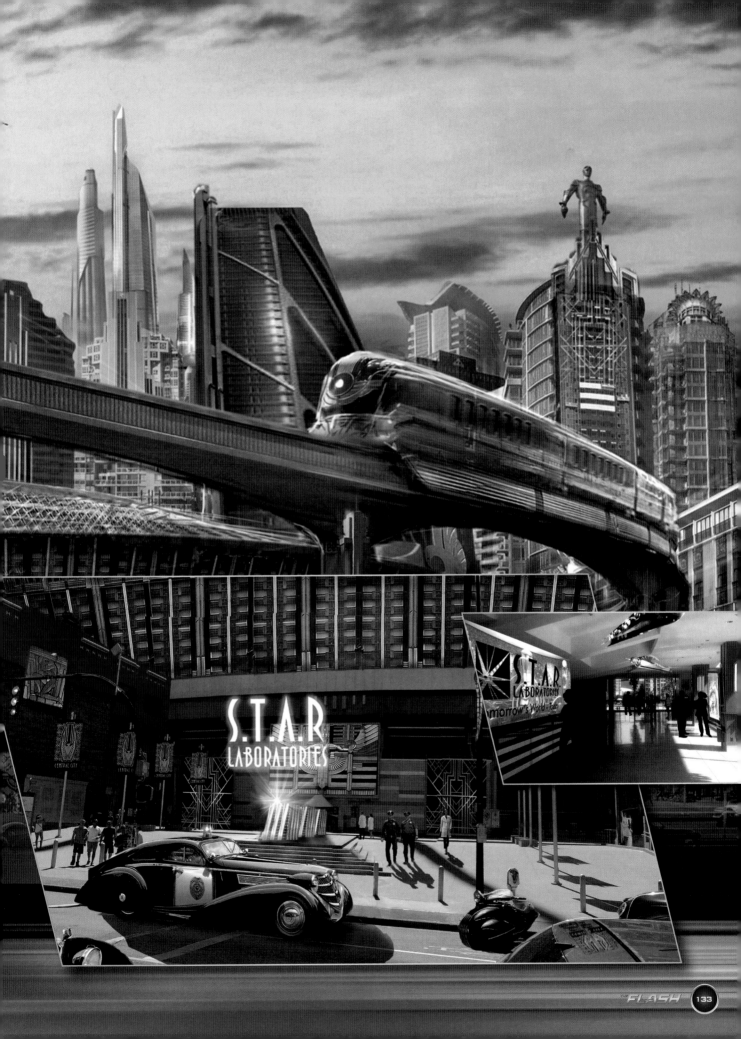

S.T.A.R
LABORATORIES

S.T.A.R
LABORATORIES
Tomorrow's World • Today

Below: Candice Patton as Earth 2 Iris West.

Right: Patrick Sabongui as Earth 2 David Singh; Darla Taylor in her role as an Earth 2 tour guide.

Opposite: The mask that Zoom forces his captive, Earth 3 Flash (John Wesley Shipp) to wear.

Harron made some alterations to the Central City Police Department set. "I took all the gold out and replaced it with silver, just to give a contrast in color there."

Kate Main says her costumes for Earth 2 "always draw from the forties. I'll draw from fifties through sixties as well. The main thing for me is the desaturated colors, because we treat all of that with a sepia feel to it, and it's really about line, structure, geometry. I think it's Art Deco, you use elements of Nouveau – it's highly stylized. So whenever I send my shoppers out, or when I'm working with [assistant] Druh [Ireland] and we're building [costumes], we want to make sure we have really strong tailoring, and it should almost be graphic. It feels like if you could draw it then it's good."

Hair designer Sarah Koppes notes, "What we've discovered is there's really no forties. In hairstyling, anyway, most of the time periods go from 1945 to 1955, it's in a ten-year, but at the five, not at the forty to fifty. Earth 2 is so much fun, especially for the women, with Kate pulling out all these amazing hats, and costumes, and Tina putting on some fantastic makeup, but with a little bit of forties futuristic feel to them. Even with our Earth 2 metas, we try to do more like a fantasy forties in there, if we can, like with Killer Frost."

Then there are the metahumans Zoom brings to Earth 1 from Earth 2. "For those guys," Koppes relates, it depends "on what they're wearing – we had fifty metahumans that Zoom was talking to, and I threw a bunch of wigs on them. We had a purple wig and a pink wig and a white wig, and I had a long silver wig, some of them had crazy hair, some of them had forties hair, some of them were in masks, some of them were in hoods. We just tried to have some fun, some fantasy hair, and just some interesting looks, with whatever we could get."

"Our producers really wanted that Art Deco feel," agrees Armen Kevorkian. "Earth 2 looks like an Earth where Art Deco got to continue for another fifty years. And that was the direction I think all our departments got – costumes,

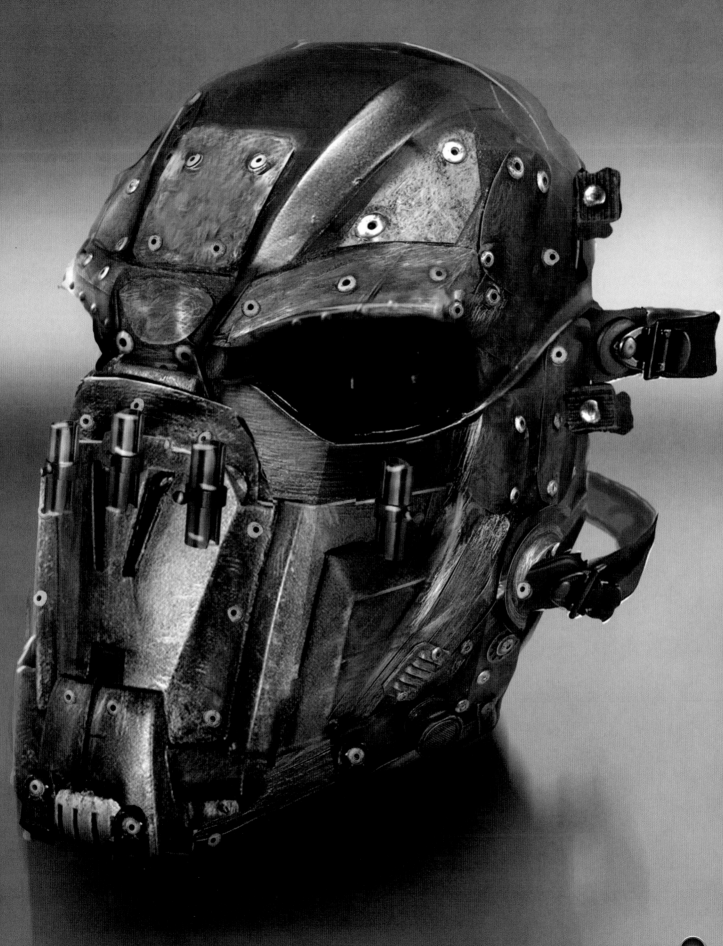

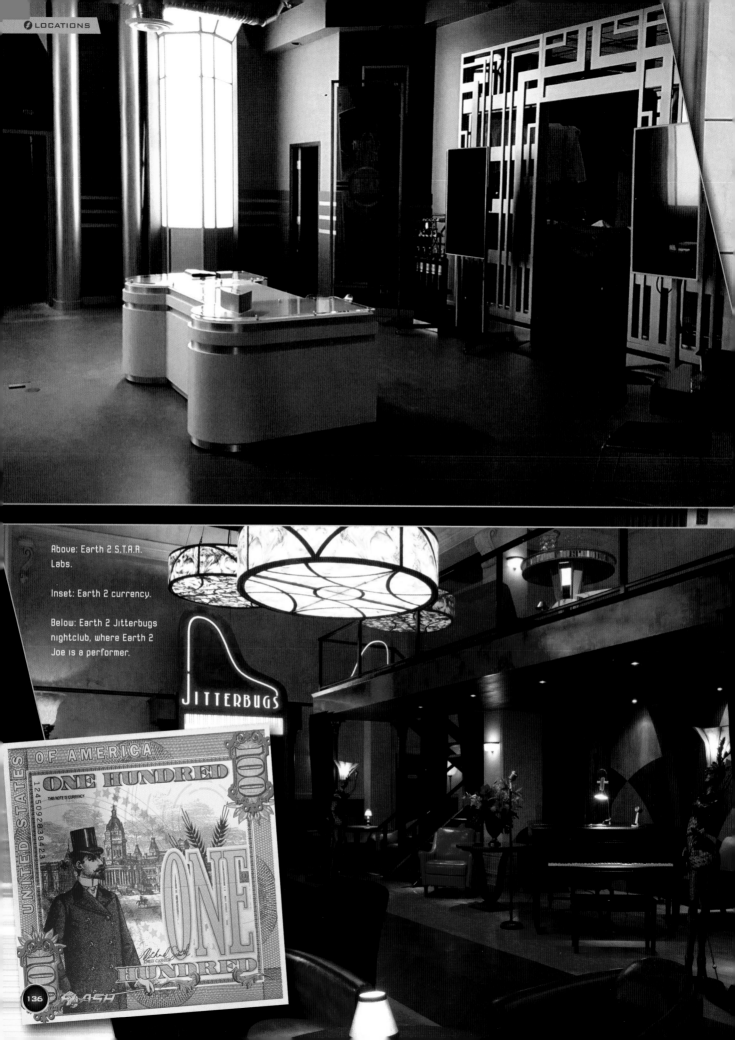

Above: Earth 2 S.T.A.R. Labs.

Inset: Earth 2 currency.

Below: Earth 2 Jitterbugs nightclub, where Earth 2 Joe is a performer.

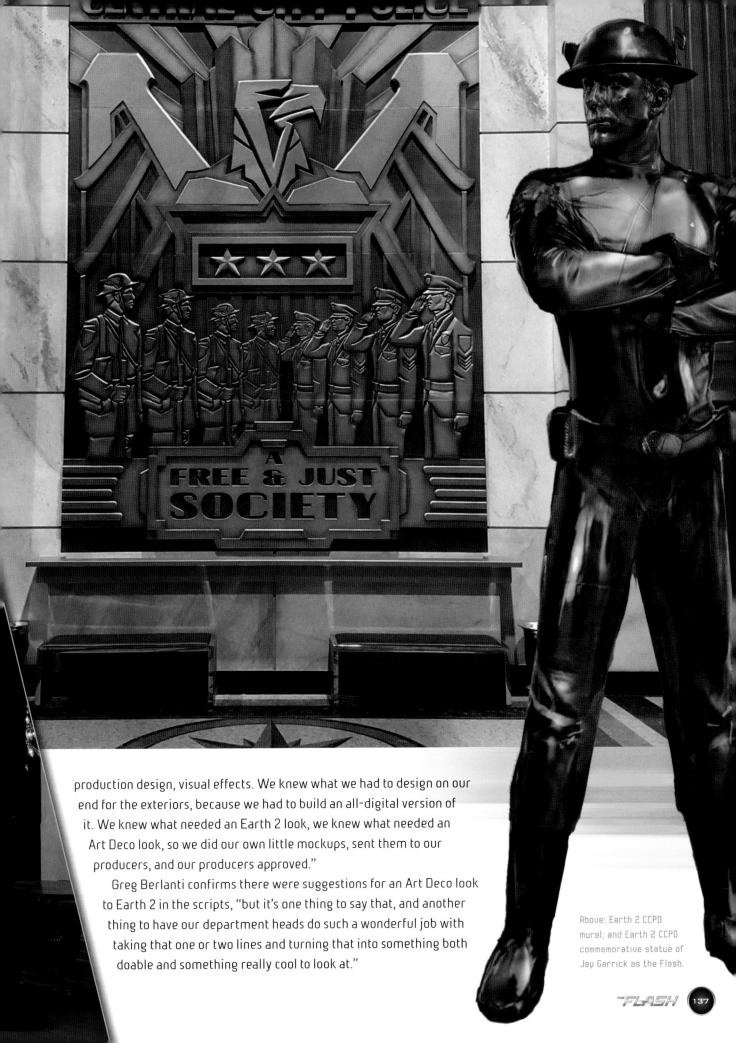

production design, visual effects. We knew what we had to design on our end for the exteriors, because we had to build an all-digital version of it. We knew what needed an Earth 2 look, we knew what needed an Art Deco look, so we did our own little mockups, sent them to our producers, and our producers approved."

Greg Berlanti confirms there were suggestions for an Art Deco look to Earth 2 in the scripts, "but it's one thing to say that, and another thing to have our department heads do such a wonderful job with taking that one or two lines and turning that into something both doable and something really cool to look at."

Above: Earth 2 CCPD mural; and Earth 2 CCPD commemorative statue of Jay Garrick as the Flash.

THE BREACH

The Breach Room set is eighty by sixty by thirty feet tall. However, there isn't that much room to create the illusion that a character is disappearing into the breach, says stunt coordinator JJ Makaro. "You'd have to pull somebody up into this really tight confine, and turn them, and then they'd have to be stopped in the middle of it, so that you could [digitally] erase them easier."

Of course, the breach itself is a CGI effect. VFX supervisor Armen Kevorkian explains, "When there are live-action plates that we're going to add CG components to, our data wranglers do HDRI spherical, which is like 360[-degree] photography that you take of a set. It takes pictures of the existing lighting conditions, and gives us reflections of the set, so when we're adding a CG element, we know exactly where all the lights were in the real world, and we'll add those lights in our CG world when we light our character."

WEAPONS, GADGETS AND VEHICLES

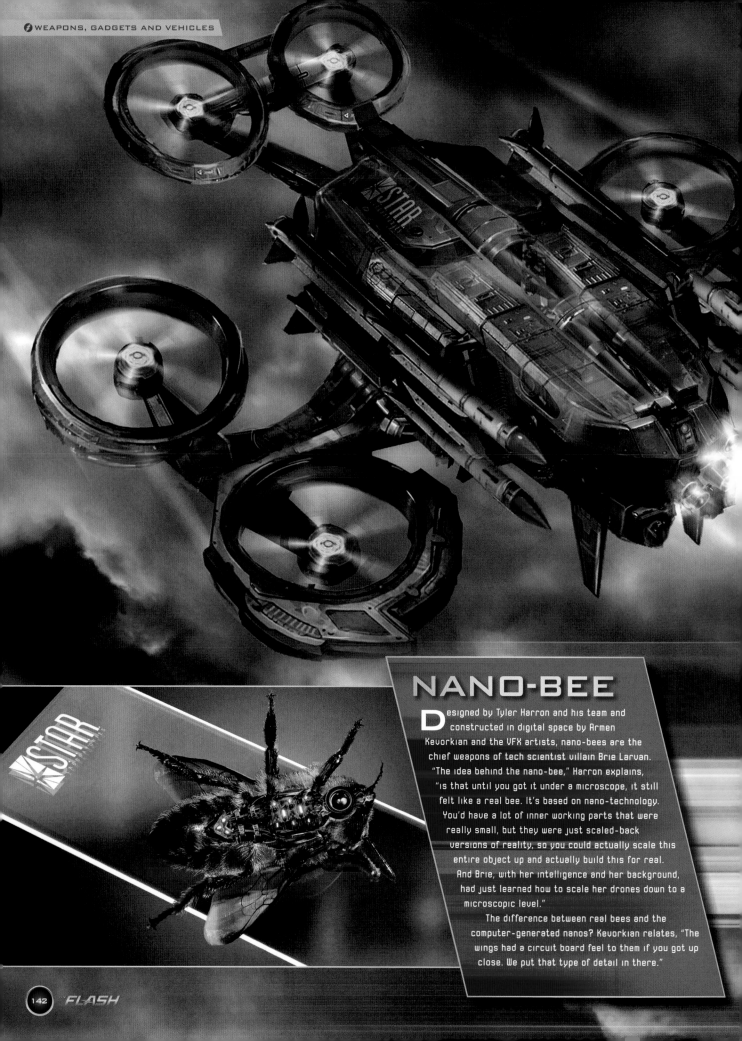

NANO-BEE

Designed by Tyler Harron and his team and constructed in digital space by Armen Kevorkian and the VFX artists, nano-bees are the chief weapons of tech scientist villain Brie Larvan. "The idea behind the nano-bee," Harron explains, "is that until you got it under a microscope, it still felt like a real bee. It's based on nano-technology. You'd have a lot of inner working parts that were really small, but they were just scaled-back versions of reality, so you could actually scale this entire object up and actually build this for real. And Brie, with her intelligence and her background, had just learned how to scale her drones down to a microscopic level."

The difference between real bees and the computer-generated nanos? Kevorkian relates, "The wings had a circuit board feel to them if you got up close. We put that type of detail in there."

TRAINING DRONE

The S.T.A.R. Labs team uses a drone, armed with tiny missiles, to chase Barry during speed-running practice. Despite its 3D appearance, Armen Kevorkian says, "The drone was CG, and so are the missiles [that it shoots]. There are some shots where the Flash was all CG, too, especially when he grabs and throws the missile."

The drone's design, Tyler Harron relates, was the result of collaboration "between myself and John Gallagher, the illustrator, who had done a bunch of drone designs before. He took a lot of fundamentals he had learned in that to play with, and from that, we came into the idea that it was very military, very predator-like. [The] first time we ever see it, before we explain what it is, it's chasing Grant down a runway. [We're planning] a reveal to the audience later that he's not actually in jeopardy; in fact, this is a training exercise. We wanted to give it a very aggressive, military look, so that once we first see it, we're kind of thrown off as the viewer, we believe that Barry's in trouble."

One portion of the drone does exist as a practical prop, Harron continues. "The first time we saw it, we only had the propeller blades made that we see Cisco pick up after it's been destroyed. Later [for the Season 2 episode "Running to Stand Still"], we had to build a full-sized one, because we needed people to be interacting with it in order for them to hook up the device to re-direct all the Trickster's bombs through a breach. So now we actually have a physically built one, but it doesn't do anything but work as a static prop."

COLD GUN

Tyler Harron says in developing Captain Cold's gun, "We looked at a lot of prototype laser references, [and] prototype absolute zero experiments. I wanted it to feel like a prototype that was made out of some titanium body, but with time, the metal was slowly degrading from the use of the absolute cold zero."

The design accommodates both double- and single-handed grips, so that actor Wentworth Miller could "pose himself with it in a variety of ways."

Harron notes, "We wanted to have nozzles that injected these [elements], one being the compound that was being turned to absolute zero, which was then meeting an electrical force, bringing its temperature down even slower. Another one, which was more like a jet port, pushes the final product out and away from the gun. We wanted to make it feel like there were different areas that had to be accessed, different chambers that either held propellant or compound or the electrical field generator. So every piece has a reason to be there."

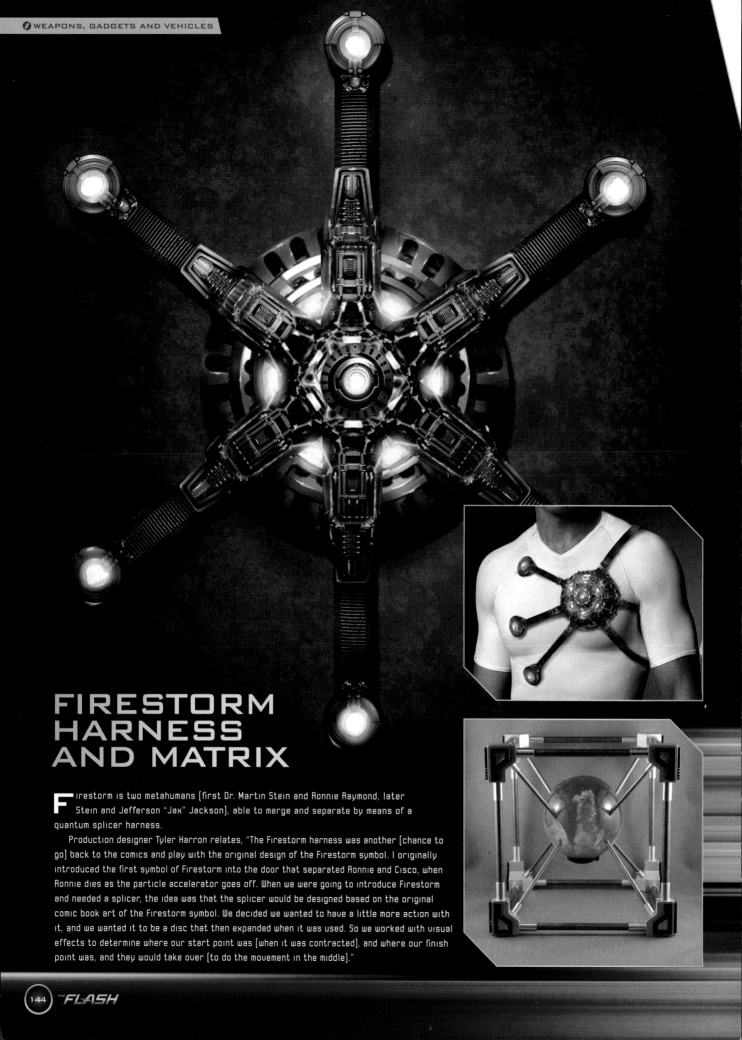

FIRESTORM HARNESS AND MATRIX

Firestorm is two metahumans (first Dr. Martin Stein and Ronnie Raymond, later Stein and Jefferson "Jax" Jackson), able to merge and separate by means of a quantum splicer harness.

Production designer Tyler Harron relates, "The Firestorm harness was another [chance to go] back to the comics and play with the original design of the Firestorm symbol. I originally introduced the first symbol of Firestorm into the door that separated Ronnie and Cisco, when Ronnie dies as the particle accelerator goes off. When we were going to introduce Firestorm and needed a splicer, the idea was that the splicer would be designed based on the original comic book art of the Firestorm symbol. We decided we wanted to have a little more action with it, and we wanted it to be a disc that then expanded when it was used. So we worked with visual effects to determine where our start point was [when it was contracted], and where our finish point was, and they would take over [to do the movement in the middle]."

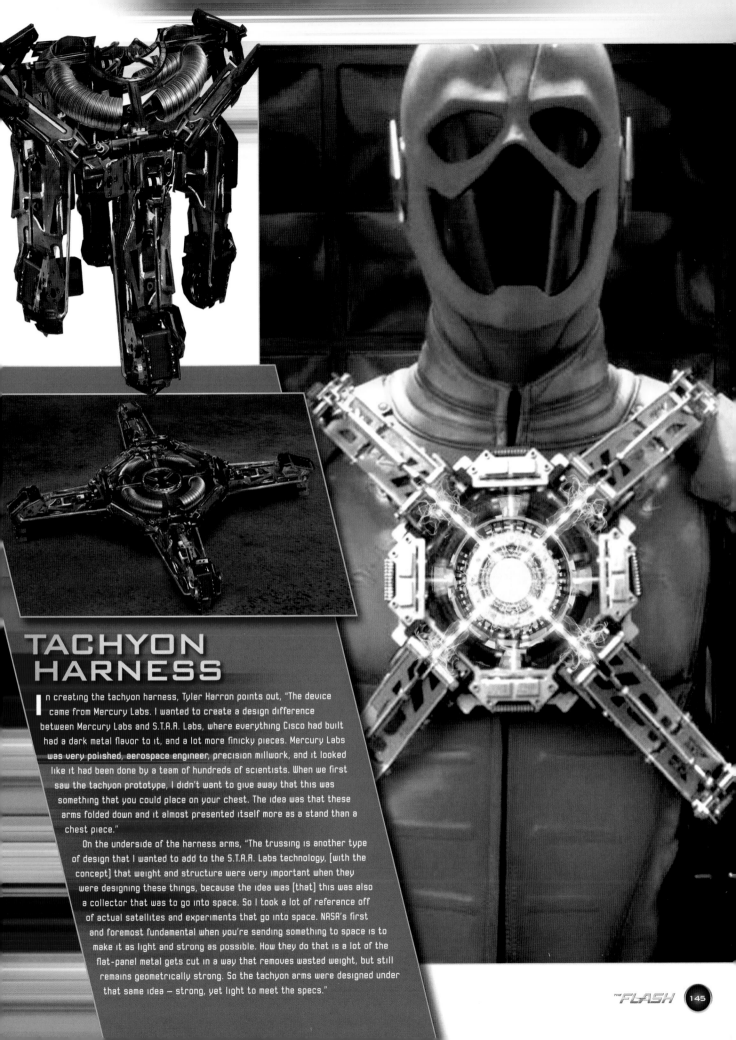

TACHYON HARNESS

In creating the tachyon harness, Tyler Harron points out, "The device came from Mercury Labs. I wanted to create a design difference between Mercury Labs and S.T.A.R. Labs, where everything Cisco had built had a dark metal flavor to it, and a lot more finicky pieces. Mercury Labs was very polished, aerospace engineer, precision millwork, and it looked like it had been done by a team of hundreds of scientists. When we first saw the tachyon prototype, I didn't want to give away that this was something that you could place on your chest. The idea was that these arms folded down and it almost presented itself more as a stand than a chest piece."

On the underside of the harness arms, "The trussing is another type of design that I wanted to add to the S.T.A.R. Labs technology, [with the concept] that weight and structure were very important when they were designing these things, because the idea was [that] this was also a collector that was to go into space. So I took a lot of reference off of actual satellites and experiments that go into space. NASA's first and foremost fundamental when you're sending something to space is to make it as light and strong as possible. How they do that is a lot of the flat-panel metal gets cut in a way that removes wasted weight, but still remains geometrically strong. So the tachyon arms were designed under that same idea — strong, yet light to meet the specs."

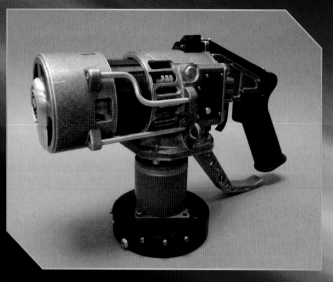

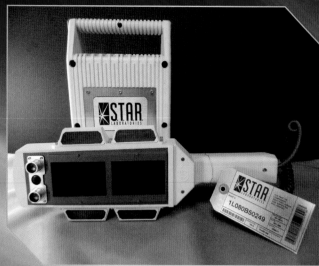

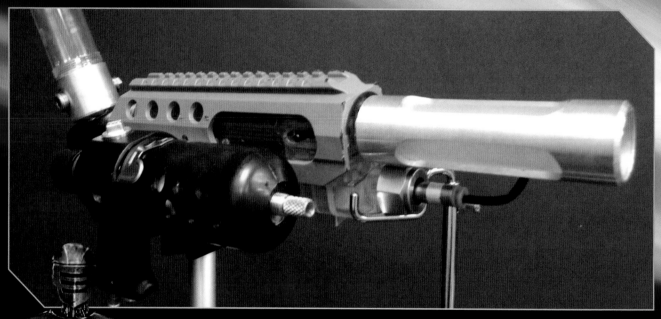

CISCO'S WEAPONS

Cisco develops a lot of weapons at S.T.A.R. Labs, but actor Carlos Valdes says his favorite piece of "Cisco tech" may be a fake-out. "The gun that was actually a vacuum cleaner that was used to stop Captain Cold, that was used as a bluff, basically. It's legitimately made from a vacuum cleaner, if you look at the detail on the gun. The props department made a gun from a vacuum cleaner, and it lights up and everything, and it's so heavy."

Another favorite Valdes prop is what Cisco uses within the episodes to *make* weapons – a practical soldering iron. Valdes explains, "The props department has this solution that they apply to whatever it is I'm supposed to be soldering, and the soldering iron is heated. So I just apply the tip of the soldering iron to the solution, and the solution dissolves, and when it dissolves it sizzles, and it creates this beautiful visual effect that's very close, if not identical, to the effect of soldering. And I feel like a little kid every time I use it," he laughs, "because I'm so mystified by something so elementary."

Valdes adds with a grin that it's fortunate that he's not really being called upon to make anything that requires real-life functionality. "I have zero aim with my soldering."

Tyler Harron advises viewers to inspect Cisco's workshop, which is "a great opportunity to bury a lot of Easter eggs with props [Cisco] has built, and just say, 'Well, this is where he stores them.' One of the fixtures of Cisco's lab is the metal girder dummy that he built [to train the Flash to fight Girder], and he stands guard by the front door. In the back, the wall panels that are raised and lowered are actual Easter eggs toward Cisco becoming Vibe. They are designed after the suit that he wears in the comics."

GARRICK'S HELMET

"Jay Garrick's helmet has been drawn a thousand times in comic books," Tyler Harron acknowledges. "But when we had his helmet coming through the Singularity, it was the first time that I had an opportunity to [imagine] what could potentially be a Deco or a Golden Age world. So the redesign of the helmet was really a redesign of the wings, just making them very streamlined, very 1920s, like they could have come off the hood of a Rolls-Royce or a zephyr from that era."

Sarah Koppes allows that there was also helmet hair, and not much that could be done about it. "They initially built it like a World War II helmet, so it was essentially a bucket. They wanted Jay to fight with his helmet on, but it couldn't stay on his head, because they didn't build a chin strap on it. The props department put something inside it so it actually sat on his head, but every time he took a hit, the helmet moved. So they ended up putting a strap on it that they CGI-ed out."

TIME SPHERE

Tyler Harron says of the Time Sphere, "The design in some ways is quite intriguing, because it has comic book roots, but we wanted to avoid [it looking too *Jetson*-like] I applied the design language that we've developed for S.T.A.R. Labs, as if it did come out of Cisco's workshop. Oftentimes, I'll get a sketch of something that the writers have in their minds, and then it's about taking the design language of the show and applying it to both being physically able to do it, and being able to pass it on to visual effects to enhance or extend it.

"The Time Sphere has a closed position and an open position. Visual effects will provide the [movement] in between. It is a physical prop that a person can sit in with the glass all around them. We have some wire work where we can raise it off the ground. Then when it gets into its full functionality, that's when visual effects takes over, and they have a 3D version of it that they can manipulate."

Michael Walls recalls, "We had nine days to build that from scratch. We had to make it so the acrylic front and back were removable because we wanted to be able to shoot from either side, so we built a skeleton frame that held the top on, and to make it light from the top."

ANTI-GRODD HEADGEAR

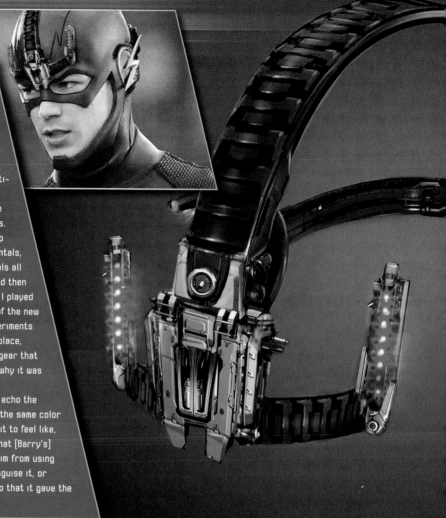

When one is dealing with a super-intelligent, mind-controlling meta-gorilla like Grodd, it's a good idea to have anti-Grodd headwear.

Production designer Tyler Harron relates, "The anti-Grodd headwear was based on a version of the Flash from a videogame series, *Injustice*. In that game, the Flash has a variety of different suits that he wears. I wanted to pay a nod to those artists who came up with that design and to take some of the fundamentals, the way that it went around the Flash, the symbols all around the ear to give it more of a tech feel, and then to also come around to the front. That's where I played with some more of the designs that came out of the new headwear that Grodd wears." Because of experiments on Grodd to make him telepathic in the first place, "S.T.A.R. Labs originally developed this headgear that Grodd would wear at one point, and this is why it was counteracting his telepathic abilities."

The colors of the device intentionally echo the Flash's suit, Harron adds. "It was within the same color palette of his cowl, because we wanted it to feel like, at first glance, Grodd may not notice that [Barry's] wearing this device that is stopping him from using his powers on the Flash. It was to disguise it, or camouflage it as much as possible, so that it gave the Flash the upper hand in the fight."

VIBE VISOR & REVERB GLASSES

Carlos Valdes says, "One of the things I love about this show is that the writers and the team allow room for things to evolve, because everything changes in life, so it's fitting that the tech that Cisco makes should get consistent upgrades. I can't see a damn thing in the goggles, which is hilarious, because there have been various instances so far where I've really needed to depend on a good field of vision to be able to execute a move in the take. There are a couple of slits that I can see through, but other than that, I can't really see much. I love when the goggles light up. When the goggles access Reverb's brainwaves, that's what triggers the lights. There are these little toggles in the back of the arms of the goggles that I press as soon as I put them on, to turn on the lights."

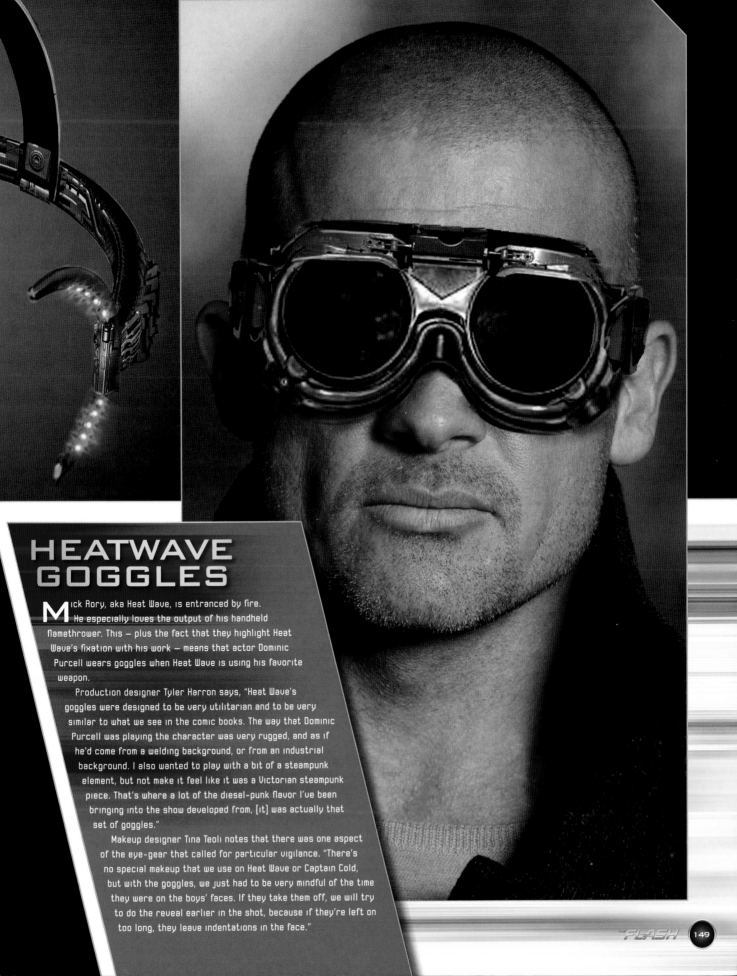

HEATWAVE GOGGLES

Mick Rory, aka Heat Wave, is entranced by fire. He especially loves the output of his handheld flamethrower. This – plus the fact that they highlight Heat Wave's fixation with his work – means that actor Dominic Purcell wears goggles when Heat Wave is using his favorite weapon.

Production designer Tyler Harron says, "Heat Wave's goggles were designed to be very utilitarian and to be very similar to what we see in the comic books. The way that Dominic Purcell was playing the character was very rugged, and as if he'd come from a welding background, or from an industrial background. I also wanted to play with a bit of a steampunk element, but not make it feel like it was a Victorian steampunk piece. That's where a lot of the diesel-punk flavor I've been bringing into the show developed from, [it] was actually that set of goggles."

Makeup designer Tina Teoli notes that there was one aspect of the eye-gear that called for particular vigilance. "There's no special makeup that we use on Heat Wave or Captain Cold, but with the goggles, we just had to be very mindful of the time they were on the boys' faces. If they take them off, we will try to do the reveal earlier in the shot, because if they're left on too long, they leave indentations in the face."

WEATHER WAND

Although there are actually two Weather Wizards on *The Flash* — Mark Mardon and Clyde Mardon — only Mark gets to wield the Weather Wand. This isn't because Mark is the older brother (although he is), but because S.T.A.R. Labs hadn't invented the Weather Wand while Clyde was still alive.

Both brothers were fleeing from the police in a two-passenger airplane when the particle accelerator exploded, giving both the power of atmokinesis, the ability to telepathically manipulate the weather. Clyde died, but battling him gave Barry and co. ideas on what they needed in terms of preventative equipment when Mark came back for revenge.

Tyler Harron says, "The Weather Wand came from inspiration from the source material, and this was created to actually not be used as a weapon, but to defeat Mark Mardon, although he later figures out a way to use it for his own purposes. [In reality], it's made out of aluminum. As opposed to the comic book, I took to using the scientific technology of weather instruments. The four claws are actually found in a lot of meteorological equipment for wind detection, and they'll often have sensors at the end of those, so they can accurately say exactly what direction wind is coming from. I wanted to make sure we added real stuff that meteorologists use to defeat the Weather Wizard."

The element in the center of the Weather Wand lights up practically rather than via CG, Harron adds. "It's an LED light."

The storms created by both Weather Wizards are VFX. Armen Kevorkian relates, "Lighting, stormy rolling clouds, and tidal waves are all simulations which get rendered out with proper shaders. Then the compositing department integrates them into live-action plates or all-CG environments."

GOLD GUN

Cisco Ramon's Gold Gun provided Lisa Snart with a weapon that suited both her needs and her *nom de crime* as the Golden Glider, it illustrated Cisco's fondness for the lady in question, and, notes production designer Tyler Harron, "It finally explained how Cisco develops weaponry or any tech very quickly by 3D-printing it. We actually show him printing the gun, when [Cisco and his brother] Dante are guests of the Rogues. One of the reasons why they kidnapped Cisco was [so he could] remake both [Captain Cold's] gun and Heat Wave's gun, because [the weapons] had been taken away when they went to prison. So now, when Lisa Snart, joining Heat Wave and Captain Cold in their criminal ways, asks Cisco to make her one as well, Cisco does just that. "The design was just a sleeker version, a feminine version, of those two guns that we had already introduced. The idea was that it was a much more feminine design, but still had a gun quality to it. The ridges in the back light up to indicate when she's actually firing it. In terms of the shape of it, Cisco kind of had a crush on her, so he actually spent a little bit more time making it ergonomic and making it less utilitarian, like the other ones had been."

Actor Carlos Valdes thinks that Cisco's feelings about Lisa Snart likely colored his sentiments about the weapon that he created for her. "I think he would pick that as his favorite [invention], just because, knowing his romantic relationship with Lisa Snart, he probably put a lot of thought and a lot of love into that gun."

EARTH 2 COP CAR

Per Tyler Harron, "The Earth 2 police car was a side project of mine [as soon as] I heard we were going to Earth 2. We had an extra Mustang that was used in the pilot for Clyde Mardon's getaway car. I came up with the concept of stripping it down and replacing the entire end with scoopy curves and pieces, to say that, yes, the modern car had developed [on Earth 2], but there were elements that were still Deco. Myself and the picture car wrangler Richard McKay rebuilt the car, because the most easily recognizable thing to an audience member is a police car. The other thing that I wanted to make sure distinguished this car from any other police car we'd seen was that I kept the identifications and the logos very simple, very 1930s L.A.P.D. design. We did a custom-made push bar that is typical of a modern-day police car, and then we also have the single red cherry on top of the car in a silver cowl."

EARTH 2 GADGETS

Production designer Tyler Harron explains why everything on Earth 2 has a feel of the forties and fifties, including a plasma gun that looks like what our own world's science-fiction writers of that era imagined a super-rifle might look like. "It's a line that we were given early in the second season, where Jay Garrick was explaining that his helmet was his father's from the War of the Americas. Talking with the writers further, I determined that World War II had never happened. Obviously, nothing in Europe happened. An event happened that caused the U.S. to get into a civil war of sorts. My history was that Deco died in our world because of World War II. Suddenly everything went from this beautiful, ornate design world to an industrialized military machine. So it stopped everything from having that filigree and having that design element; it became very utilitarian. My thought behind Earth 2 was that since that war never happened, that design field was never changed, or it was never interrupted. That allowed me to explore where Deco would have gone had it kept going for another seventy years, and how it would have evolved into a modern technology.

"I played with the computer monitors. All the monitors on Earth 2 are in vertical position. I decided that it was probably better to play with shapes and colors than it was just to change formats, or just change the color."

VFX supervisor Armen Kevorkian elaborates, "We knew that there was a train that we had to design that had an Earth 2 look, we knew that S.T.A.R. Labs needed an Earth 2 look, we knew that the buildings needed an Art Deco look." The VFX department proceeded to do computer mock-ups of everything from skylines to gadgets, in some cases because the real thing didn't exist anywhere, and in others because the physical props needed the assist of something like a plasma blast.

As for Earth 2's square currency, Harron relates with a laugh, "That was a note from the writers that the money was red, as opposed to green, and I said, 'That money works to tell the story, but perhaps we want to do a different shape, because it could just be considered Canadian money.' Our [Canadian] fifty-dollar bill is actually that same color."

Art director Simone Gore spent days creating authentic-looking currency; the image of the gentleman in the top hat on the bill is her great-great-grandfather.

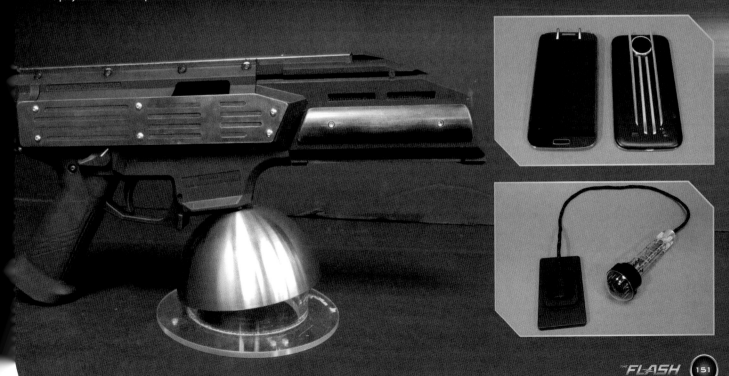

ARROWS

When Oliver Queen helped out on *The Flash*, Tyler Harron says, "We had to create more arrows than had ever been introduced on *Arrow*. We took the methodology of how they dressed their arrows, and added the S.T.A.R. Labs quality, creating devices at the ends of these arrows, so that it feels like it was something that Cisco made.

"On the freeze arrow, the idea is that they contain liquid nitrogen, and those are compressed air canisters for compressed air pellet guns."

However, "No arrow is ever fired on a show. They're all CG, for safety reasons. You don't want to shoot the sound man, and in order to create these types of arrows, the research and development work just to balance them would take much longer than anyone had time to develop. We build practical, full-length arrows with the devices on them, and then we also create the plant-on version of those, so that they can be placed onto an actor with a threaded rod through their costume to hold them in place once the arrow has [within the story] hit the person."

BLACK CANARY'S NECKLACE

Black Canary's necklace was invented by Cisco. Tyler Harron, who really developed it, says, "Black Canary's choker was the first time that I'd been asked to develop a prop for *Arrow*. We were suggesting that Laurel had to ask Cisco to develop a Canary Cry that she could wear, as opposed to having her use her handheld device. So, because a lot of the Cisco-designed stuff, or 'Cisco-tech,' as we call it, has come out of my designs, it was an opportunity to cross our two shows together with that technology. The idea behind it was that it was not quite a jewel piece, but that it looked very feminine with her costume." The exposed bits of gold, Harron adds, "are supposed to be generators of the sound waves."

As to why Cisco was so eager to help out Laurel Lance, actor Carlos Valdes offers, "I think Cisco is attracted to bad girls, absolutely. Cisco always wanted the bad girl, but always lamented the fact that he could never get the bad girl, because he was never bad enough to get the bad girl."

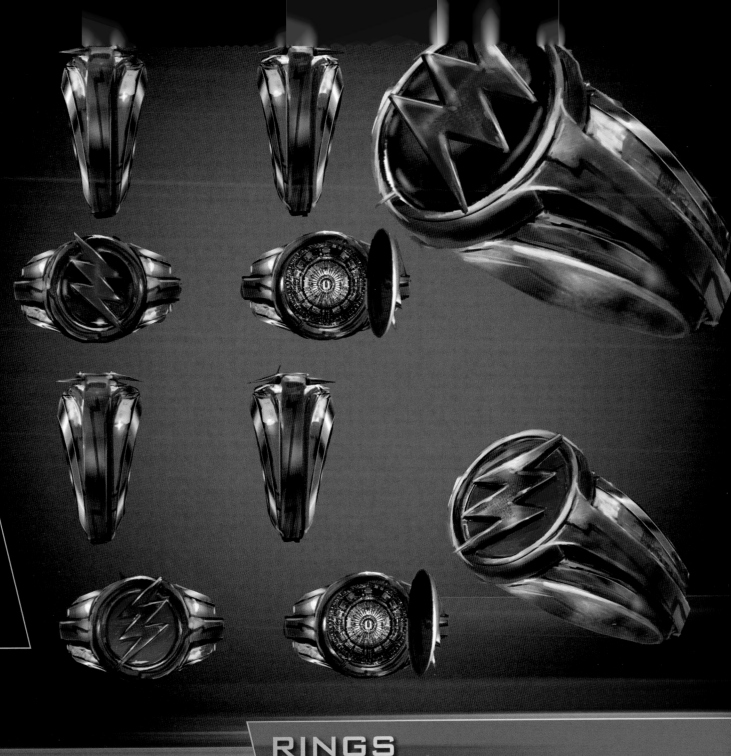

RINGS

The Flash's ring is gold on red, while the Reverse Flash's ring is red on black. Tyler Harron explains, "The first illustration is a known artifact in the comic books, the Flash ring, which contains Barry Allen's suits. By using micro-technology, a suit can get sucked back into that ring or projected out. That way, there was no need to explain where he put his suit every time he ran out. With the Reverse Flash was the introduction of that ring, as if that [future is] where the technology came from.

"The second illustration shows it opening, and the nano-verse within that ring. We never get a good look at this, because it became cost-prohibitive to do the visual effects for the result of the gag. I have the script page where I was doodling the original design of the ring. We had the prototype made up, believing that the Flash was eventually going to get one. Then it turned out he wasn't going to get one for at least the first two seasons. We had to make the Reverse Flash ring, and we had to flip the symbol over to make sure that it wasn't a Flash ring. We ended up going gold on gold with the toning. I personally wear on my finger the only prototype Flash ring."

PALM DEVICE

Gideon is the female-voiced artificial intelligence that accompanies Eobard Thawne in his guise as Harrison Wells. She is part of the palm device, which Tyler Harron explains, "was created for Eobard's [Matt Letscher's] arrival into our timeline, before he kills Harrison Wells. The idea is, even though he can run really fast, he can't carry a lot, but he wanted to bring his computer with him. Again, I see the world in a way that technology will keep moving forward. We need to learn how to compact more information into smaller spaces. That said, the best transportation of information in small spaces is through DNA. I wanted it to feel like there's a bit of mechanical technology, [with] the projector in the center, and then there are blue veins that come out that have little connecting points to his hand, those are organic-filled tubes, [and] that actually is [Gideon's] entire consciousness, condensed down into DNA or into an organic compound similar to DNA. She could be this vastly large computer intelligence that has been shrunk down, using organic technology, and is basically a combination between organic and mechanical, since we're believing that Eobard is from a distant future, and technology has jumped ahead by quantum leaps."

GAUNTLET

In the comics, Hartley Rathaway, the Pied Piper, uses a wind instrument to manipulate sound waves in order to control people. In *The Flash*, the Piper instead has gauntlets, which turn out to work on enraged Time Wraiths as well as on humans. This leads to a timeline with a much friendlier Hartley. Production designer Tyler Harron explains why the Piper has arm-wear rather than some version of his musical gear. "We wanted something that wasn't a flute, because that might look a little silly, so I came up with the concept that if he's wearing these gloves, and these gauntlets have speakers in the palms of them, he could project forward, or if they're on the back of his palms, he could almost punch with them in order for him to adjust the frequencies to attack people, either Barry or later the Time Wraith. I took the idea that he had actually taken the keys off of a flute and used those as control valves to adjust the frequency on the forearm." The metal slides on the sides of the gauntlets, Harron continues, "are actually very similar to the valve stems off of a flute, so it does have that musical instrument quality."

METAHUMAN WATCH

Earth 2 Harrison "Harry" Wells is no slouch when it comes to invention. When his Earth 2 particle accelerator exploded, Harry attempted to make the situation a little less hazardous by creating a number of devices meant to help normal people cope with the superpowered folk now in their midst. One such innovation is a wristwatch that detects metahumans.

Tyler Harron says, "When we first meet Earth 2 Harry in Season 2, he has this interesting watch on. At the same time [late 2015], the [real-world] Apple watch was coming out. I wanted to avoid having any confusion that this was an Apple watch that he had. So in the way of again going to that kind of Golden Age of comic history, I decided to give it a feel as if it's more of a Dick Tracy-style watch that contains similar technology [to what] would be in an Apple watch. [Wells,] as an industrialist like Steve Jobs on his world, has got his prototype and he's wearing his test before anyone else does. It's very silver, and the black stripes are giving that Deco feel to it, but also the flip quality to it [allowing the top to close and conceal the screen] for production reasons avoided us always having to have an active glowing screen on it."

GEOMANCER GLOVE

Geomancer, aka Adam Stafford, takes advantage of the Flash's absence [when Barry is on Earth 2] to terrorize Central City. To emphasize how Geomancer works his will, production designer Tyler Harron says, "We needed a set of gloves that were worn and were the fulcrum of the villain. And since we saw him placing his hands or using his fists to start the effect and then drive it forward through whatever was in his gloves, I took reference from [that and had] a glove base, but I also wanted to kind of give it a jackhammer-style feel. So a lot of it is pistons and spring-action cylinder shock absorbers, and I wanted to give it real grounding in jackhammer technology."

Even the fingers of the gloves are detailed, Harron notes. "The articulation of the fingers was to give a feeling like these were fully encased gloves that could take anything, and that every joint and portion of his hand was protected, so creating the shaking was still doing some damage to him."

When Geomancer attacks, it's a combination of practical and VFX. Practical effects supervisor Michael Walls relates that for "Geomancer, we just shook a lot of things around. We put shaker motors on objects wherever we could, wherever he was close by, and [tried] to get stuff to fall and also [used] falling debris and dust and stuff like that from above [the] camera." What high-tech method is required to get the debris to fall into the shot? It wouldn't be just practical effects workers dropping things, would it? "Yup."

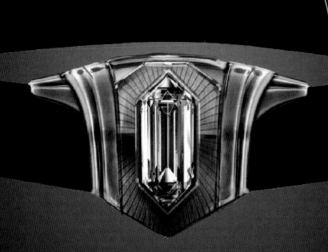

DR. LIGHT BELT BUCKLE

Earth 2 Linda Park, aka Dr. Light, derives her metahuman powers from starlight. This is reflected in aspects of her costume, including her belt buckle, which looks something like an amethyst jewel in a silver setting. Production designer Tyler Harron developed both Dr. Light's helmet and belt buckle working in conjunction with Super Hero costume designer Maya Mani. He relates, "The idea behind that was that we take a lot of the tone notes from the original [comic books]. In the source material, Dr. Light actually has a jewel on her forehead, but we felt that that was a little over-the-top for our show. We just wanted to give a nod to the original portrayal of her in the comic books, but we actually just made that adjustment and placed it onto her belt buckle as the tie-in." The jewel is made of "what we call acrylic that we mill down and then polish. It's a plastic derivative." As for the setting, "It's laid into another opaque plastic that has been pre-printed to that, and then painted to have a metallic finish to it."

EOBARD THAWNE'S TACHYON COLLECTOR

Once you know what's beneath his wheelchair, it makes sense that Eobard Thawne/Harrison Wells never wanted to be separated from it. Tyler Harron relates, "The tachyon collector was a power source that he could use to charge himself. That's eventually what becomes the energy source to keep Stein from dying once Ronnie dies. It keeps him from phasing out of reality."

In terms of design, "The colors are very reminiscent of the Gideon device, the handheld palm device, in that it was also technology that Thawne had created himself in the future. This was a really big compact storage device. A lot of that LED microscopic rope lighting was utilized again to give it that organic technology feel."

LED microscopic rope lighting is real-world tech. "It's something that was developed, as all good prop stuff, for the U.S. military, because it's extremely low-voltage and lasts incredibly long in the field, being that it's encased in a silicone membrane, so it doesn't break down. This allows it to be flexible and warm, without creating a tremendous amount of heat. So we build some of that technology into props, because it makes them a little more technical."

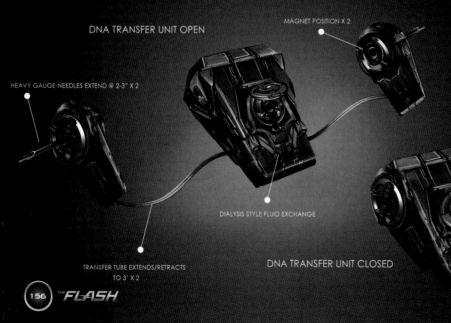

DNA TRANSFER UNIT OPEN

MAGNET POSITION X 2

HEAVY GAUGE NEEDLES EXTEND @ 2-3" X 2

DIALYSIS STYLE FLUID EXCHANGE

TRANSFER TUBE EXTENDS/RETRACTS TO 3" X 2

DNA TRANSFER UNIT CLOSED

DNA TRANSFER UNIT

The DNA transfer unit is what Eobard Thawne uses to steal Harrison Wells' DNA. Armen Kevorkian explains how the transformation was accomplished. "We did CG face transitions to go from one character to the other while they were doing the 360 [with the camera].

"We scan both actors, so we have their faces. When we get the plate, the corresponding actors standing where they are, and we do something called the 'match-move' of the face. What happened was, the Wells character actually deteriorated and decomposed as the DNA was being sucked, so we created the decomposed look and match-moved and tracked that onto Wells' face, and then we tracked Wells' face on top of Eobard's face to show that transition."

TACHYON DETECTOR

Although it looks like a high-end version of a metal detector, this tachyon detector is in fact yet another piece of "Cisco tech". In our world, it was created by production designer Tyler Harron, who says it is meant to look like it was invented and assembled in haste. "The idea is that he throws these devices together quickly, and we needed to show that he had developed something just before they left for Star City [in *Arrow*], that he could [use to] trace these tachyon emissions." The theory, proven correct, was that the Reverse Flash/pseudo Dr. Wells might have left traces of the emissions at the crash site where the real Dr. Wells had his identity stolen and died.

The tachyon detector is in reality "based over a metal detector The base of it being a flat grid, [it] was to be like a receptor on a satellite dish. Being that tachyons are something that are found within the universe, [the tachyons] kind of clung to these grooves [in the grid], and that's how they could detect if the tachyons were there or not. So it was a cross between a hand metal detector, a beach-combing metal detector, and a satellite wing."

GENERAL EILING'S MASK

The mask that General Eiling wears serves a twofold purpose: it hides his face from the Flash, and it prevents the Flash from realizing the General is being telepathically controlled by Grodd.

In reality, Tyler Harron says, the mask is "made out of carbon fiber and, again, 3D printed plastics. This was designed after actual military armor that is now being utilized on the front lines that, while not bulletproof, is a much better barrier than nothing. So the turn on that, to make it different, and again, to make a nod back to the comics, is that General Eiling in the comics is actually a deformed metahuman who almost looks like a rhino with tusks coming out of the side of his mouth. [While Eiling is] not that type of villain yet, I wanted to make a nod back to comics and, in the gas mask, have things that looked like they could be silver tusks coming up."

THE TRICKSTER'S DRAWINGS AND BOMB

Regarding the artwork of the Flash dying in various ways, Tyler Harron says, "Those are the Trickster's prison drawings. The Trickster has become obsessed in Season 2 with killing the Flash, and he's now drawing almost primitive, childlike drawings, because that's how he perceives the world. And he adorns his entire cell at Iron Heights with these types of drawings. Michael Erickson and Jessica Fish are the *Flash* art department Trickster illustrators. They draw all those, and come up with a bunch of those ideas."

Why does Harron think the Trickster-style villain – the Joker, the Toymaker, the Trickster himself – is such a recurring figure in DC lore? "They're so over the top that they realize how crazy they are, they're actually portraying the craziness on the outside. A lot of people hide that. These people are willing to embrace it and own it. And on almost all occasions, the Trickster and the Joker and the Toymaker, their villainy is in a lot of ways just insanity. But they're also characters that, when you read what their backstories are, they're not that dissimilar to the heroes. They are that close to being heroes [rather] than villains, that the joke is always on the hero, because the hero is not much different than the villain."

KHANDAQ STATUE

Appearances can be deceiving. For example, dimensional though it looks, this is not a statue, but rather an illustration, drawn by Brentan Harron, a production designer and artist — and father of *Flash* production designer Tyler Harron. The younger Harron explains why an actual statue was never made.

"When we first introduced Captain Cold, we had an exhibit, the Khandaq Diamond." This large jewel was the object of Cold's thieving plans, but aficionados of DC lore know that the diamond exists within a larger legendary context.

"Khandaq is a fictitious nation in the DC world. It's a society very similar to the Egyptian society, but a completely made-up nation. This is where the Black Atom comes from. It was a nice little Easter egg for the fans to have this diamond appear, which may or may not be a power source of great strength. But my art director [for Season 1, the elder Harron] worked and came up with this whole design of sculptures that would have been for that Khandaq dynasty that he photo-realistically illustrated."

VANDAL SAVAGE'S WEAPONS

When villain Vandal Savage throws his knives, they're like arrows on *The Flash* — that is, they're completely CG. Armen Kevorkian says the animation for both types of flying weapon is the same. "Obviously, whatever design has been established, you build it, and then you render it and composite it."

Once Vandal Savage has inflicted a wound, Michael Walls says, "A lot of the knife gags are the result of seeing him swipe a knife across an arm or a neck. That would be a special rig that we put on the back side of the blade, which is basically like a blood sponge, where he pushes hard against the neck with a sponge on the back side of the knife, which creates that perfect look of a cut."

When he's not murdering people, Vandal Savage needs a place to keep his knives close. *Flash* costume designer Kate Main says that she, *Legends* designer Vicky Mulholland and *Arrow*'s Maya Mani keep in close touch, but generally leave the other's work as is when characters cross over from their home shows. "Vicky had already created a brilliant silhouette for Vandal Savage. We took part in just augmenting a coat that needed to be lined in a certain way, because there was a script point which required him to open his coat, and it's lined with knives. So we added a liner."

THE ART AND MAKING
OF *THE FLASH*

ISBN 9781785651267
Printed in Canada
Published by Titan Books
A division of Titan Publishing Group Ltd
144 Southwark Street
London, SE1 OUP
United Kingdom

First edition: October 2016

10 9 8 7 6 5 4 3 2 1

The publishers would like to thank Greg Berlanti, Andrew
Kreisberg, Geoff Johns, Carl Ogawa, Tyler Harron, Armen
Kevorkian, Sarah Koppes, Kate Main, JJ Makaro, Maya Mani,
Tina Teoli, Grant Gustin, Carlos Valdes, Michael Walls, Josh
Anderson, Amy Weingartner, Carrie Stula, and everyone at
Encore, Warner Bros. and Berlanti Productions who helped
make this book what it is.

Image on p88 © Elizabeth Dubney

Did you enjoy this book? We love to hear from
our readers. Please e-mail us at:
readerfeedback@titanemail.com or write to Reader
Feedback at the address top left.

To receive advance information, news, competitions,
and exclusive offers online, please sign up for the Titan
newsletter on our website: www.titanbooks.com

A CIP catalogue record for this title is available from the
British Library.